dinosaurs

Dinosaurs

How to Draw Thunder Lizards and Other Prehistoric Beasts

Steve Miller

Watson-Guptill Publications
New York

This book is intended as an artistic guide and not as a science manual. Any mistakes in data, names, and classifications should be attributed to the author and not the individual artists who have contributed artwork. When writing these chapters, I kept in mind my father's old biology textbook; glancing at its coverage of dinosaurs, it is readily apparent that most of its information is incorrect by today's standards, even though it was taught as scientific truth in the 1950s. Paleontology is a rapidly evolving field of study and old "facts" are discarded as new data is gathered.

Art credits. Credits for images not noted either in the caption or on the art:

Bryan Baugh: pp. 6,9, 32–33, 40–41 (top images), 44, 46–47, 48, 50, 51, 56, 60–61, 63, 64 (top), 66, 67, 68, 70, 71, 74, 75, 77, 81, 86, 87, 90, 93, 97, 98, 99, 100, 101, 102, 103, 108, 110–115, 119–129, 137

Brett Booth: half-title; title page; pp. 39 (middle heads), 82–83, 91

Scott Hartman: 22–23 (sauropod)

Steve Miller: pp. 5, 14–17, 22–23 (horse, man, T. rex skull), 29, 39 (therototter), 130–136

Senior editor: Candace Raney
Editor: Sylvia Warren
Senior production manager: Ellen Greene
Designer: Jay Anning, Thumb Print

ISBN-10: 0-8230-9919-9
ISBN-13: 978-0-8230-9919-1

First published in 2005 as *Thunder Lizards* by Watson-Guptill Publications (ISBN: 978-0-8230-1663), Nielsen Business Media, a division of The Nielsen Company
770 Broadway, New York, NY 10003
www.watsonguptill.com

Library of Congress Control Number: 200596015

Printed in the United States
First printing, 2005

1 2 3 4 5 6 7 8 9 / 14 13 12 11 10 09 08

This book is dedicated to
my daughter, Jorja, and my son, Camden.
My love for you two is bigger than an
Argentinosaurus and will never go extinct.

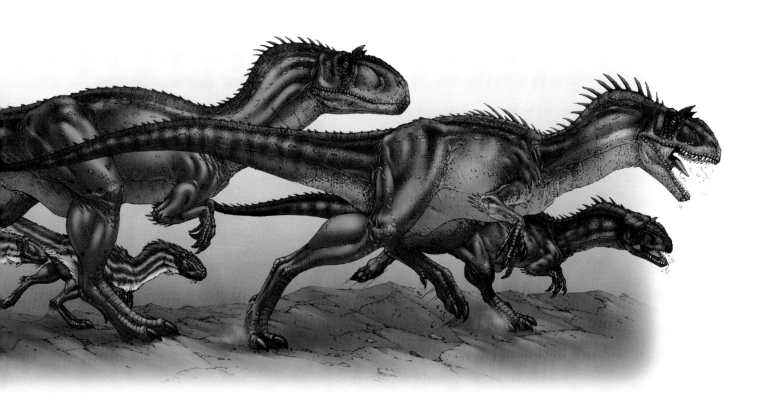

Acknowledgments:

I would like to thank the following people for their invaluable assistance in compiling this manuscript and/or influencing my vision of dinosaurs: Arthur Adams, Bryan Baugh, Brett Booth, Jessica Ruffner Booth, Ray Bradbury, Frank Cho, Mike Compton, Michael Crichton, Ricardo Delgado, Frank Frazetta, James Garney, Mark Hallett, Ray Harryhausen, Scott Hartman, John Horner, Ryan McClay, Willis O'Brien, Gregory S. Paul, Greg Pullman, Mark Shultz, Dr. Joshua B. Smith and all the members of the "dinosaur list" at dinosaur@usc.edu, Steven Spielberg, Tomoyuki Tanaka, Demetrios Vital, Connie Weiland, and Bernie Wrightson.

I used literally hundreds of books, websites, videos, and museums for gathering information and cross-referencing data on this project. It would be impossible to credit all sources used, but I would be amiss if I did not include those resources I found especially informative, and these are listed at the end of the book, on page 143.

Finally, I would like to extend a special extra thank-you to Sylvia Warren, my editor on all three books in this series, for her tireless dedication and commitment to fact-checking. You continue to make me look smarter than I really am.

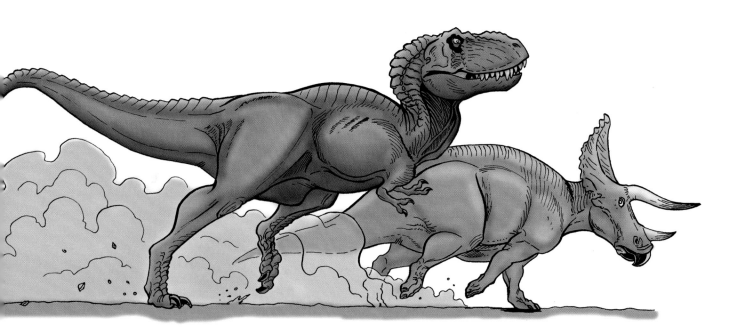

Contents

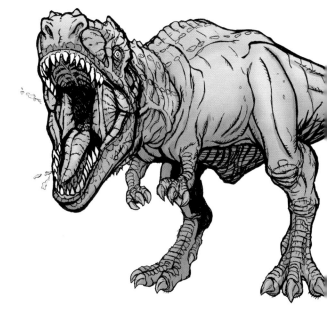

ABOUT THE ARTISTS

Arthur Adams has been involved in the comics industry since the early eighties. Arthur combines a dynamic, lively, and often humorous style with well-planned layouts and incredible attention to detail. His credits are legion. Suffice it to say that he has worked for every major comic book publisher in America. His fan base is so well established that he is considered the first choice whenever a cover artist is needed to help attract readers to a new series.

Bryan Baugh regularly works as a storyboard artist for animated television shows. His credits include *Batman, Jackie Chan Adventures, Roughnecks: The Starship Troopers Chronicles, Men In Black, Masters of the Universe*, and several others. He has also contributed artwork to children's books and magazines. Baugh currently writes and illustrates his horror comic book, *Wulf and Batsy*, for Chanting Monks Studios. With Steve Miller, he coauthored *Scared: How to Draw Fantastic Horror Comic Characters.* He grew up in Fairborn, Ohio, but now lives in Thousand Oaks, California, with his green-eyed goth-queen wife, Monica, and two ferocious jungle cats, Lucy and Tiger.

Brett Booth wrote and penciled Wildstorm Productions' *Kindred, Backlash, Wildcore,* and *Backlash/Spider-Man* comic books. He was also the artist on Wildstorm/DC's *Thundercats: Dogs of War* and *Extinction Event.* At Marvel Comics he penciled *Heroes Reborn: Fantastic Four, X-Men Unlimited*, and *X-Men.* He has always been fascinated by dinosaurs.

Jessica Ruffner Booth is one of the most sought-after colorists working in the comics field today. She has been the colorist on comic books for Marvel and Image, including *Backlash, Gen13, Backlash/Spider-Man, Wildcore,* and *Heroes Reborn: Fantastic Four.* In her spare time she likes to paint portraits of her 17 dogs.

Frank Cho is the creator of the popular syndicated comic strip *Liberty Madness*, which appears daily in newspapers and in an unexpurgated form in Image Comics. Cho effortlessly combines the classic illustration disciplines used to create action comic strips for the newspapers with the timing and humor of a master gag artist.

Mike Compton has been interested in illustrating dinosaurs since childhood. His first serious dinosaur piece, completed in 1987 when he was in college, was included in a Society of Illustrators exhibit. Mike, who has worked in illustration-related fields for the almost 20 years, believes that a successful scientific illustration is one that blends accurate information with strong emotional appeal for the popular audience. Recently, Mike has been serving a variety of markets, including product packaging, publishing, and commercial advertisement. He currrently works at Ascendant Studios, near Columbus, Ohio.

Scott Hartman currently attends the University of Wyoming. He works closely with other paleontologists to recreate scientifically accurate anatomical skeleton representations. Dinosaurs have been a lifelong passion for Scott, both scientifically and artistically. He has taught paleontology, evolutionary biology, and geology at the high school and college levels. Scott is a member of the Society of Vertebrate Paleontology, where he has presented his research at numerous conferences, including work on the posture of duck-billed dinosaurs and on the origin of flight in birds. Check out his website at www.skeletaldrawing.com.

Jim Lawson is best known for his work on Mirage Studio's *Teenage Mutant Ninja Turtles* comic book. He is also the creator and artist of the Blade Biker series and is a co-creator, with Peter Laird, of the sci-fi comic book series Planet Racers. His highly detailed dinosaur work is featured in the comic books *Dino Island* and *Paleo*.

Steve Miller is an author and artist who has worked in numerous areas of the entertainment field. His drawings have been used in the production of videos, toys, RPGs, and video games. Steve's latest book, which he coauthored with Bryan Baugh, is *Scared: How to Draw Fantastic Horror Comic Characters.* He lives in Ohio with his lovely wife and two wonderful kids.

Gregory S. Paul is an acclaimed paleontologist, author, and illustrator. Paul's anatomical studies of dinosaur musculature and skeletons have set the new standard for scientific accuracy. He has had numerous scientific articles published, as well as two paleontology books: *Predatory Dinosaurs of the World* (1988) and *Dinosaurs of the Air* (2002). He is frequently utilized as a consultant on all things dinosaur-related, from dinosaur movies to museum displays.

While in college in Minnesota, **Demetrios Vital** had the privilege of working with many wonderful paleontologists and artists. Now in New York, Vital has continued to illustrate dinosaurs professionally, always learning new ways to bring life to these ancient animals and their world.

Bernie Wrightson, widely recognized as the Master of the Macabre, needs no introduction. The legendary Wrightson has illustrated the works of Stephen King, Edgar Allen Poe, H. P. Lovecraft, and Mary Wollstonecraft Shelley. His comic book credits include *Swamp Thing, Creepshow, House of Mystery, House of Secrets, Creepy, Eerie, Twisted Tales*, and countless others. He currently resides in Southern California.

Preface

I was shocked to realize that even though dinosaurs have always occupied a special place in our hearts, there exists a profound lack of quality educational books on drawing and designing them. Many of the previously published attempts taught how to string a series of simple shapes into the rough approximate form of a dinosaur, but they all stopped short of teaching an actual constructive understanding of basic dinosaur anatomy. This book is designed to fill that gap. Not only are the processes broken down into a simple-to-follow step-by-step method that any beginner can follow, but also additional information is provided into the more subtle nuances of building dinosaurs with solid anatomy. This means that as your artistic abilities grow so will your enjoyment of this book.

You will notice a lot of this book is dedicated to not only showing you what shapes to draw, but also how you should think before even starting your drawing. Art starts in the mind and flows out to your hand, transforming your pencil into a divining rod in search of the perfect line. Understanding the forms and functions of the different basic shapes that make up dinosaurs will allow you to move and pose your creatures mentally, before your lead ever touches the paper. It is what will convert you from a simple copier to a true artisan, capable of drawing these beautiful behemoths in any position imaginable.

If you want to get the maximum satisfaction from your drawing experience, don't skip the first two chapters: "Setting Up" and "Dinosaur Anatomy." The latter will give you a solid foundation—in comparative anatomy and dinosaur anatomy—for the step-by-step exercises which follow. After that, feel free to skip around to the dinosaurs of your choice, digesting the material at your own pace.

A quick note to beginners: When you are just starting out you may get frustrated when your initial efforts result in less than perfect drawings. This is great news! This means that you are able to recognize the difference between where your drawing skills are currently and where you want them to be! Artists stop growing when they feel they have arrived and no longer have room for improvement. Truly successful artists need to learn how to critique their own artwork as well as recognize their progress. Your desired results should always be a good ten paces out from your current abilities. Art should be viewed as a process, rather than as a final product. A bad drawing is only a failure if you do not learn from it. Take note of what did not work well and practice specifically on those areas in your next drawing. It should reassure you to know that for every successful drawing in this book there is a trash can full of mistakes from earlier in the artists' careers. Little by little, drawing by drawing, you too will get better!

VITAL STATISTICS

HERRARASAURUS

Length: 13 ft (3.9 m)

Height: 4 ft (1.1 m)

Weight: 460 lb (210 kg)

Fossil remains of Herrarasaurus ("Herrera's lizard") were found by a rancher in Argentina, Don Victorino Herrera, in 1958. Herrerasaurus was a bipedal carnivore, which means it was a meat-eater that walked on two feet.

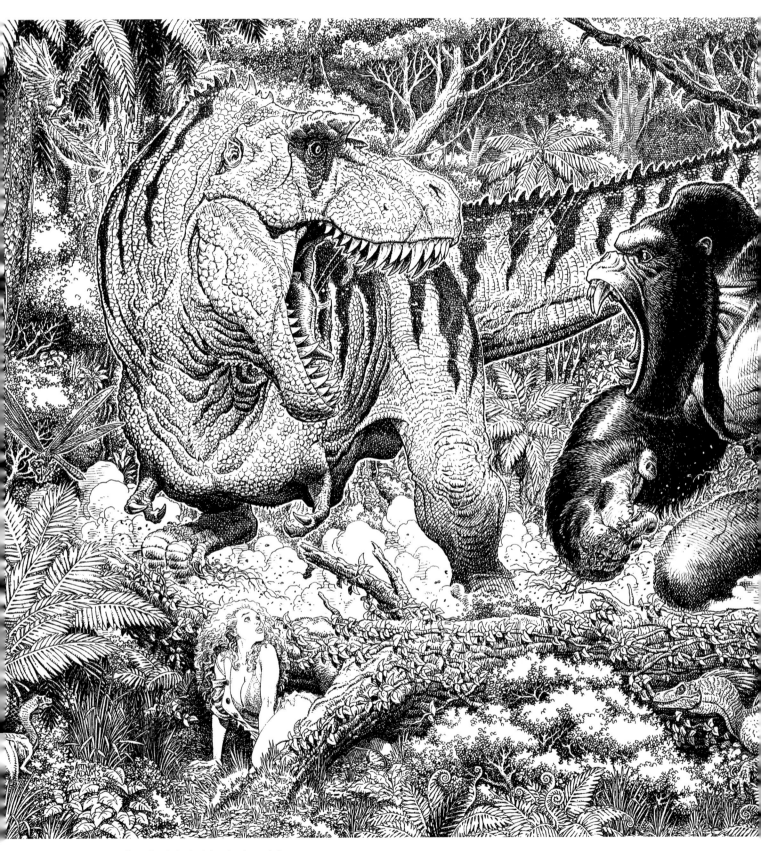

T-rex vs. Kong, by the inimitable Arthur Adams.
The tiny Velociraptor at the lower right is just
about to pick apart somebody its own size.

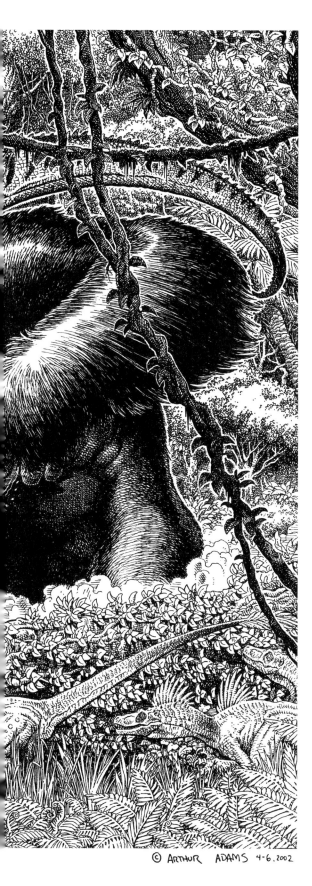

© ARTHUR ADAMS 4-6, 2002

Introduction

Dinosaurs are alive. I'll prove it to you. What do you picture when you hear the name *Tyrannosaurus rex*? Is it dead dry fossilized bones? Or is it a kinetic image of teeth and claws, scaled skin draped over muscles more powerful than a bulldozer, a thundering beast bigger than a stampeding elephant and twice as fierce? I'm guessing it is closer to the latter image, but the former is all we have left of this animal. The rest is conjured up by your memory of inventive depictions of the creature. Your ideas of dinosaurs may be fed by what you see in comic books, video games, science books, or the latest big-budget Hollywood extravaganza, but they all started as drawings brought to life by a skilled artist's hand.

Scientists and artists have always had a symbiotic relationship when it comes to dinosaurs. It is the crossroads where fact and the fanciful meet. From early on paleontologists, scientists who study dinosaurs, needed artists to help them visualize what their recent discoveries might have looked like. Conversely, artists started clamoring for more scientific facts so they could more accurately portray the fearsome creatures. Their initial attempts are flawed by today's standards, as the huge statues at England's Crystal Palace Park (1850) (see page 21) clearly show, but they ignited the public's interest in dinosaurs. These bizarre-looking animals were no longer just bones and fossilized footprints, but could now be viewed at bigger-than-life dimensions. When stop-motion-animator Willis O'Brian later brought these moving, fighting, and biting "terrible lizards" to movie houses across the world in the classic *King Kong* (1933) some audience members fainted with fright at the towering images. No matter that they had gone extinct; they were now a permanent part of the public's consciousness. Since then our love of dinosaurs has only grown, hitting new heights with the *Jurassic Park* series. This book is designed to transform you into one of those magic artisans who release these rampaging giants to rumble across the plains of our imaginations.

etting Up

It is important to provide yourself with adequate space to work. Find an area in your home where you are the most comfortable and free of distractions. Make sure you keep all of your materials within arm's reach so you do not have to keep getting up to find things.

orkspace

You will need a desk (or table) to work at and a comfortable chair. If you are serious about drawing, you will spend hours upon hours here, so choose your furniture carefully. To minimize the strain on your back you will want your workspace to be high enough so that you do not have to lean over it. Ideally you want a drawing table designed specifically for artists, but a homemade drawing board (a quality piece of smooth wood will do) that you can fasten your work to with thumbtacks or masking tape will suffice. Until you set up a permanent work area, you can use any flat, clean surface in a well-lighted space.

The best drawing tables are the ones that allow you to adjust the angle of the drawing surface. An angle that is roughly a 90-degree angle from your eyes prevents eye fatigue and also minimizes unwanted distortions in your drawings. A swivel chair with an adjustable height is perfect, but get one without arm rests because they will only get in your way. I suggest a chair that allows the forearms to be horizontal to the floor when your back is straight and your hands are resting on the table. If you can't afford a top-quality, fully-adjustable chair, just make sure the one you use is comfortable and has good back support. And when you are drawing, be sure to bend your waist, not your back. Good posture will prevent back strain and allow you to work for several hours without discomfort. If you find yourself leaning over your drawings, try raising the drawing suface or lowering your seat.

Depending on how much space you have you may want to consider purchasing a separate art cart or table that will hold all your supplies: the essentials, plus extra things like reference material, rulers, French curves, paper towels, triangles, T-squares, markers, and tape. Use a fisherman's tackle box to keep pens, pencils, and other small doodads organized. They are less expensive than the boxes sold at art supply stores, but work just as well.

For lighting get yourself a lamp with a flexible neck and a strong incandescent bulb.

Consider setting up a mirror next to your drawing desk. When you hold up a drawing to a mirror, the flipped image will sometimes reveal problems not apparent when you're looking at it straight-on, such as poor perspective or proportion.

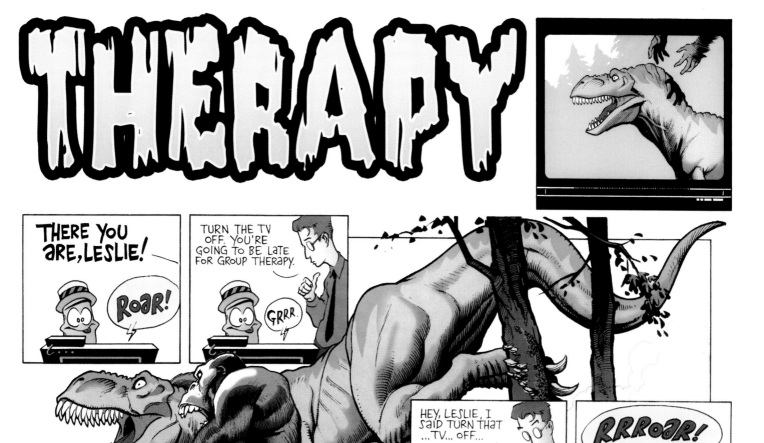

There really is something universally appealing about dinosaurs. For artists, especially cartoonists, choosing these "terrible lizards" as a subject seems to be a way to connect to the inner child, as Frank Cho so ingeniously illustrates in this scene from "Therapy," a strip from his *Liberty Meadows* comic.

Supplies

The basic supplies you need are pencils, erasers, ink, and correction fluid or a substitute for correction fluid.

There are a variety of drawing pencils to choose from. The most common are wooden pencils, which come in grades from 9B (which has the softest lead and makes the blackest mark) through 9H (which has the hardest lead and makes a very light mark). HB is the midpoint.

Try using an HB or 2B pencil to start with. It is good to learn the control and discpline required with the softer leads. When you have been practicing for a while you may want to use an H or 2H to lightly sketch in your practice lines. Beware: If you press too hard with these, they will gouge or even tear your paper.

Nonphoto blue or nonphoto green pencils—the marks of which do not reproduce when run through a copier—are good for doing preliminary linework, like placing bones and musculature. Make sure you keep a pencil sharpener handy. An investment in a good-quality electric one will pay off in saved time and energy later.

Some pencils have replaceable lead; these are called mechanical or "clutch" pencils. They can be loaded with any grade of lead and require a special sharpener to touch up the point. Some mechanical pencils use very thin lead that never needs to be sharpened. If you don't have access to special art pencils, don't worry. The good old inexpensive No.2 pencil that everyone remembers from grade school can produce a wide variety of tones and marks. I used one for almost all the how-to steps in this book. Experiment with different pencils until you find the ones that work best for you.

Just as there are many types of suitable pencils, there are also many types of erasers: gum, white plastic, mechanical, and kneaded, to name just a few. Steer clear of all the pink varieties; they will smear and stain your drawing. Try a gum or white plastic eraser for removing large mistakes. The gray kneaded eraser, which has a consistency rather like Silly Putty, is designed for making lines lighter by dabbing rather than rubbing. Try to avoid erasing a lot because it tends to make your drawings look messy and weakens the paper. Learn to wait until your drawing is almost done before erasing anything. If you've made a mistake, leave it and draw the correct line right over the error. If you make several mistakes, it is best to just start over on a clean sheet. Keep the initial drawing for reference or copy the lines you like by tracing.

It is not as important that you draw each of these steps as it is you understand the reasoning behind them. You need to be able to construct your drawing in your head before you put it to paper. In general, the line weight for the outline and body contours of your dinosaurs should be thicker than the lines you use to draw the details like the scales, eyes, and teeth.

As you become more comfortable with your art you develop your own processes for constructing convincing dinosaurs. The steps provided are one way to go. Feel free to modify the procedures if you discover something that works better for you and still produces excellent results.

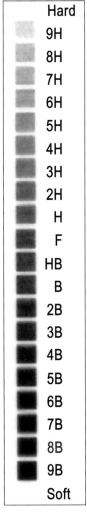

	Hard
	9H
	8H
	7H
	6H
	5H
	4H
	3H
	2H
	H
	F
	HB
	B
	2B
	3B
	4B
	5B
	6B
	7B
	8B
	9B
	Soft

Pencil lead gradations from 9H to 9B.

A stereo and headphones will help you shut out the distractions of the world and let you drift back to prehistoric times.

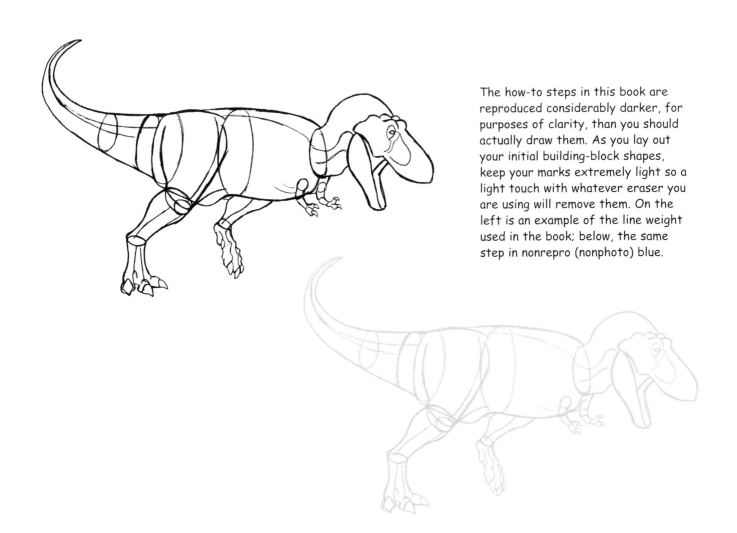

The how-to steps in this book are reproduced considerably darker, for purposes of clarity, than you should actually draw them. As you lay out your initial building-block shapes, keep your marks extremely light so a light touch with whatever eraser you are using will remove them. On the left is an example of the line weight used in the book; below, the same step in nonrepro (nonphoto) blue.

You may be content with your drawings after the penciling stage or you may prefer to ink them. Going back over them with ink will give them permanence and allow you one final opportunity to refine your linework. Several different kinds of inks, pens, and brushes are readily available at any decent art supply store. Explore your options to find what works best for you. I use a combination of dip pens with removable nibs (the Hunt 102 crow quill is my weapon of choice), several sizes of technical pens, and sable brushes. An intense black ink is best for brush and dip-pen work; I use either Higgins Black Magic or Daler Rowney Calli brand black calligraphy ink. Technical pens require a special type of ink that won't clog them up, so be sure to check with the manufacturer to see what brands the company suggests. After every session clean your inking utensils thoroughly. Remember: Take care of your art supplies and they will take care of you!

Inked lines are not easily erased; it is best to paint over mistakes and reink the correct lines. Final artwork is scanned before being printed and all your touch-ups will magically disappear when run through a copy machine. (And you thought pros never made mistakes!) For painting over inking mistakes, I use Pro White illustration correction fluid or slightly diluted white gouache . The gouache can also be used for special effects, such as "splattering" with an old toothbrush.

Many artists now make final corrections to their work using an image manipulation computer application such as Adobe Photoshop.

There are hundreds and hundreds of different types of paper. For most of your sketches you will want to work on whatever inexpensive paper you have handy. Tabloid, or ledger, 11 x 17-inch (or A3) paper is ideal for laying out large or highly detailed dinosaur drawings. For smaller drawings, plain 8½ x 11-inch (or A4) paper copier/printer paper is fine. You may also want to purchase bound sketchpads of various sizes. Once your skills are more advanced, you will want to visit an art supply store and look at their professional grades of paper. I use 2-ply Bristol board for most of my professional illustration work.

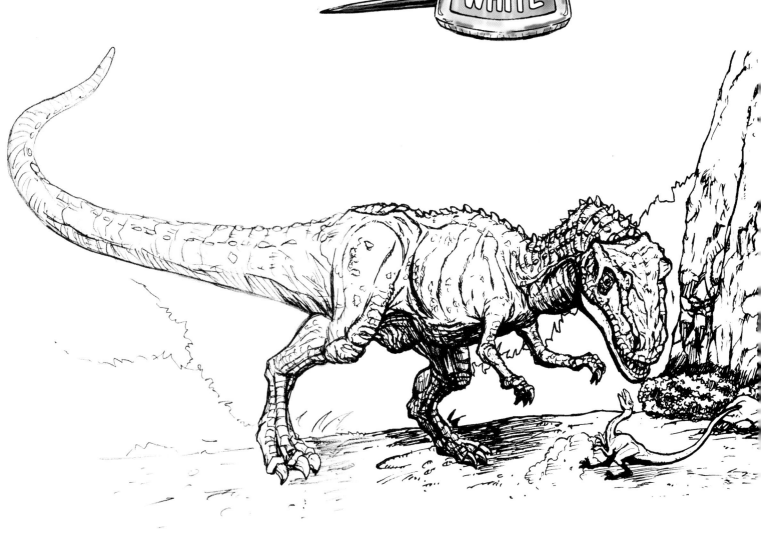

The tail of this T-rex is lightly penciled; the right leg is in pencil, but darker. The inked parts of the drawing are much darker.

A Few Quick Tips

Here are a few quick tips for more professional results. These are trade secrets. I could lose my membership to the artist's guild for giving them out so freely, but you seem okay to me. Now that you know how valuable they are, I trust you will make good use of them. Learn to vary how dark your pencil marks are by varying pressure on the pencil. It is helpful, as you train yourself to make very light marks, to first draw your marks in the air, about ¼ inch above your paper. Once you have the motion correct, then put the lead on the paper and draw lightly. A good way to loosen up before you start to draw is to practice making several circular shapes on your paper. When you are doing this start your drawing movements with your shoulder; this will allow you to produce more graceful shapes. This will become especially important later for drawing large body parts, like the tail, where a fluid motion is important. Try to make your drawings large. If you are using 8½ x 11-inch (or A4) paper, your dinosaur should take up most of the sheet. Don't worry about fitting the whole tail on the page, the body and limbs are the key components to master first. If you have a problem with the pencil marks being smeared by your hand, lay a scrap sheet of paper under your hand as you draw. Always start on the large forms and work toward the small. Don't draw things like the eyes and teeth until you have the whole body laid out.

This next one might shock you: Don't be afraid to copy the dinosaur pictures in this or any other book or magazine you come across. Copying is part of the process of learning, and it is perfectly acceptable as long as you don't try to pass someone else's work off as your own.

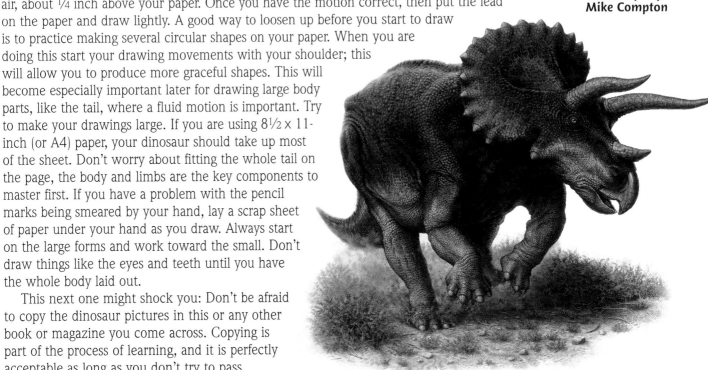

Triceratops by Mike Compton

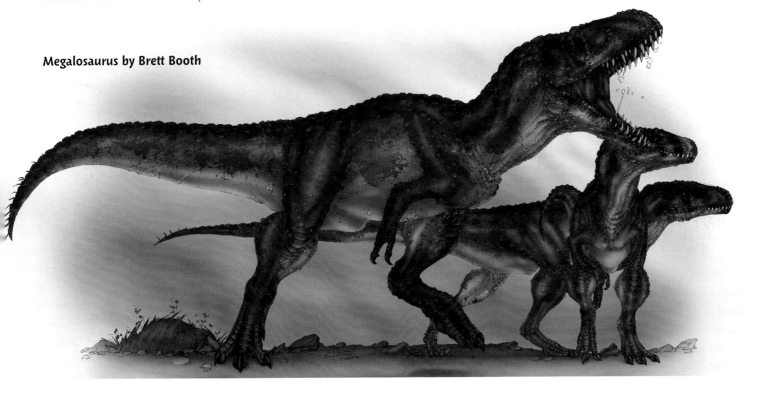

Megalosaurus by Brett Booth

Two Secrets to Success

First, don't worry about style. You will, over time, develop your own unique drawing style, which may be superrealism, pure cartoon, or something in between. Once you have the basics down, you will find your own artistic voice.

Second, the most important thing you need to become a successful artist can't be found in an art supply store or developed by copying the work of artists you admire. It is something you have to bring with you every time you sit down to the drawing table: Determination. You have to learn self-discipline and work very hard at being an artist. You will experience numerous setbacks and failures before you begin to see the fruits of your artistic labors, but eventually they will come. Think about it. No one has ever become a worse artist by practicing and no one has ever become a better artist by being lazy. Remember that and you will do fine.

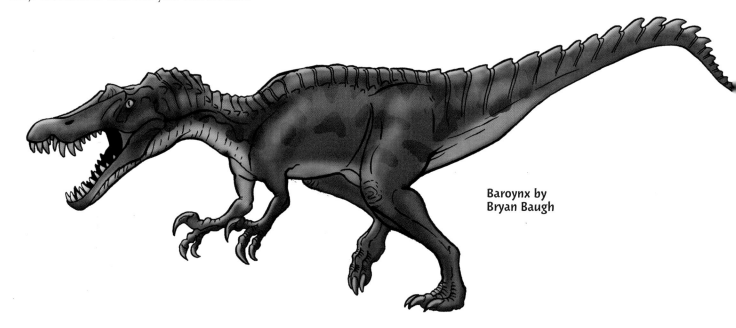

**Baroynx by
Bryan Baugh**

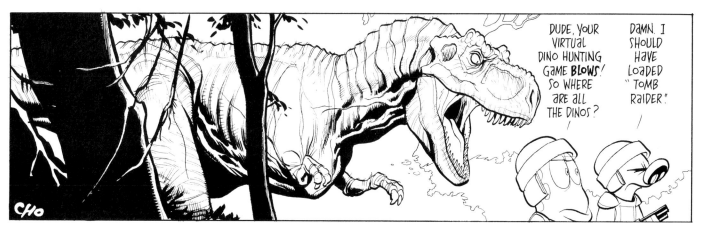

Virtual T-rex by Frank Cho

Four different artists—four different styles—four great drawings.

Dinosaur Anatomy

Sir Richard Owen (1804–1892) gave dinosaurs their name. After examiningan unusual group of fossils, he decided that they were the remains of an entirely new form of animal. In an article published in 1842, Owen proposed that the animals were reptiles, far larger than any previously classified, and gave them the name *Dinosauria* (from the Greek words *deinos*, meaning "terrible," and *sauros*, meaning "lizard"). He was then commissioned to work with sculptor Benjamin Waterhouse Hawkins and architect Sir Joseph Paxton to build life-size models of dinosaurs for Crystal Palace Park, which opened in 1854. The models were viewed with a mixture of awe and fright, but they were, understandably, way off the mark. Since Owen's time, the fossilized remains of hundreds of different dinosaur species have been found. Paleontologists, experts in comparative anatomy, and artists have worked together to reconstruct these amazing creatures.

Comparative Anatomy

Comparative anatomy is just what it sounds like: the comparing of anatomical features among organisms to look for similarities. For dinosaurs this is especially helpful in determining what the animals looked like since all we have left are fossilized bone and a few skin imprints. If we look at living animals with similar skeletal systems, we can start to piece together where the muscles needed to move dinosaur bones might have been connected and what size and shaped they needed to be. I suggest that before you tackle the anatomy of dinosaurs, you start by studying the skeletal and muscular systems of the human body. It is not necessary to memorize the names, locations, and functions of all the muscles and bones in the human body, but if you are serious about being an artist you will need to learn at least a dozen or so key ones. If memorizing names like *vastus medialis* (the muscle that extends the knee) or *thoracic vertebrae* (that part of the backbone that lines up with the chest) is just too boring, give the muscles nicknames that are easy for you to remember.

Here is the neat thing about anatomy; once you have a basic understanding of the anatomical features of a human being you can apply that knowledge to many different animals because the basic muscle and skeletal systems are repeated in many different types of vertebrates.

So please don't skip over the anatomy sections of this book, since they are what really set it apart from all of its How-to-Draw-Dinosaur predecessors. I would go as far as to say that it renders them . . . well, extinct.

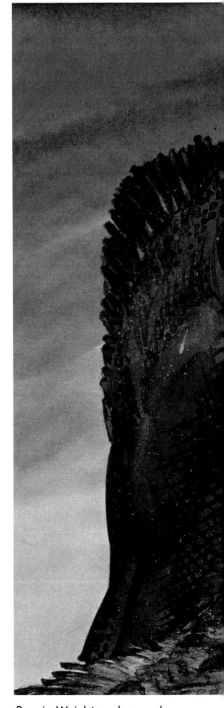

Bernie Wrightson has made a career out of illustrating what scares us, and here he has brought to vivid life a truly terrifying Allosaurus. The scariest thing about dinosaurs is that they aren't mythological monsters: They lived and breathed and walked the earth.

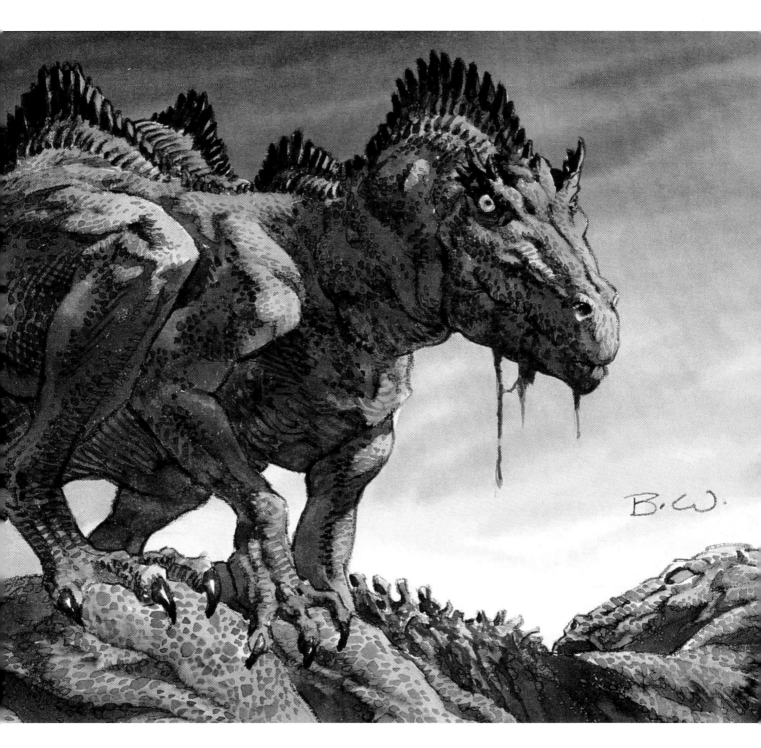

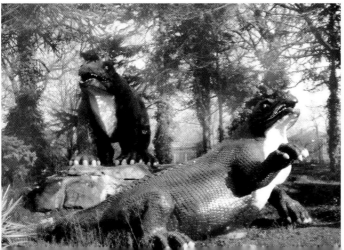

The creators of the Crystal Palace dinosaurs may have gotten the details wrong, but they got the scale right. On New Year's Eve 1853, sculptor B. W. Hawkins gave a dinner party—inside the iguanodon mold! *(Photograph courtesy Dr. Joshua B. Smith.)*

The Skeletal System

The skeletal system of a dinosaur, like the skeletal system of any vertebrate, is divided into several major sections: skull, axial skeleton (basically, the vertebral column), and the limbs and the bones that attach the limbs to the axial skeleton. Parts of the dinosaur skeletal system that are *not* analogous to anything in the human skeletal system are:

- All dinosaurs had various openings in the skull and jaw called *fenestrae* (from the Latin word for "window").

- Dinosaurs, like many land vertebrates (but not humans) had *gastralia*, or "belly ribs," which were not attached to the spinal column.

- Some dinosaurs had *scutes*, bony parts of the skin used for armor.

- The hip sockets of dinosaurs had only a sheet of cartilage, rather than bone, on the part of the hip socket toward the center of the animal.

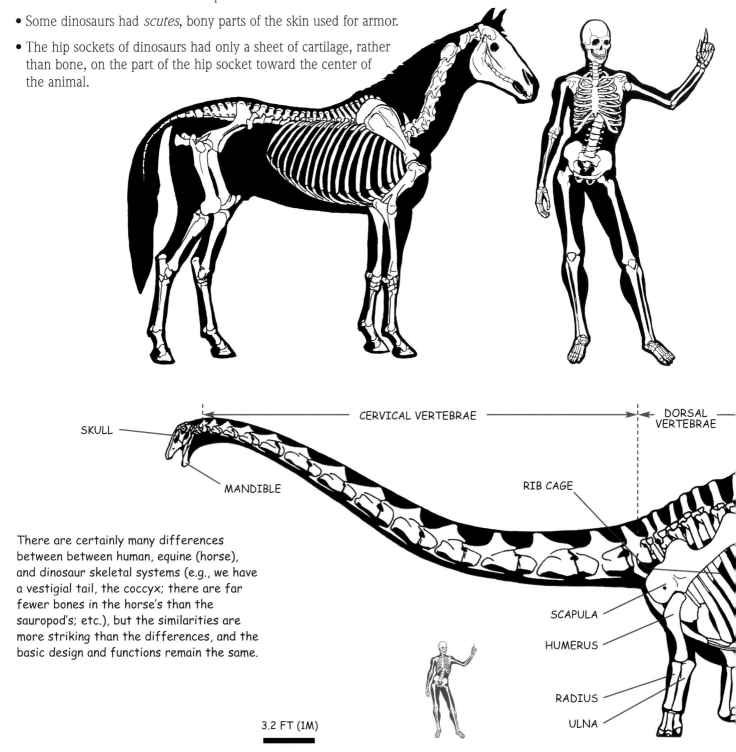

SKULL

MANDIBLE

CERVICAL VERTEBRAE

DORSAL VERTEBRAE

RIB CAGE

SCAPULA

HUMERUS

RADIUS

ULNA

There are certainly many differences between between human, equine (horse), and dinosaur skeletal systems (e.g., we have a vestigial tail, the coccyx; there are far fewer bones in the horse's than the sauropod's; etc.), but the similarities are more striking than the differences, and the basic design and functions remain the same.

3.2 FT (1M)

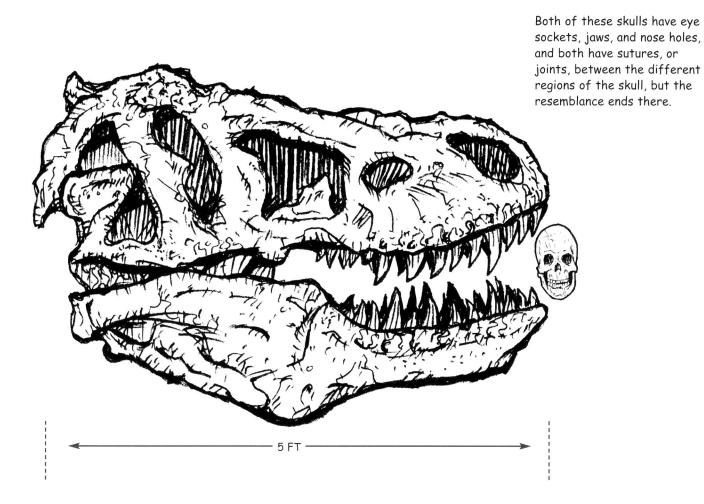

Both of these skulls have eye sockets, jaws, and nose holes, and both have sutures, or joints, between the different regions of the skull, but the resemblance ends there.

5 FT

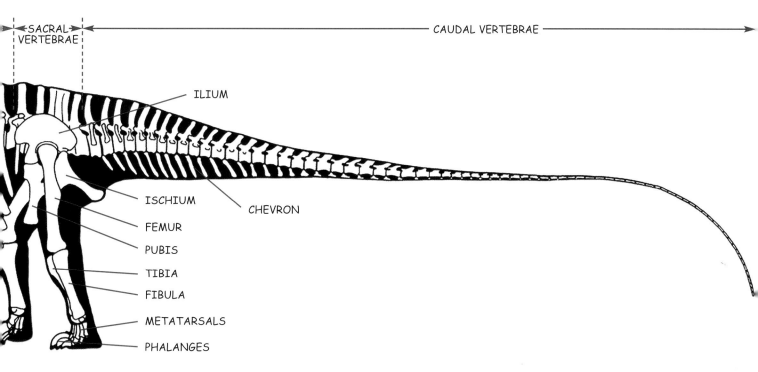

SACRAL VERTEBRAE

CAUDAL VERTEBRAE

ILIUM

ISCHIUM

CHEVRON

FEMUR

PUBIS

TIBIA

FIBULA

METATARSALS

PHALANGES

Muscles and Deep Soft Tissue

To construct models of dinosaur muscles, scientists use the latest information available on the scarring of the fossilized bones, as well as the principles of comparative anatomy. Bone scarring occurs when a muscle repeatedly rubs against a bone; this gives us clues as to what muscles were attached where and what they were used for. In your drawings, most of these individual muscles will be obscured by the dinosaurs' thick hides, but their overall mass is what will help give the drawings a sense of weight and authenticity. Once the skeletal and superficial muscle systems have been reconstructed, scientists can make educated guesses on deep musculature and soft tissue systems. Finally, after we have built a dinosaur from the inside out we can cover it with a thick, leathery skin and have a pretty good idea of what the animal looked like. Of course all of the data collected still leaves plenty of wiggle room for artistic guesswork and that is where you come in!

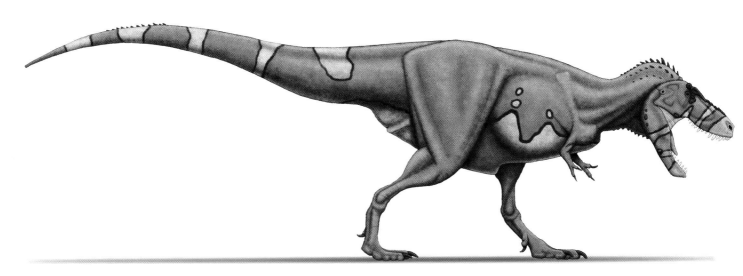

T-rex, like Allosaurus, is a theropod, and the muscles beneath its skin were very similar to those of Allosaurus. This drawing of T-rex by Scott Hartman shows a thorough knowledge of theropod anatomy.

Opposite page, top: Superficial musculature; opposite page, bottom: deep musculature and soft tissue. In these drawings by Scott Hartman of Allosaurus, the parts are labeled with the names of corresponding muscles and soft tissue in the human body.

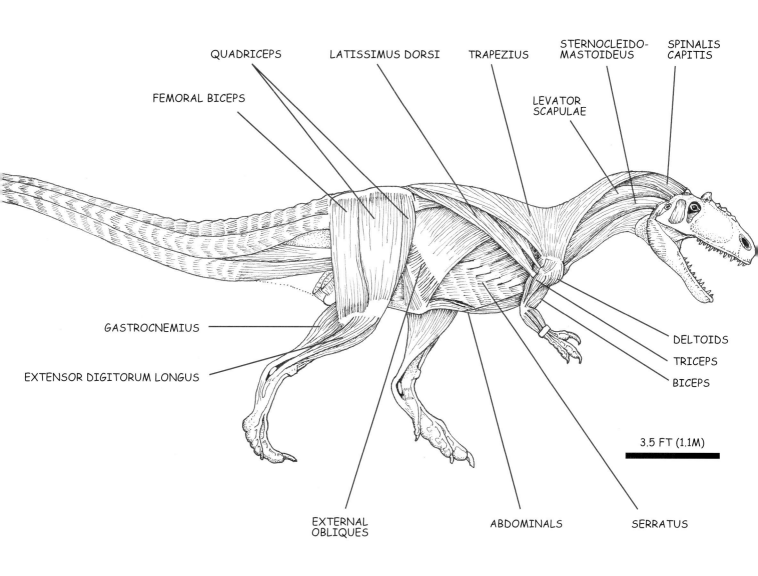

QUADRICEPS

FEMORAL BICEPS

LATISSIMUS DORSI

TRAPEZIUS

STERNOCLEIDO-
MASTOIDEUS

SPINALIS
CAPITIS

LEVATOR
SCAPULAE

GASTROCNEMIUS

EXTENSOR DIGITORUM LONGUS

DELTOIDS

TRICEPS

BICEPS

3.5 FT (1.1M)

EXTERNAL
OBLIQUES

ABDOMINALS

SERRATUS

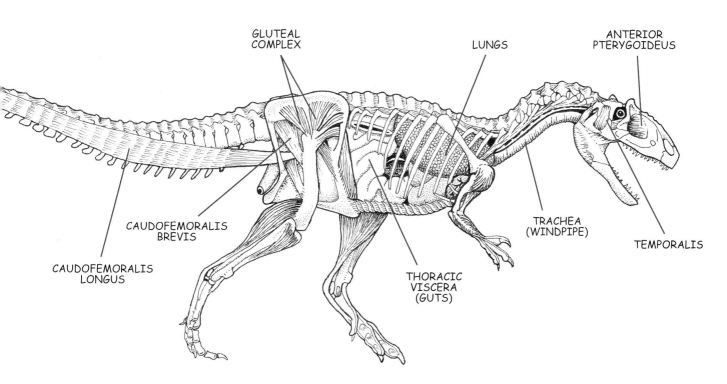

GLUTEAL
COMPLEX

LUNGS

ANTERIOR
PTERYGOIDEUS

CAUDOFEMORALIS
BREVIS

CAUDOFEMORALIS
LONGUS

THORACIC
VISCERA
(GUTS)

TRACHEA
(WINDPIPE)

TEMPORALIS

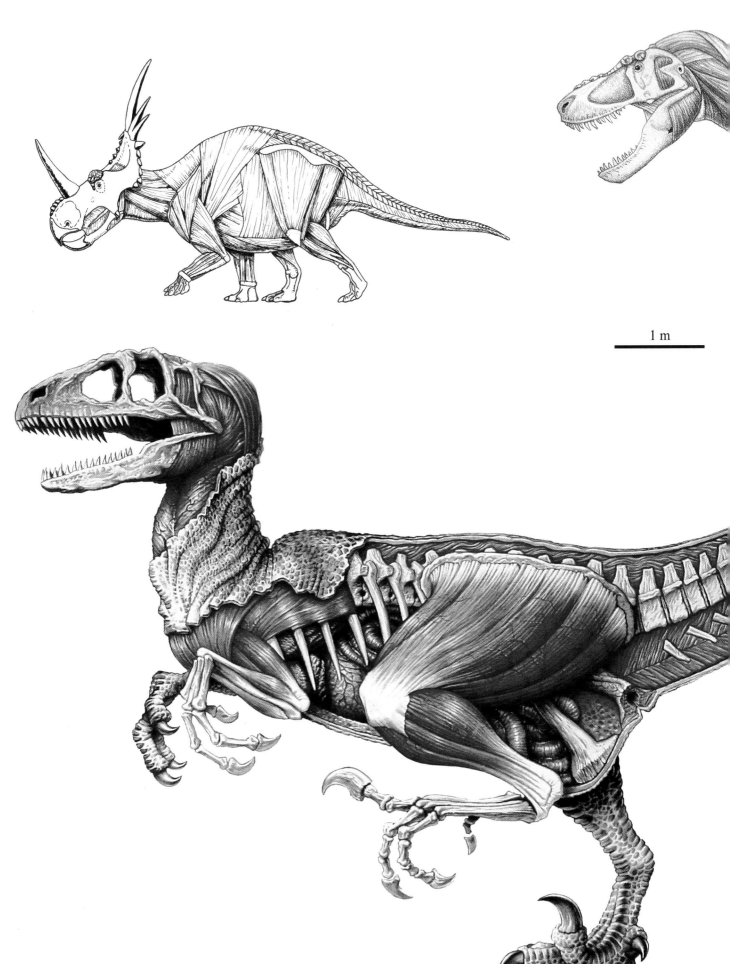

1 m

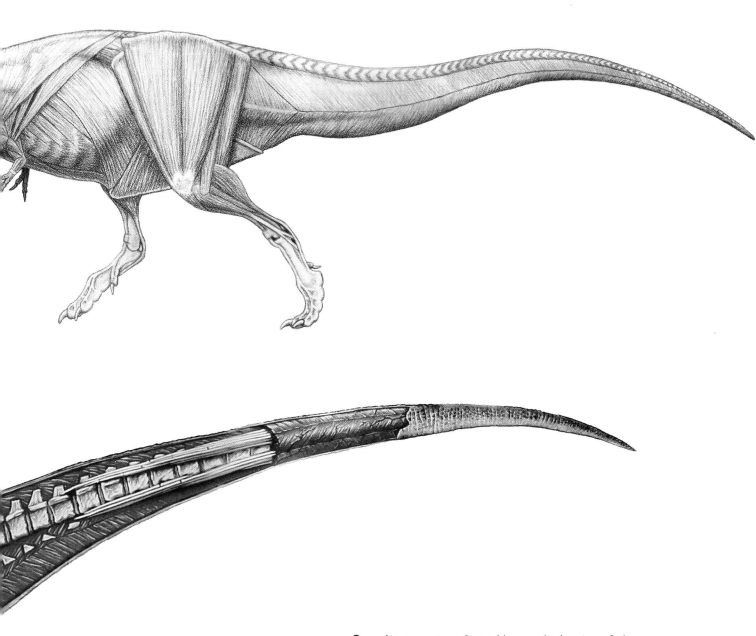

Opposite page, top: Scott Hartman's drawing of the superficial muscles of Styrocosaurus. This page, top: Hartman's drawing of the superficial muscles of T-rex. Left: This wonderful drawing of Deinonychus by Mike Compton puts it all together: skeletal system, musculature, deep soft tissue, hide, and even teeth and talons.

The Basic Classifications

There are two major subgroups of dinosaurs, the Saurischia and the Ornithischia:

• The saurischians, or "lizard-hipped," dinosaurs. There are two major subgroups of the lizard-hipped dinosaurs: Saurischia, the meat-eating theropods—ranging in size from tiny chicken-sized Compsognathus to the immense Giganotosaurus, who was over 50 feet (15.2 meters) tall—and the plant-eating sauropods.

• The ornithischians, or "bird-hipped," dinosaurs. There is big-time disagreement among paleontologists about the subgroups of the Ornithischia. The ornithischians in *Thunder Lizards!* are thyreophorans (two famous thyreophorans are Ankylosaurus and Stegosaurus); ornithopods, a group that includes the duck-billed dinosaurs; and marginocephalians ("fringe-headed" dinosaurs), a group that includes Triceratops.

All pelvises—mammalian and reptilian—have three bones: the ilium, ischium, and pubis. The major difference between the lizard-hipped and the bird-hipped dinosaurs is the orientation of the pubis. In saurischian dinosaurs, this bone points toward the front of the animal. Ornithischians have a reversed pubis, which points toward the tail and lies alongside and parallel to the ischium. This is an important difference to understand when drawing your dinosaurs, as either or both pubis and ischium visibly affect the dinosaur's undercarriage.

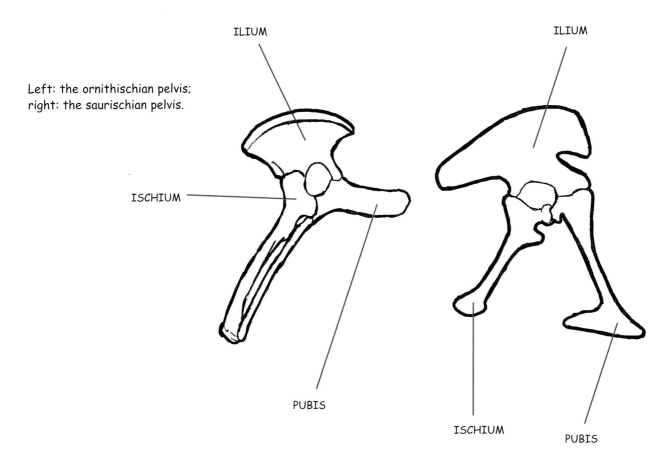

Left: the ornithischian pelvis;
right: the saurischian pelvis.

ILIUM

ILIUM

ISCHIUM

PUBIS

ISCHIUM

PUBIS

FRONT ⟶

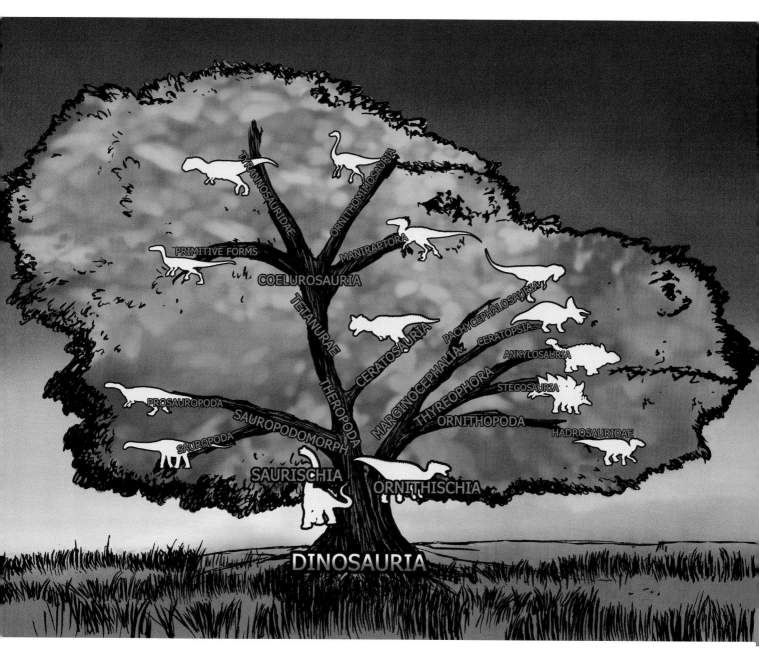

The branches of the Dinosauria family tree shown here, while currently accepted by many paleontologists, will almost certainly be revised in the future to reflect information gathered as new fossils are discovered.

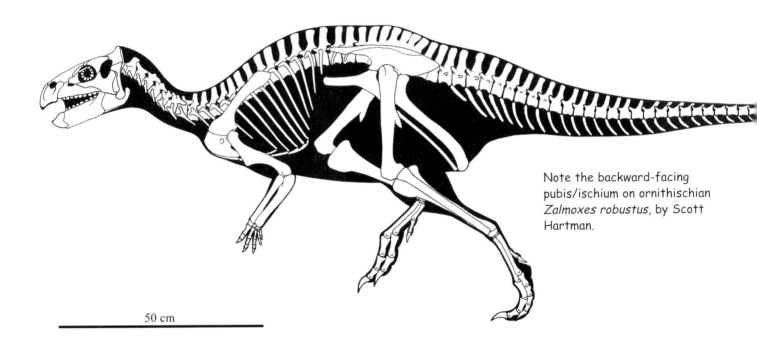

Note the backward-facing pubis/ischium on ornithischian *Zalmoxes robustus*, by Scott Hartman.

50 cm

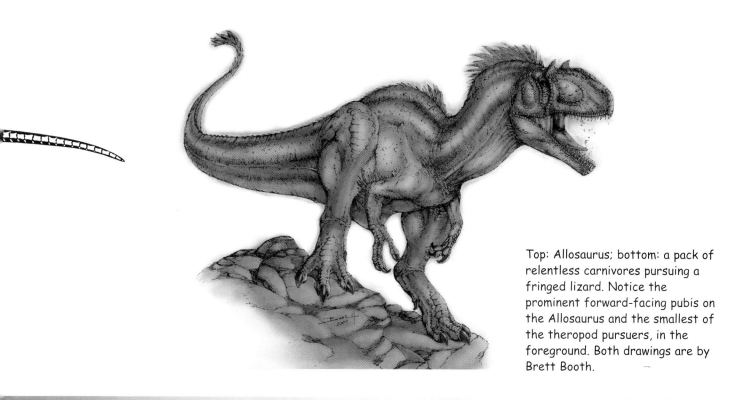

Top: Allosaurus; bottom: a pack of relentless carnivores pursuing a fringed lizard. Notice the prominent forward-facing pubis on the Allosaurus and the smallest of the theropod pursuers, in the foreground. Both drawings are by Brett Booth.

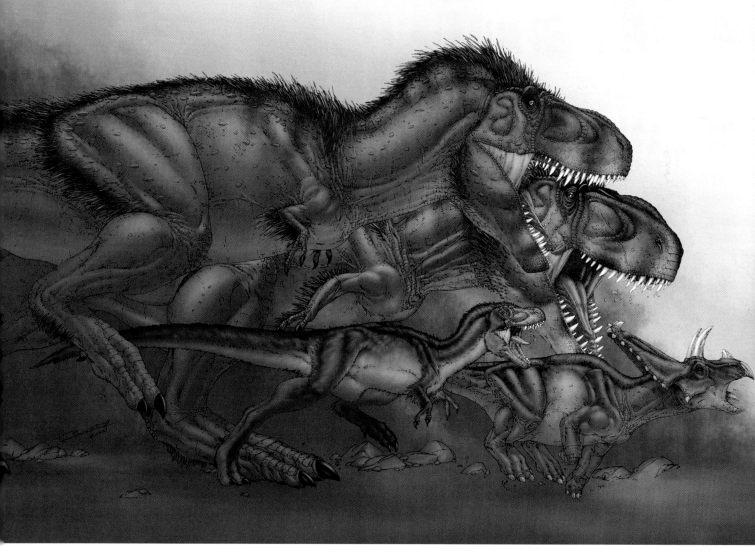

The Six Basic Parts of a Dinosaur

All dinosaurs, no matter what kind they were, had six basic parts: head, neck, torso, pelvis, limbs, and tail. Let's "dissect" a dinosaur into these parts and take a closer look at each.

Head and Neck

Almost every dinosaur head you need to draw can be reduced to two parts, the skull and the jaw. There are a few different methods for quickly roughing in the basic shapes for the skull and jaw, but my preferred technique for most theropods (a group that includes T-rex) is what I call the "lunchbox method."

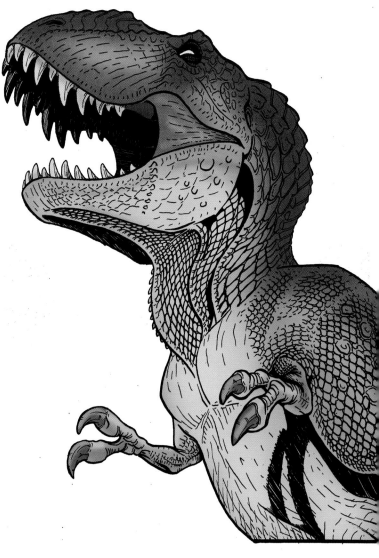

The Lunchbox Head

I draw a simple lunchbox-type shape, but instead of placing the hinge along the long side, I have the lunchbox's fulcrum at one of the short ends. Notice how the jaws line up in an arc. This alignment becomes very important once you start working on filling in your dinosaur's toothy grin. Nothing is worse than a dinosaur with bad teeth. Also notice that the two parts of the lunchbox originate in a modified sphere, a design that reflects the fact that the two pieces are connected and move as one unit where they meet the neck.

Moving down from the head, we come to the neck. Some dinosaurs have long, skinny necks; some have thick, tree-trunk necks; and some have necks so short that it looks like the head is just stuck onto the shoulders. It doesn't matter what the size is; all dinosaur necks are basically cylindrical in form.

Many dinosaurs had long, flexible necks, and to draw those it may help you to think of the neck as a series of short cylinders or as one long bent and curving cylinder.

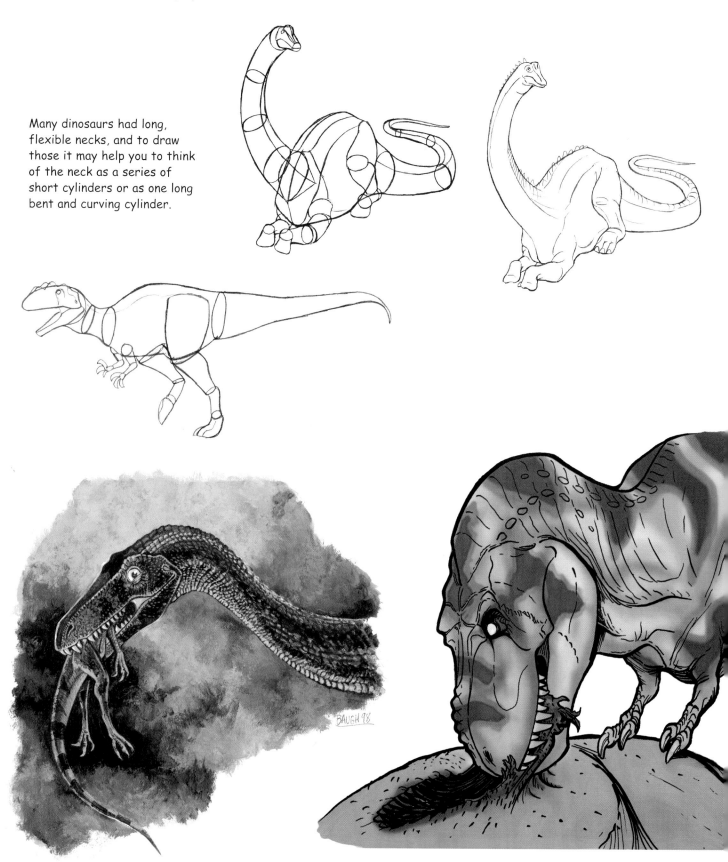

Torso and Pelvis

Many dinosaur torsos are best rendered as an oval shape that has been squared off at the ends. I think of it as being similar to a perfume or shampoo bottle for the thinner-chested dinosaurs like the raptors. Some of the bigger dinosaurs, like all of the sauropods, have a chest that is more barrel-shaped. Most dinosaurs did not have a tremendous amount of flexibility in their spines. In most cases, the pelvic region can be drawn with the torso as a single mass, but as you refine your sketch, you'll need to give special attention to the underlying bones, especially the pubis and/or ischium.

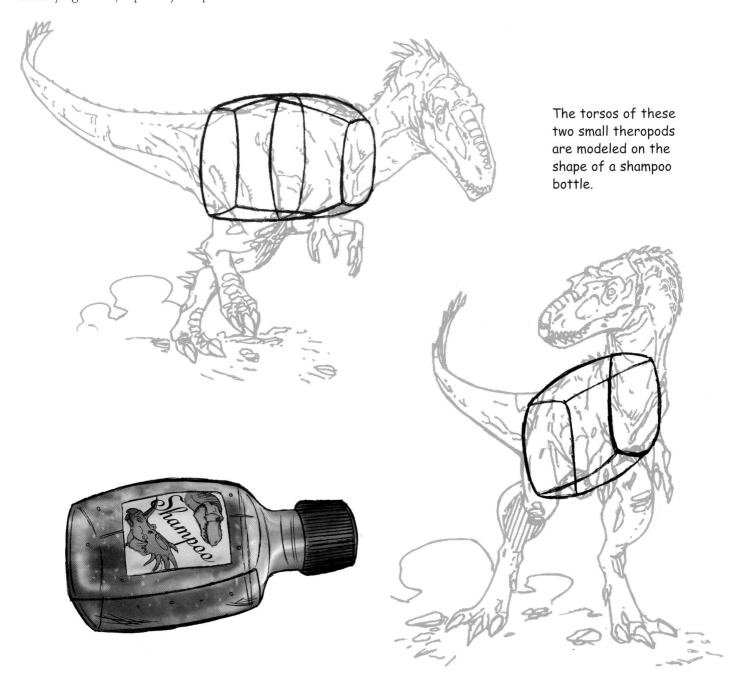

The torsos of these two small theropods are modeled on the shape of a shampoo bottle.

Tail

A dinosaur's tail can be thought of as either a long, thin pyramid shape or a gradually tapering cylinder. Its basic position should be drawn in one fluid motion to capture the serpentine qualities. Some dinosaurs had tails with a limited range of motion; others whipped their flexible tails to and fro. You will need to reference the particulars of the dinosaur you are drawing to get the tail's correct attributes.

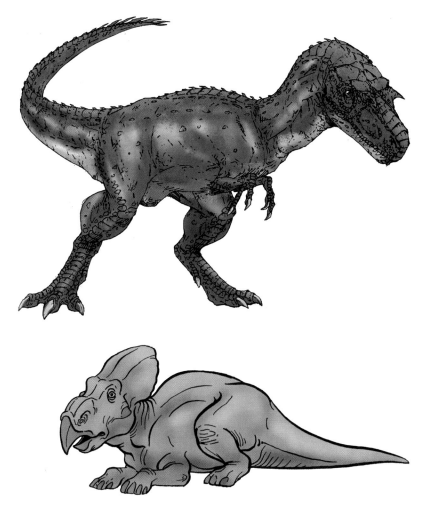

Clockwise from top left: Brett Booth's theropod; Booth's Utahraptor; Bryan Baugh's Leptoceratops.

Limbs

The limbs of dinosaurs vary in size from animal to animal. Most can be rendered with a series of cylinders and modified oval shapes. The quadrupeds used all four similarly shaped limbs to carry their weight. The bipedal dinosaurs moved about on their hind limbs, using their front limbs to fight or forage for food. The limbs are covered in more detail in the sections for each different type of dinosaur.

Each of the following chapters covers one of the five major groups of dinosaurs, and each contains dinosaurs of similar shapes and sizes. Once you learn the basic structure, you will be shown how to modify it to fit each new example. Are you ready to get started? Then you are in for a treat. Our first dinosaur group covers some of my favorites. So turn the page and get ready to meet the theropods.

Terror on Two Feet: The Larger Theropods

Theropod literally means "beast foot," referring to the three-toed clawed feet that these creatures walked on. The central fourth clawed toe, called a hallux, was shorter and was found farther up the leg, similar to a dog's dewclaw. Theropods were fast-moving carnivores (meat-eaters) with grasping hands and claws. They were bipedal, which means they moved about on their two hind limbs. Theropods ranged in size from Giganotosaurus, who was over 50 feet (6.2 meters) tall, to tiny Compsognathus, who was probably about the size of a large chicken.

The larger theropods usually had enormous heads in proportion to the rest of their bodies. The thick, massive necks were often S-shaped, and had a considerable range of motion. The front limbs, which were smaller than the hind limbs, might have been used for balance, for holding down prey, or both. Their long tails had a limited range of motion, but provided an effective counterbalance to their massive torsos and skulls and would have been useful for quick pivoting. Some of the larger theropods, including T-rex, may have been scavengers.

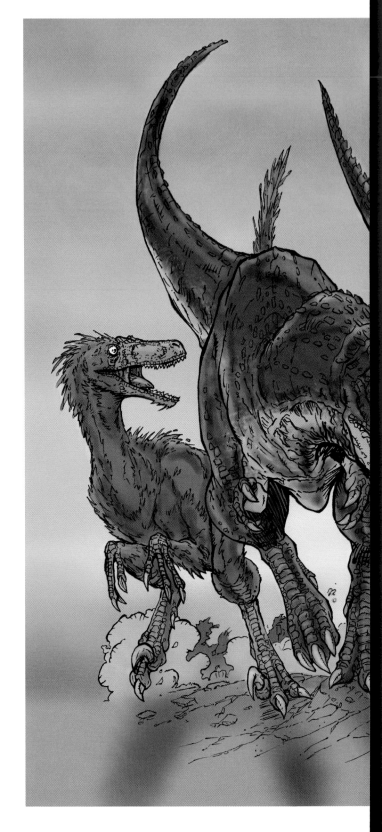

Hunting in packs would have been especially helpful when trying to take down larger prey or when keeping scavengers at bay. Although it may seem unlikely that a group like this one—consisting of two Velociraptor (the ones on the far left and far right) and three larger theropods—would have banded together, recent evidence suggests that theropod predators may in fact have hunted in mixed packs.

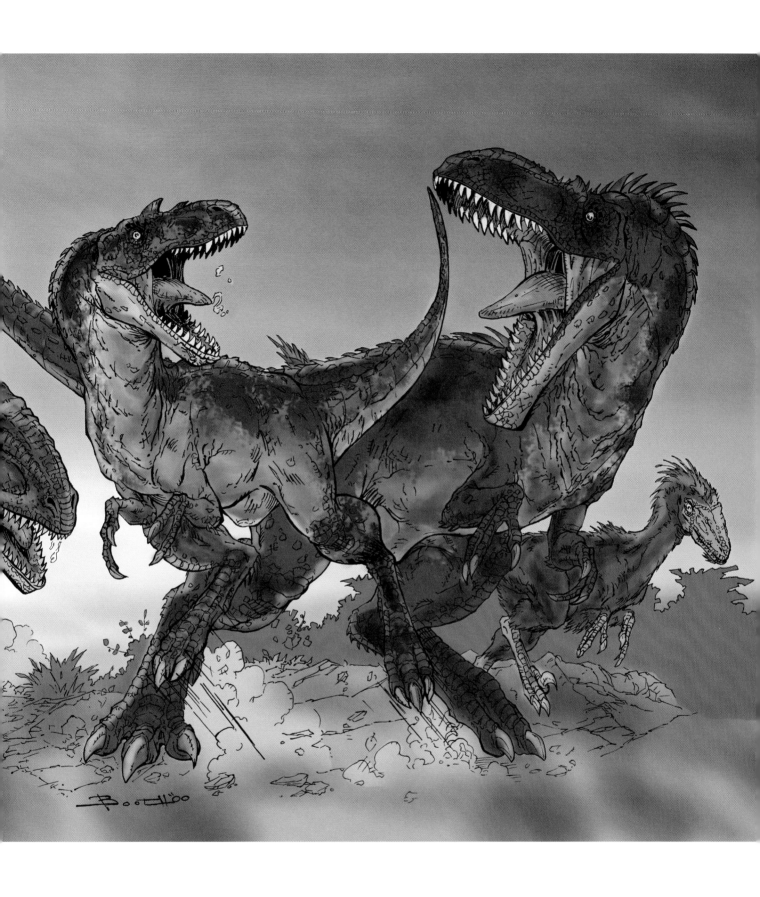

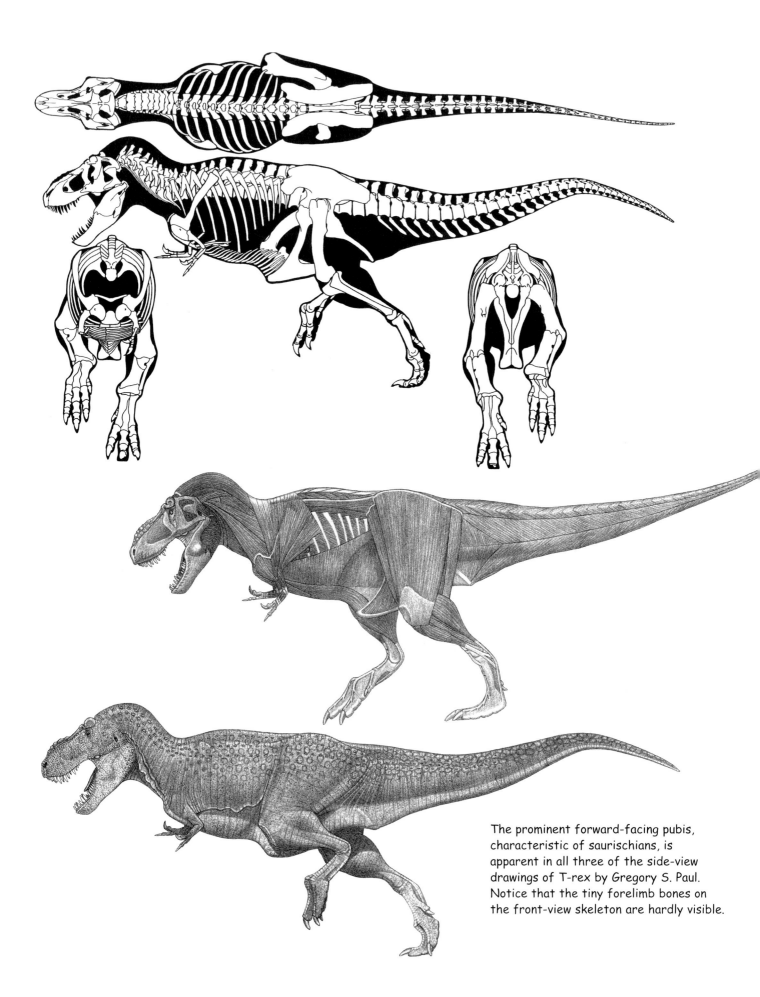

The prominent forward-facing pubis, characteristic of saurischians, is apparent in all three of the side-view drawings of T-rex by Gregory S. Paul. Notice that the tiny forelimb bones on the front-view skeleton are hardly visible.

Theropods' heads may look complicated, but if you start with simple shapes you should have no problem drawing their ferocious skulls and gaping maws.

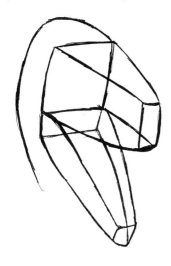

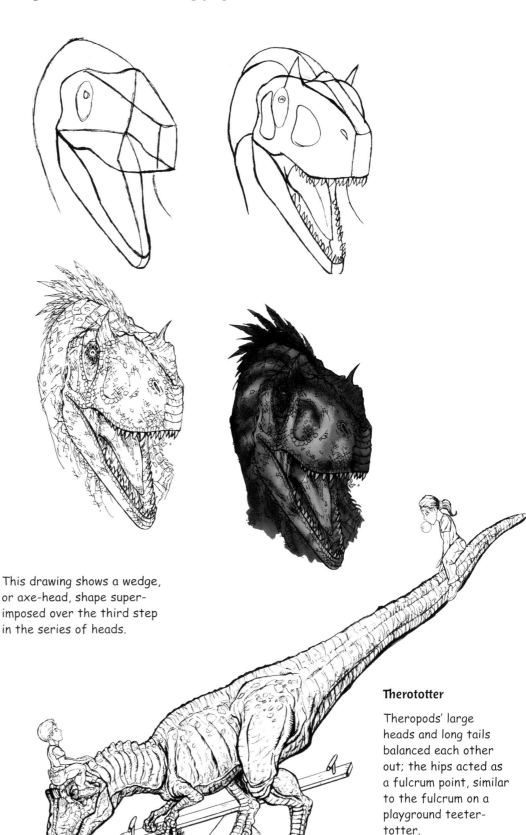

Start with a simple wedge and divide it into two parts, one for the skull, and one for the jaw. Add the shape of the crests over the eyes. Add the basic shapes for the tongue and teeth. Erase your guidelines and add details like scales and spines or feathers.

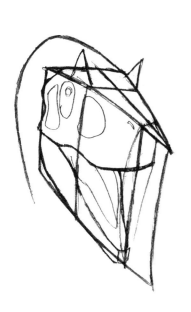

This drawing shows a wedge, or axe-head, shape super-imposed over the third step in the series of heads.

Therototter

Theropods' large heads and long tails balanced each other out; the hips acted as a fulcrum point, similar to the fulcrum on a playground teeter-totter.

Acrocanthosaurus

Acrocanthosaurus ("high spine lizard") had spines along its neck, back, and tail possibly up to 2 feet (51 centimeters) along the back. It was once mistakenly classified as a spinosauran, since spinosaurans also have long vertebral spines, but the rest of Acrocanthosaurus's anatomy is closer to that of T-rex. Acrocanthosaurus, like T-rex, would have been a formidable carnivore. It had a big head, with a skull that was 4.5 feet (1.4 meters) long, and 68 thin, sharp, serrated teeth. Paleontologists disagree on whether the vertebral spines were connected, serving as a sort of anchor for the powerful neck, back, and tail muscles. It had strong arms, and each hand had three fingers, equipped with long, sickle-like claws.

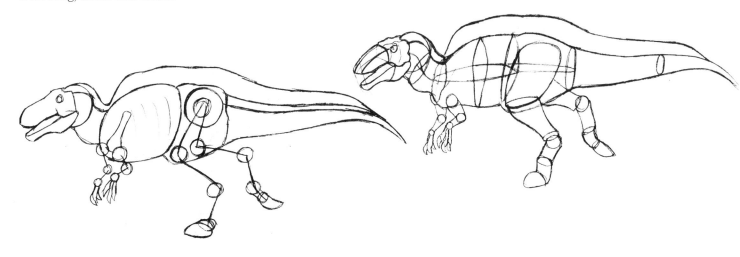

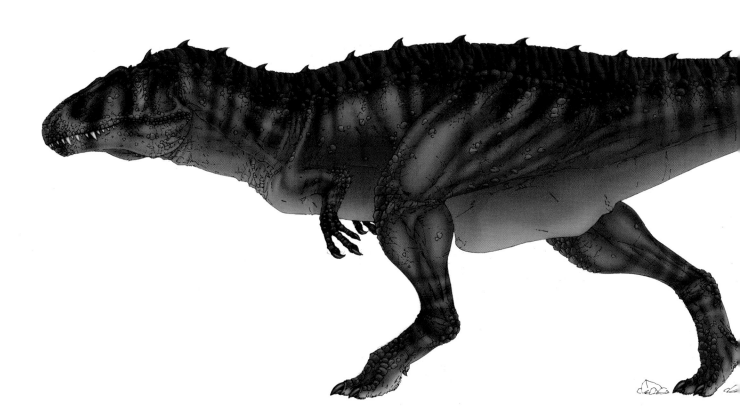

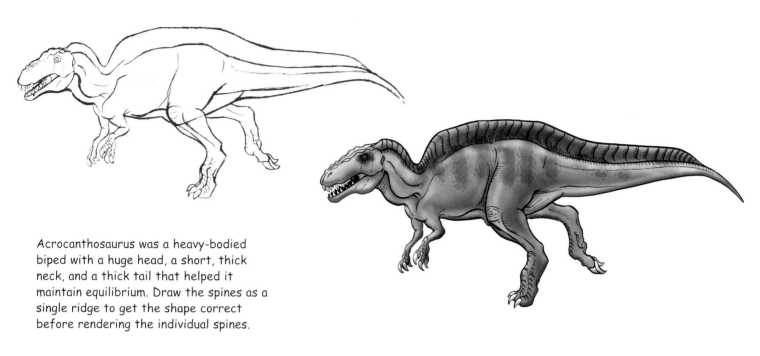

Acrocanthosaurus was a heavy-bodied biped with a huge head, a short, thick neck, and a thick tail that helped it maintain equilibrium. Draw the spines as a single ridge to get the shape correct before rendering the individual spines.

Brett Booth has drawn the ridge of spines as a single unit, but has added a row of individual spikes. His Acrocanthosaurus is sort of a russet-gray. Since no one knows what color dinosaurs were, almost anything goes!

Allosaurus

Allosaurus ("different lizard," so-named because its vertebrae were different from those of other dinosaurs), a member of the subgroup Carnosauria ("meat dinosaur"), was a large theropod with powerful hind legs, a strong, S-shaped neck, and a head over 3 feet (nearly 1 meter) long. It had well-defined but short brow horns and bony knobs and ridges above its eyes and on the top of its head. It had a massive tail, a bulky body, and heavy bones. Its short arms had three-fingered hands with sharp claws that were up to 6 inches (15 centimeters) long. Allosaurus had large, powerful jaws with long, sharp, serrated teeth 2 to 4 inches (5 to 10 centimeters) long. Like all theropods, Allosaurus had gastralia—thin, fragile ribs that helped support and protect the internal organs (like the lungs) in the middle area of the body. These ribs were not attached to the backbone, but to the skin in the belly area. This becomes important when drawing the creature's underbelly. Allosaurus's pubis and ischium bones are quite prominent, and should be visible in your final drawing.

Allosaurus was very similar to T-rex, but was probably not quite as strong. The chest cavity was smaller and the skull more compact.

VITAL STATISTICS
ALLOSAURUS
Length: 38 ft (12 m)
Height: 16.5 ft (5 m)
Weight: 1.5–2 tons (1,400–1,800 kg)

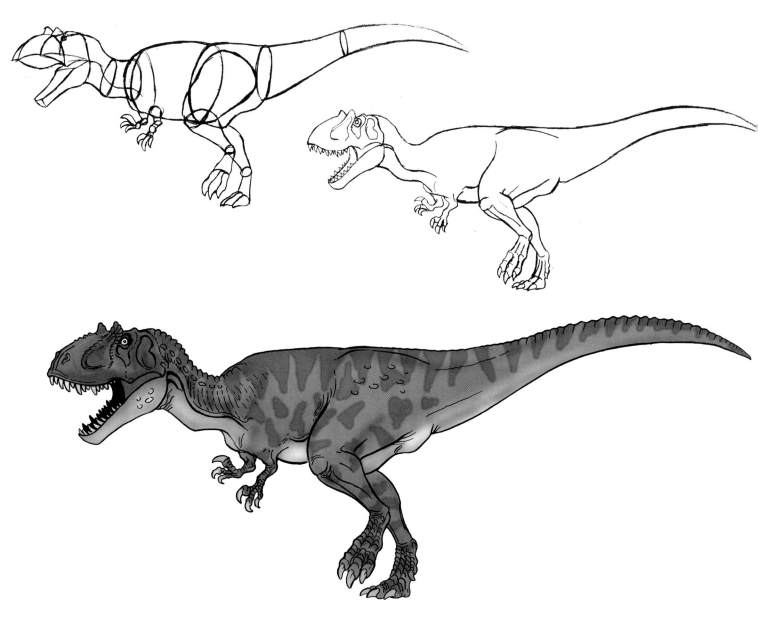

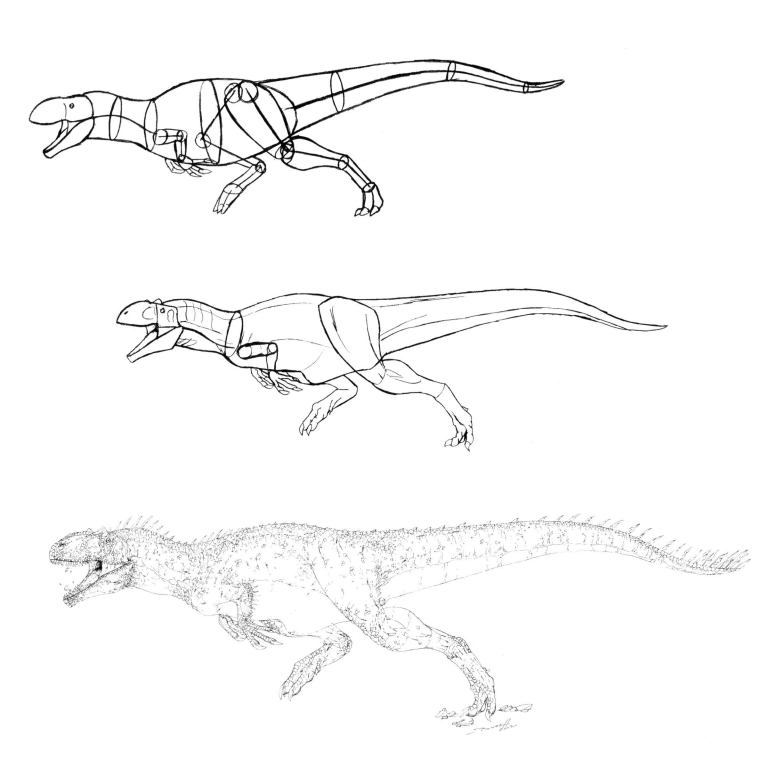

Bryan Baugh (left) and Brett Booth (this page) have very different styles. Although the steps involved in building these drawings are similar, Booth's final step before coloring the drawing is to do a detailed black-and-white version, which gives the drawing a rich texture. Start by laying out a quick action line of how you would like your Allosaurus to be posed, beginning with the jaw and continuing out to the tail. Sketch in the basic shapes for the head, neck, torso, waist, limbs, and tail. Refine your forms to reflect prominent muscle and skeletal features. Finish by adding details like eyes, teeth, claws, and facial horns. Add lines for scales and wrinkles.

Carnotaurus

Carnotaurus ("flesh-eating bull") was a large, bipedal, meat-eating dinosaur, so named because it had two knobby horns that made it look slightly like a bull. It had a small, blunt skull, extremely tiny arms (even smaller than those of T-Rex), and a long, thin tail. There are numerous fossilized remains of this animal, including some that show rows of bony scales. It is possible that two carnotaurans could have faced off like bulls, using their horns to test each other's strength.

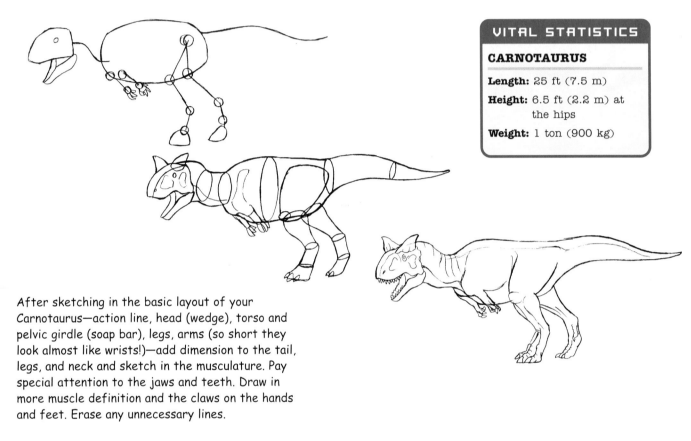

VITAL STATISTICS

CARNOTAURUS

Length: 25 ft (7.5 m)

Height: 6.5 ft (2.2 m) at the hips

Weight: 1 ton (900 kg)

After sketching in the basic layout of your Carnotaurus—action line, head (wedge), torso and pelvic girdle (soap bar), legs, arms (so short they look almost like wrists!)—add dimension to the tail, legs, and neck and sketch in the musculature. Pay special attention to the jaws and teeth. Draw in more muscle definition and the claws on the hands and feet. Erase any unnecessary lines.

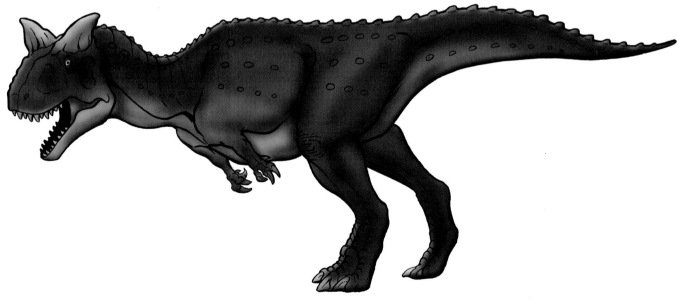

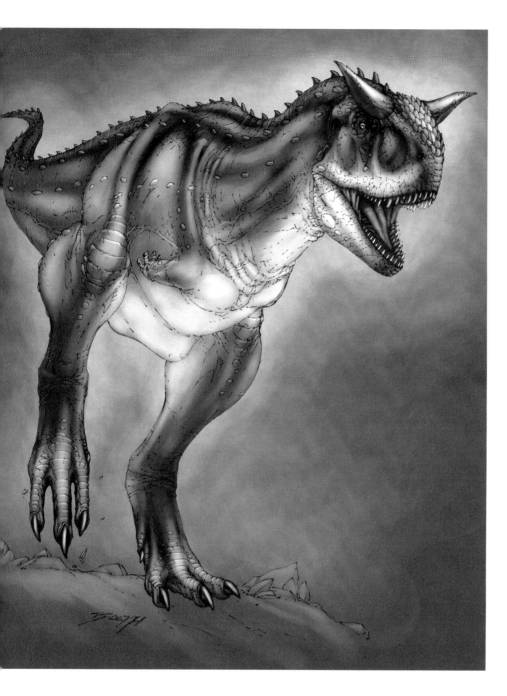

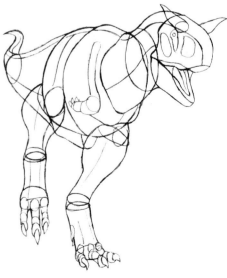

In Brett Booth's drawing, the forelimbs seem almost vestigial. The bony scales in rows along the side of this beast (which also appear in Bryan Baugh's version) are not figments of the artist's imagination, but based on fossilized skin impressions.

Ceratosaurus

Ceratosaurus ("horned lizard") was a powerful predator that walked on two strong legs, had short feeble arms, a strong, S-shaped neck, a short snout, two short brow ridges, and bony knobs and ridges above its eyes and on the top of the head. It had a massive, broad tail (possibly used for swimming), a bulky body, and heavy bones. Its hands had four fingers in a primitive configuration with sharp claws, but its primary weapons were its powerful jaws and sharp teeth.

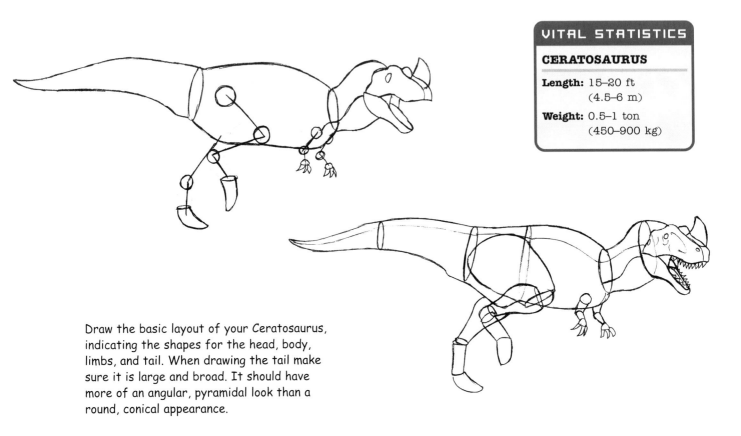

VITAL STATISTICS	
CERATOSAURUS	
Length:	15–20 ft (4.5–6 m)
Weight:	0.5–1 ton (450–900 kg)

Draw the basic layout of your Ceratosaurus, indicating the shapes for the head, body, limbs, and tail. When drawing the tail make sure it is large and broad. It should have more of an angular, pyramidal look than a round, conical appearance.

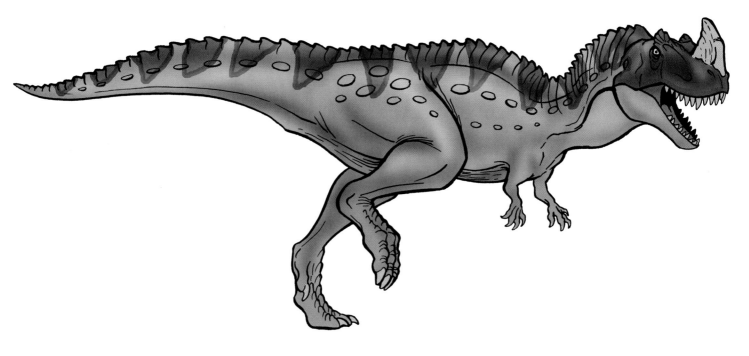

Cryolophosaurus

Cryolophosaurus ("frozen-crested lizard") is the only known theropod from Antarctica, and the first dinosaur from there to be named and classified. Its most distinctive feature was a forward-facing crest projecting upward from between its eyes. Because of its pompadour-like crest, this animal is referred to informally as Elvisaurus.

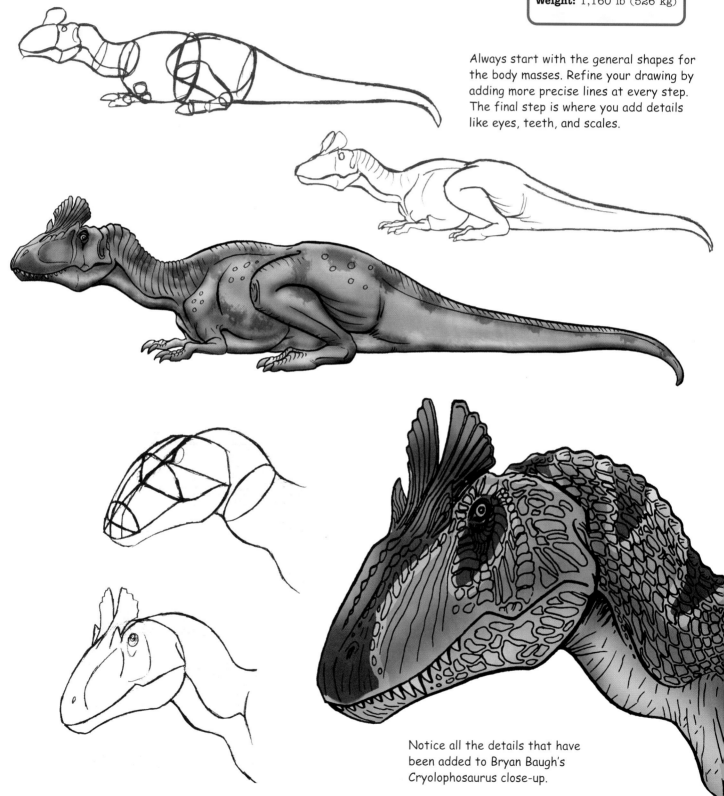

Always start with the general shapes for the body masses. Refine your drawing by adding more precise lines at every step. The final step is where you add details like eyes, teeth, and scales.

Notice all the details that have been added to Bryan Baugh's Cryolophosaurus close-up.

Giganotosaurus

Giganotosaurus ("giant southern lizard"), which outweighed T-rex by 1 ton (907 kilograms), is the largest two-legged creature, as well as the largest carnivore, discovered to date. Despite its size, scientists believe it was a mobile hunter that may have hunted in packs. Its skull was over 6 feet (1.8 meters) long and its scissor-shaped jaw contained serrated teeth up to 8 inches (20.3 centimeters) long, which were used to slash prey with deep, long cuts. It was more lightly built than T-rex, and had a smaller brain case.

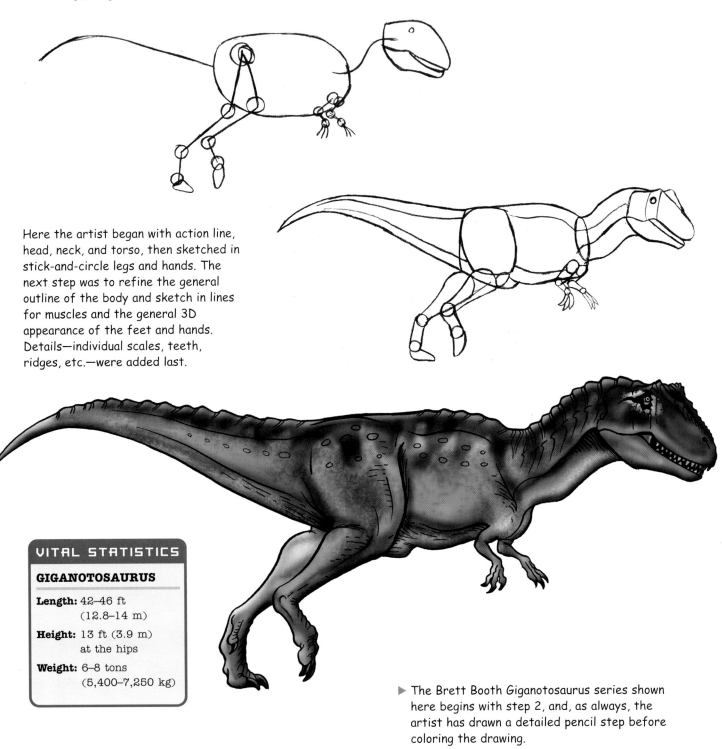

Here the artist began with action line, head, neck, and torso, then sketched in stick-and-circle legs and hands. The next step was to refine the general outline of the body and sketch in lines for muscles and the general 3D appearance of the feet and hands. Details—individual scales, teeth, ridges, etc.—were added last.

VITAL STATISTICS

GIGANOTOSAURUS

Length: 42–46 ft
(12.8–14 m)

Height: 13 ft (3.9 m)
at the hips

Weight: 6–8 tons
(5,400–7,250 kg)

▶ The Brett Booth Giganotosaurus series shown here begins with step 2, and, as always, the artist has drawn a detailed pencil step before coloring the drawing.

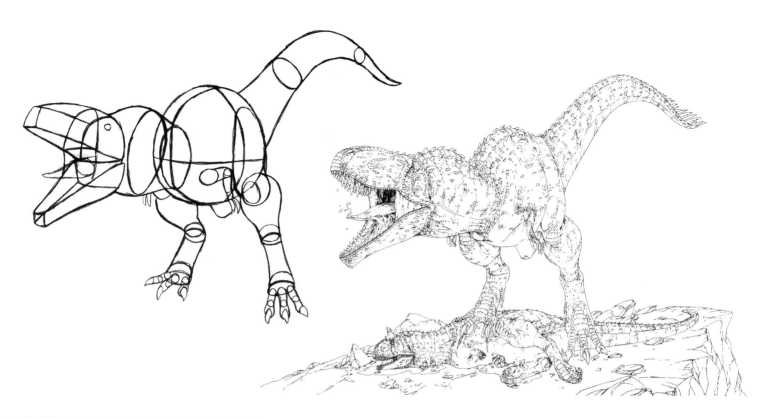
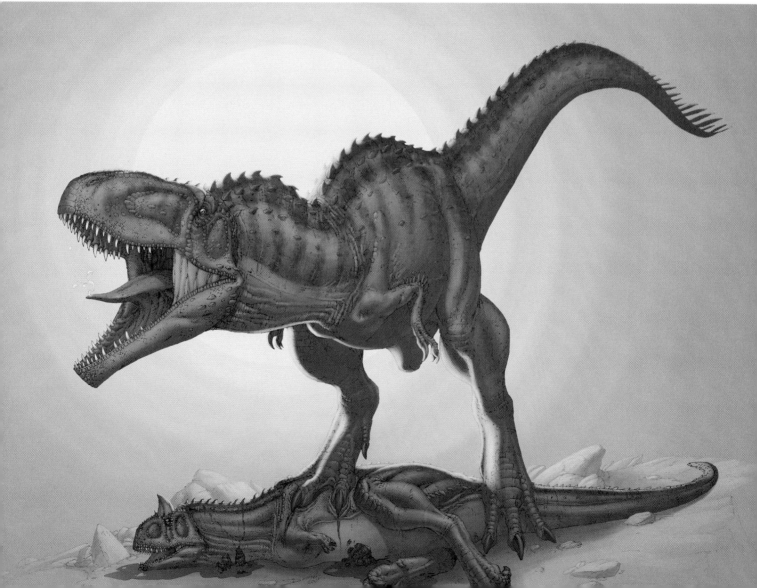

Megalosaurus

In the opening paragraph of *Bleak House* Charles Dickens conjures up the image of a 40-foot-long Megalosaurus "waddling like an elephantine lizard" through the streets of London. Dickens had the size all wrong, but his incorrectly oversized Megalosaurus ("giant lizard") is just an early example of the many mistakes made over the years in trying to flesh out megaliz. With only a partial skeleton to work from, science is still trying to separate fact from fiction on this dinosaur, and the vital statistics given here are approximations only.

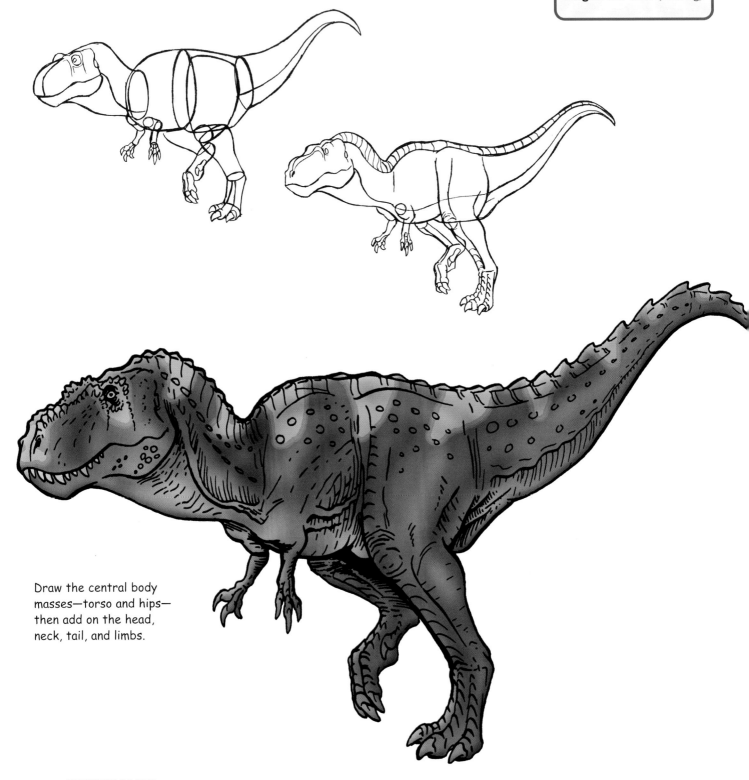

Draw the central body masses—torso and hips—then add on the head, neck, tail, and limbs.

Spinosaurus

The neural spines (Spinosaurus means "spiny lizard") that came out of this dinosaur's vertebrae reached lengths of up to 6 feet (1.8 meters). They were flexible relative to the spines of other theropods, forming a sail-like fin. The upper spines of spinosaurs were also relatively flexible, and Spinosaurus may have been able to arch its back to spread the sail. The sail may have helped regulate body temperature by collecting warmth from the sun and, when the animal was in the shade, dissipating heat. It may also have been used in mating rituals and/or for threat displays.

Scientists believe that Spinosaurus was one of the most intelligent of the larger theropods, and the animal's intelligence, coupled with its large size, would have made it a formidable foe. Spinosaurus had a large head with sharp, straight, cone-shaped teeth in powerful, crocodile-like jaws. It had a notch in its upper jaw which, combined with its nonserrated teeth, made it perfectly designed for catching fish. Its arms were large when compared to those of other theropods and each hand had three fingers.

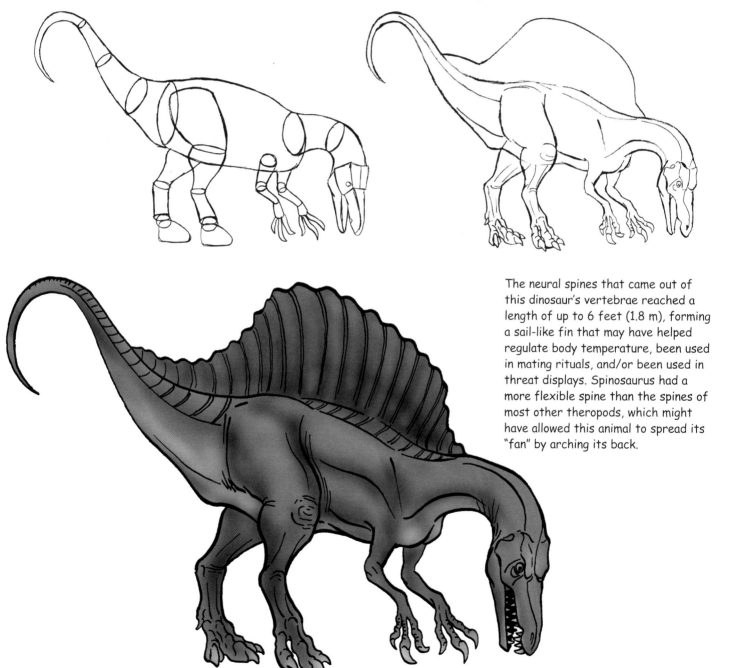

The neural spines that came out of this dinosaur's vertebrae reached a length of up to 6 feet (1.8 m), forming a sail-like fin that may have helped regulate body temperature, been used in mating rituals, and/or been used in threat displays. Spinosaurus had a more flexible spine than the spines of most other theropods, which might have allowed this animal to spread its "fan" by arching its back.

Suchomimus

Suchomimus ("crocodile mimic") was very similar to Spinosaurus. This carnivore had short clawed arms with three fingers. On the end of the digit that corresponds to the human thumb was a 1-foot-long (0.3-meter-long) sickle-like claw that was 16 inches (40 centimeters) long and was probably used as a built-in fish skewer. Its crocodile-like jaw had nearly 100 razor-sharp rear-facing conical teeth. The longest teeth were at the end of the snout in a projection called a rosette, making them ideal for snatching fish. Suchomimus, like Spinosaurus, had a sail-like structure along its back, perhaps used for thermal regulation.

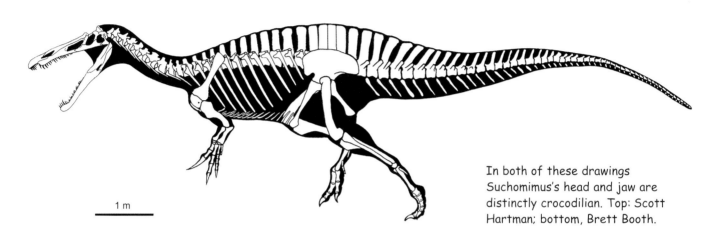

1 m

In both of these drawings Suchomimus's head and jaw are distinctly crocodilian. Top: Scott Hartman; bottom, Brett Booth.

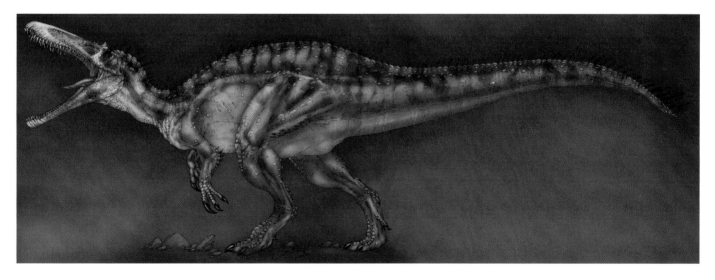

◀ A complete skeleton of Spinosaurus has never been found, but recent discoveries suggest that this beast was taller and heavier than T-rex. This beast, by Brett Booth, certainly looks capable of snapping a T-rex's neck, as the Spinosaurus in *Jurassic Park III* did.

VITAL STATISTICS

SUCHOMIMUS

Length: 40 ft (13 m)
Height: 16 ft (5 m)
Weight: 6 tons (5,400 kg)

Therizinosaurus

Therizininosaurus ("scythe lizard") has been included in this section because most paleontologists classify it as a theropod. There is, however, considerable debate as to whether it really is a theropod. (The arguments are analogous to the arguments over the red panda, which is placed by some scientists in the bear family [it has many traits in common with bears] and by others in the raccoon family [it looks like a raccoon].) Theropods are meat-eaters, but it is not at all certain that Therizinosaurus ate anything but plants. Wherever it belongs , it was one certainly one of the more bizarre-looking animals ever to live! Easily the most striking feature is its fearsome-looking claws—3 feet (1 meter) long—at the end of 7-foot (2.3-meter) arms. How, exactly, Therizinosaurus used those claws is still a mystery; though they look formidable, they were not exceptionally sharp. They might have been used for nothing more than tearing open a termite mound, or perhaps they were useful in gathering up vegetation. They could also have served as defensive weapons.

Therizinosaurs had fairly long necks, small heads, and short tails. Note that the pubis is backward-facing, which is characteristic of animals belonging to Theropoda. This skeleton was drawn by Steve Miller.

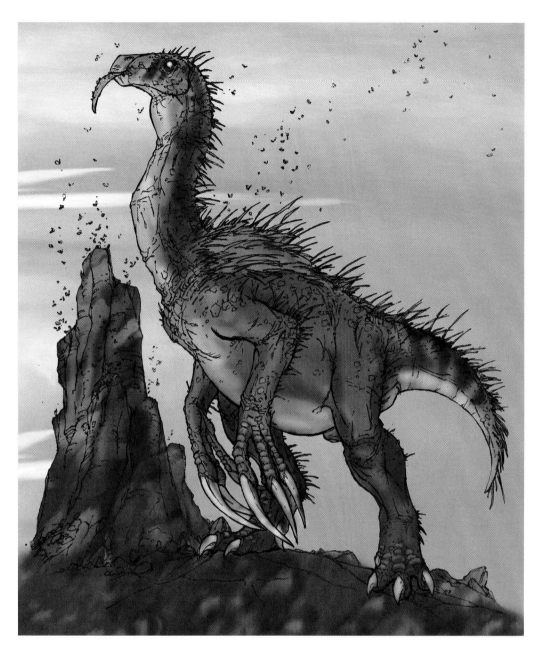

Here are two takes on this uncanny creature. The styles are very different (left, Bryan Baugh; right, Brett Booth), but the basic shapes used to build up the drawings are the same.

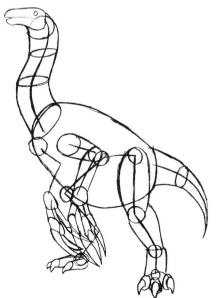

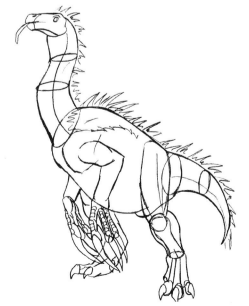

Tyrannosaurus Rex

Tyrannosaurus Rex ("tyrant king lizard") is easily the most popular dinosaur ever discovered. This lizard king raced about on massive, densely muscled rear legs with bird-like feet. Each foot had three large toes, all equipped with claws, plus a little dewclaw on a tiny, vestigial fourth toe. Its slim, stiff, pointed tail provided a counterbalance for its massive head and helped to maintain stability when executing quick turns. T-rex hunted with its colossal 5-foot (1.5-meter) head jutting forward, armed with dagger-like replaceable 6- to 10-inch (15.2- to 25.4-centimeter) teeth. Its 4-foot (1.2-meter) jaws were hinged with powerful, well-developed jaw muscles that could crush and hold prey like a modern bear trap. It had tiny arms, each with two fingers, seemingly useless for anything practical, but possibly used to anchor T-rex to its victims between bites. T-rex had a squat neck attached to a solidly built body. Most scientists agree that T-rex had extremely large olfactory lobes and used these to smell food several miles away.

<div style="border:1px solid;">

VITAL STATISTICS

T-REX

Length: 41 ft (12.4 m)

Height: 15–20 ft (4.6–6 m)

Weight: 5–7 tons (4,500–6,300 kg)

</div>

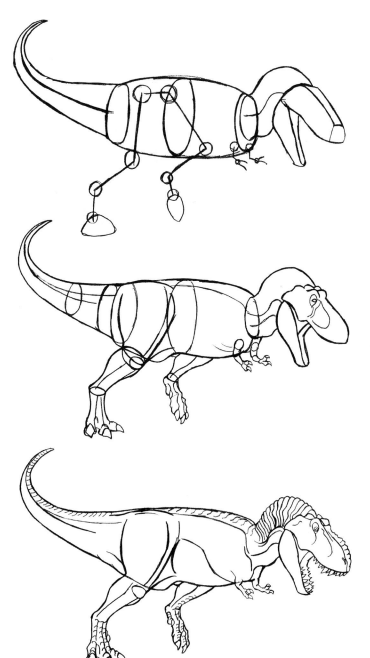

Draw the central body masses—torso and hips—then add on the head, neck, tail, and limbs. When drawing T-rex remember that it had a wraparound overbite. When T-rex closed its mouth, the lower jaw's teeth fit neatly inside the upper jaw's teeth. When drawing the head, use references for the skull (for example, the skull on page 23 of this book) so that you can correctly place the creature's eyes where the occipital sockets (the holes in the skull for the eyes) are. Finish by adding eye details, teeth, and claws, then whatever else you need to render the skin texture of the face. Add lines for body scales and wrinkles last.

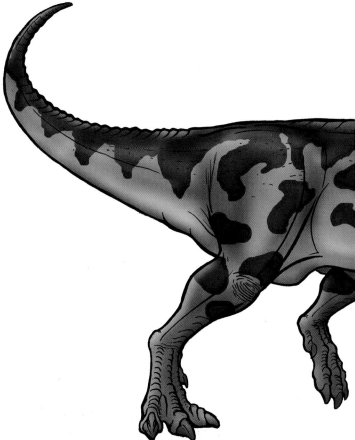

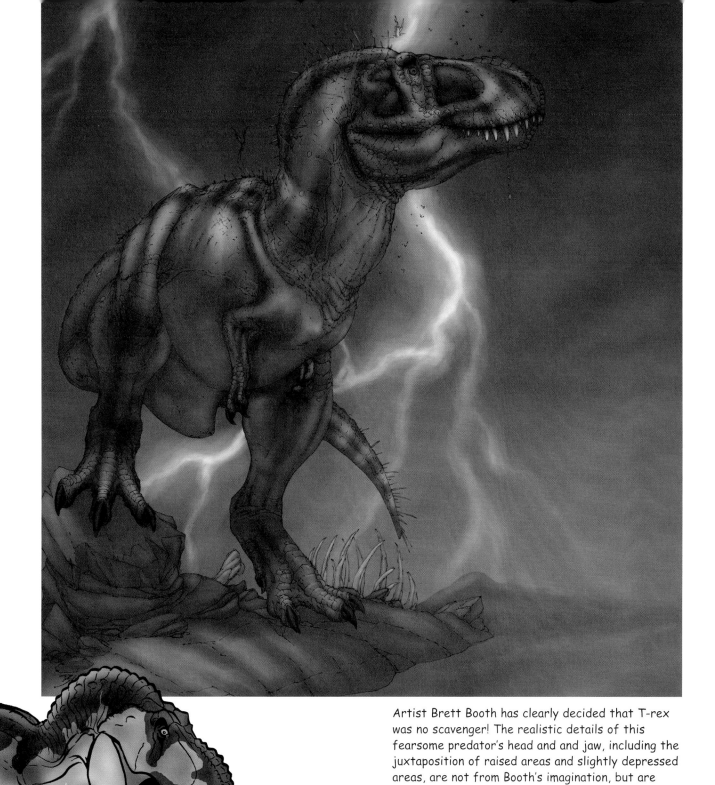

Artist Brett Booth has clearly decided that T-rex was no scavenger! The realistic details of this fearsome predator's head and and jaw, including the juxtaposition of raised areas and slightly depressed areas, are not from Booth's imagination, but are based on knowledge of the bones beneath the skin.

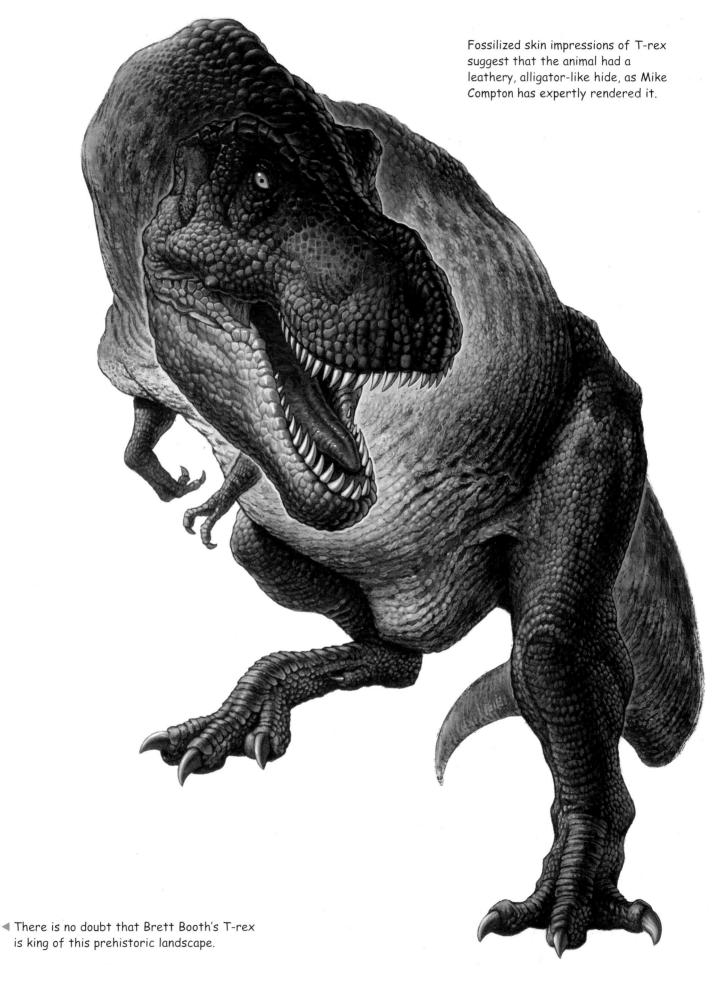

Fossilized skin impressions of T-rex suggest that the animal had a leathery, alligator-like hide, as Mike Compton has expertly rendered it.

◀ There is no doubt that Brett Booth's T-rex is king of this prehistoric landscape.

The Smaller Theropods

The distinction between the larger theropods and the smaller theropods isn't one based on scientific classification, but rather on overall body size and mass. The dinosaurs in this chapter are very similar to the animals in the previous chapter, but all attributes are smaller. They had much less sheer muscle mass than their larger relatives; they were built for speed and depended on intelligence and cunning rather than brute force for bringing down their prey.

- A dinosaur's speed is estimated by a calculation involving leg length, estimated body mass, and stride length, which is determined when a fossilized trackway—a series of two or more tracks made by the same foot—for that animal exists.

- Scientists believe that the "smartest" dinosaurs, those with the highest EQs (encephalization quotients), belong to this group. An animal's EQ is the ratio of the brain weight of the animal to the brain weight of a typical animal of comparable body mass. It is beyond the scope of this book to go into the scientific basis for obtaining those numbers, but EQ is widely accepted by scientists as a way to measure the relative intelligence of extinct species. The higher the EQ, the more intelligent the animal. The largest plant-eating dinosaurs had the lowest EQs (up to 0.2) and the smaller theropods—for example, Troodon, Velociraptor, and Deinonychus—had the highest EQs (just under 6, similar to modern ostriches). Another way to look at EQ is to translate EQ numbers into brain mass as a *percentage* of body weight: elephants, 0.15%; humans, 2.1%; T-rex, 0.0079%; Triceratops, 0.0035%.

The leader of this pack of Velociraptors has many of the features associated with the smaller theropods. The pubis and ischium are prominent; the rib cage is compact; the limbs are long, thin, and birdlike; the skull is narrow; the eyes are large relative to the rest of the facial features; and the insertion point of the leg bone is prominent. (The insertion points of the smaller theropod leg bones were very close to the surface.) Feathers may have covered parts of some specimens, and the feathers on these raptors add a nice detail to the drawing.

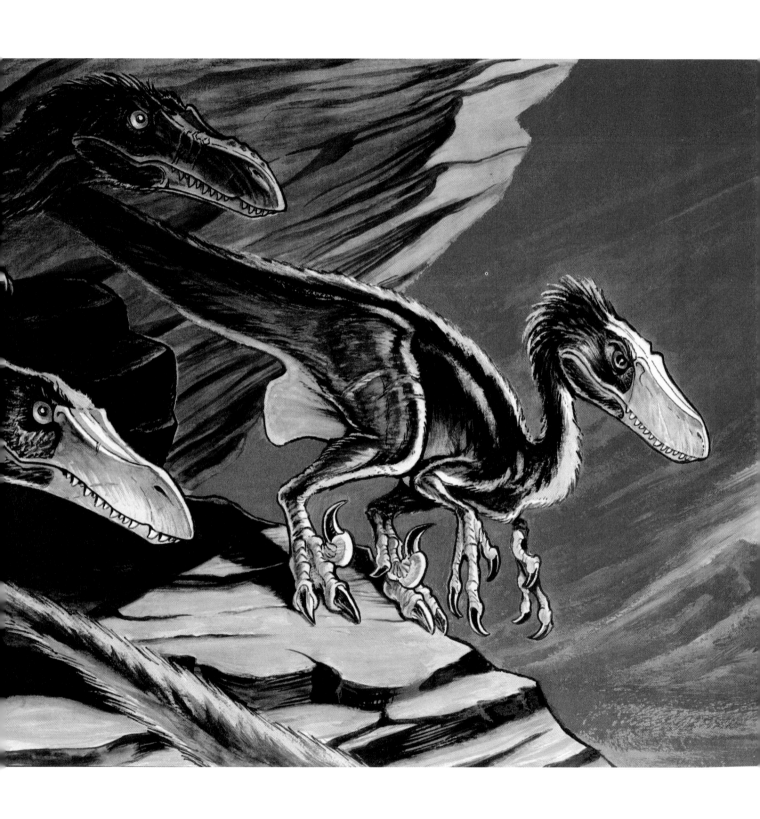

Coelophysis

Coelophysis ("hollow form") was a carnivore with a long, narrow head and a jaw filled with razor-edged teeth. Coelophysis's fossilized stomach remains have been found containing everything from small reptiles and fish to other Coelophysis bones, indicating that it praticed cannibalism to some degree. Coelophysis probably lived and hunted in packs; this is suggested by the existence of hundreds of Coelophysis fossils unearthed in 1947 at Ghost Ranch in New Mexico. Coelophysis had a slight build, hollow bones, long legs, and a long stride. In Coelophysis trackways, the footprint is 4 inches long and the stride length is 2.5 feet (0.75 meters), further evidence that Coelophysis was built for speed. Nimble Coelophysis was the greyhound of the dinosaur world.

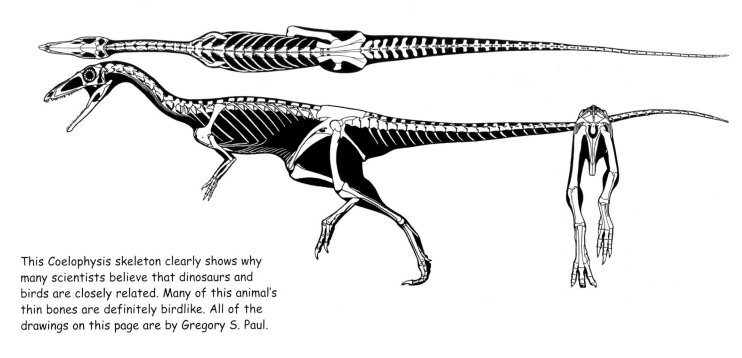

This Coelophysis skeleton clearly shows why many scientists believe that dinosaurs and birds are closely related. Many of this animal's thin bones are definitely birdlike. All of the drawings on this page are by Gregory S. Paul.

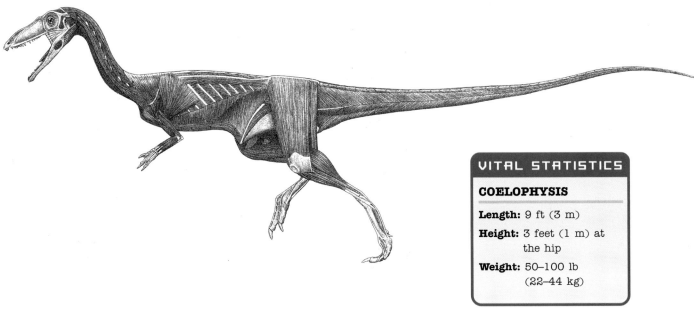

VITAL STATISTICS

COELOPHYSIS

Length: 9 ft (3 m)

Height: 3 feet (1 m) at the hip

Weight: 50–100 lb (22–44 kg)

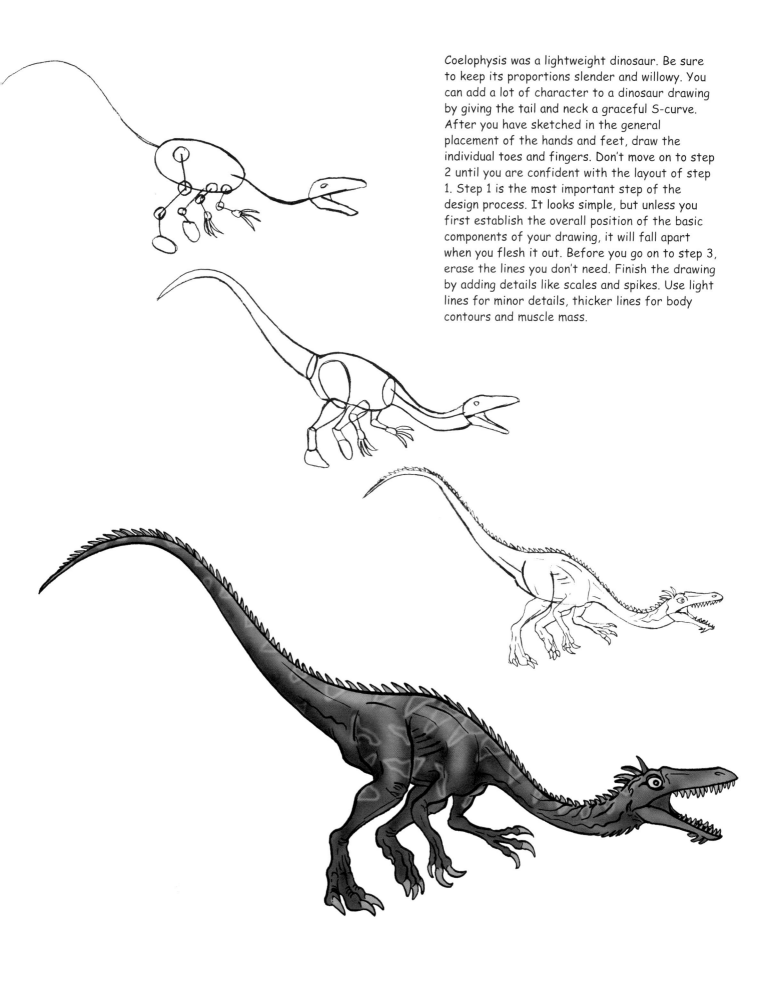

Coelophysis was a lightweight dinosaur. Be sure to keep its proportions slender and willowy. You can add a lot of character to a dinosaur drawing by giving the tail and neck a graceful S-curve. After you have sketched in the general placement of the hands and feet, draw the individual toes and fingers. Don't move on to step 2 until you are confident with the layout of step 1. Step 1 is the most important step of the design process. It looks simple, but unless you first establish the overall position of the basic components of your drawing, it will fall apart when you flesh it out. Before you go on to step 3, erase the lines you don't need. Finish the drawing by adding details like scales and spikes. Use light lines for minor details, thicker lines for body contours and muscle mass.

Chirostenotes

Chirostenotes ("narrow hand") was a small bipedal hunter with a long S-shaped neck and a prominent nasal crest. Not a whole lot else is known about this animal. Since scientists discovered the first Chirostenotes bones, they have changed its family classification a number of times, and they are still not sure exactly where it fits in. Since there is so little hard information about this animal, current models and drawings are based more on artistic guesswork than solid scientific fact.

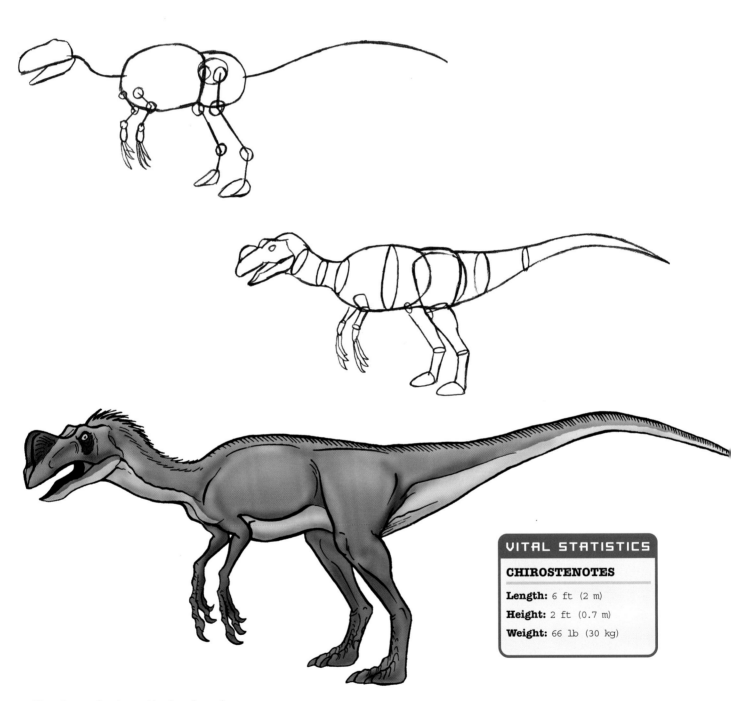

VITAL STATISTICS

CHIROSTENOTES

Length: 6 ft (2 m)

Height: 2 ft (0.7 m)

Weight: 66 lb (30 kg)

For the early steps, the hands and nails are drawn as banana-type shapes and refined for the final drawing.

Compsognathus

Compsognathus ("elegant jaw") was a birdlike dinosaur, probably about the size of a chicken. Compsognathus walked and ran on two long, thin legs; it had three-toed feet. Compsognathus was built for speed. Its long tail probably acted as a counterbalance and to provide stability during fast turns. It had two front arms, each with two clawed fingers. Compsognathus had a small, pointed head with small, sharp teeth, hollow bones, and a long, flexible neck with a graceful S-curve. Compys were fast; their fossilized remains have shown that quick little lizards were part of their diet.

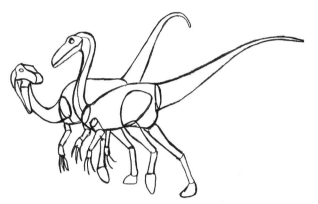

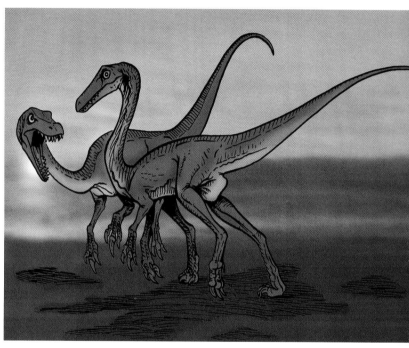

"Slender" and "aggressive" describe Compsognathus. Keep your linework graceful, but be sure to put a lot of attitude into the pose. Sketch in the claws on its feet and hands. Add the teeth and put a fierce gleam in its eyes.

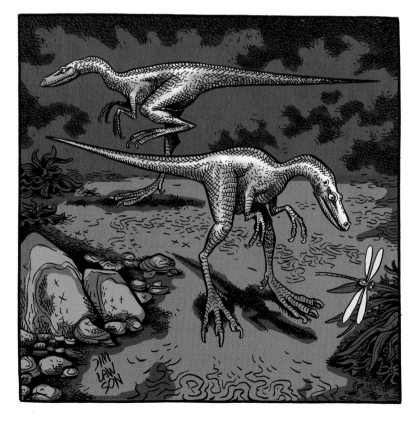

Jim Lawson's Compsognathus is about to snap up a prehistoric dragonfly.

VITAL STATISTICS
COMPSOGNATHUS
Height: 2 ft 4 in (0.7 m)
Length: 3.3 ft (1.0 m)
Weight: 8 lb (3.6 kg)

Deinonychus

Deinonychus ("terrible claw") was a highly specialized hunting and killing machine: powerful, fast-moving, and agile, and designed with specialized hunting equipment. Because many skeletons have been found together, paleontologists believe that these animals hunted in packs. Deinonychus's most remarkable feature, and the basis for its name, is the large second toe on its feet. The claw was up to 5 inches (13 centimeters) long, and was sickle-shaped with a razor edge capable of disemboweling prey. This meat-eater had a relatively large head and brain, huge eyes, a curved, flexible neck, and powerful jaws with sharp, serrated teeth which pointed down and back, the perfect configuration for slicing off chunks of flesh. Its long, slender forelimbs had three fingers on each hand which, like the claws on its feet, were equipped with razor-sharp, curved claws. Its long tail had bony rods running lengthwise along the spine, which provided enough rigidity for balance and enough flexibility to allow the animal to shift its weight rapidly when executing turns.

VITAL STATISTICS
DEINONYCHUS
Length: 10 ft (3 m)
Height: 5 ft (1.5 m)
Weight: 175 lb (80 kg)

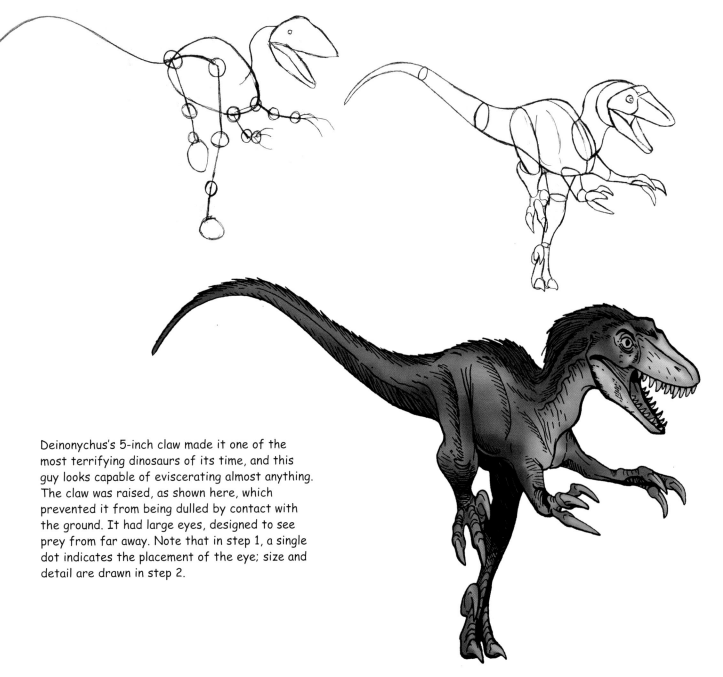

Deinonychus's 5-inch claw made it one of the most terrifying dinosaurs of its time, and this guy looks capable of eviscerating almost anything. The claw was raised, as shown here, which prevented it from being dulled by contact with the ground. It had large eyes, designed to see prey from far away. Note that in step 1, a single dot indicates the placement of the eye; size and detail are drawn in step 2.

Eoraptor

Eoraptor ("dawn thief") was a lethal combination of speed and intelligence. It had hollow bones and extremely large eye sockets. Eoraptor's teeth were serrated, the better to tear flesh from bone. Paleontologists speculate that its lightweight frame and strong hind legs allowed Eoraptor to run at speeds approaching 40 miles per hour (64 kilometers per hour).

The action line in step 1 clearly establishes that this is an animal on the run. The eyes, which look truly fearsome in the final drawing, are sketched out early on in more detail than Deinonychus's eyes were.

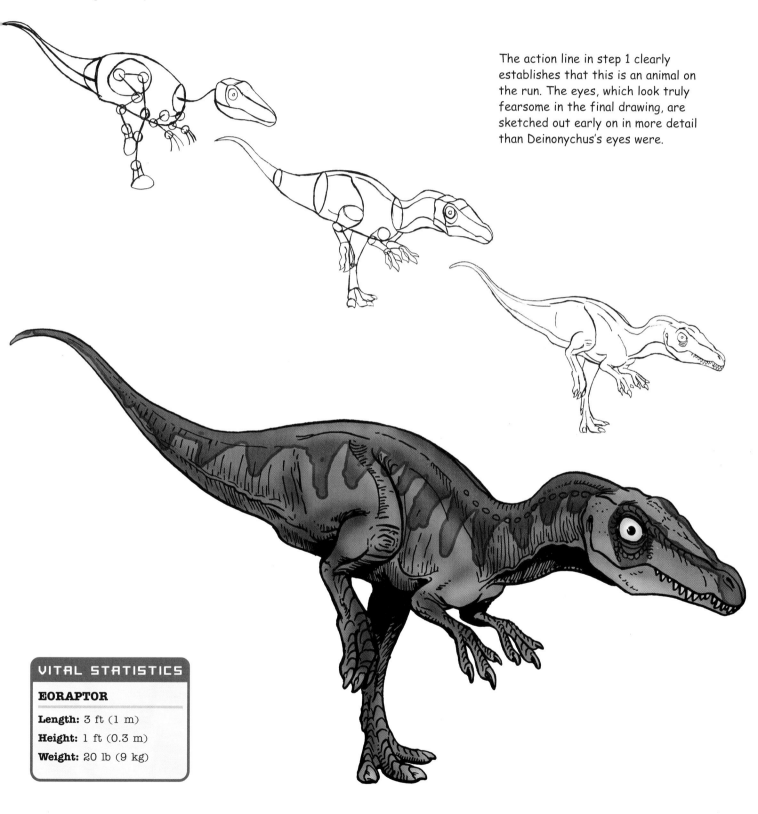

VITAL STATISTICS

EORAPTOR

Length: 3 ft (1 m)

Height: 1 ft (0.3 m)

Weight: 20 lb (9 kg)

Gallimimus

Although Gallimimus means "fowl mimic," the skeleton of this dinosaur resembles the skeleton of an ostrich. (The "ostrich" dinosaurs are ornithomimisaurs.) Gallimimus was a speedy, slender, bipedal dinosaur with long limbs and neck. Its small head had a relatively large brain and a toothless beak with a shovel-like lower jaw. Its big eyes were flat on its skull, making them useless for depth perception. Its long legs were designed for shock absorption as Gallimimus raced about at breakneck speeds—possibly up to 50 miles per hour (80 kilometers per hour). Some members of this group had short arms; the arms of others were relatively long. All had three clawed fingers on each hand, and long legs with three clawed toes on each.

Think of the grace of a ballerina when drawing Gallimimus. This dinosaur should look as if it could go airborne at any time.

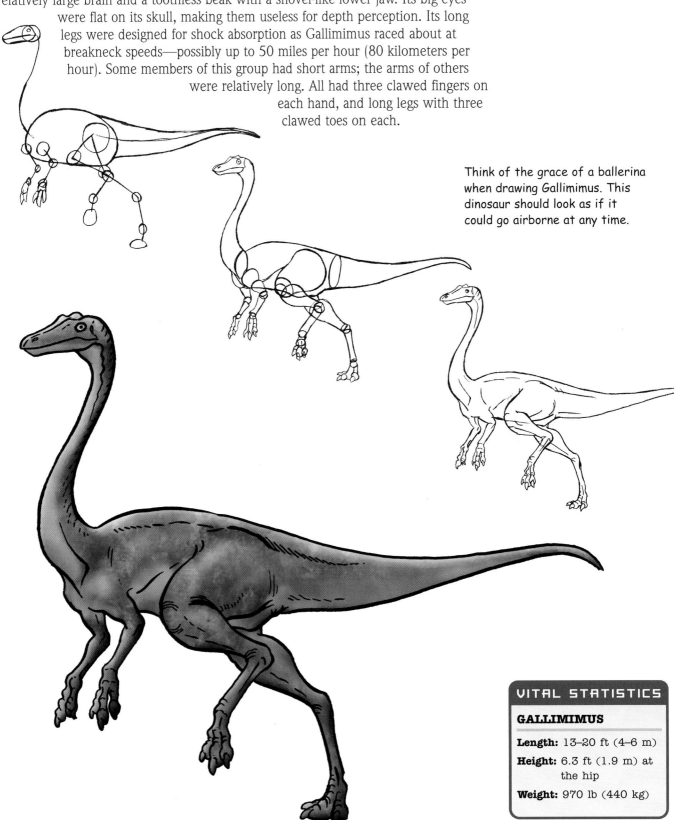

VITAL STATISTICS
GALLIMIMUS
Length: 13–20 ft (4–6 m)
Height: 6.3 ft (1.9 m) at the hip
Weight: 970 lb (440 kg)

Ornitholestes

Despite its name (Ornitholestes means "bird robber") this animal probably ate lizards, small mammal, and carrion. It closely resembled Coelophysis (see page 63). Ornitholestes had flexible wrists, so it could fold its hands up the way some birds fold up their wings, and a long tail that gave it superior maneuverability and balance when hunting.

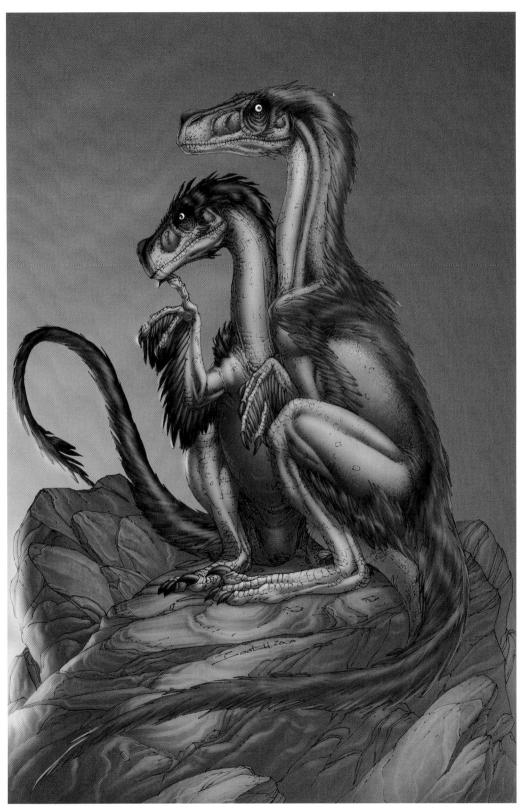

Even though Brett Booth's charming—and carnivorous—Ornitholestes couple is sitting down, all the distinctive features described by paleontologists are there: small head with crest on the snout; long, curvy neck; lightly built body; and long, tapered tail. The color and the feathery details are the types of artistic flourishes paleo-artists like Brett Booth are allowed to have fun with.

VITAL STATISTICS

ORNITHOLESTES

Length: 6.5 ft (2 m)

Height: 16 in (40.6 cm) at the hip

Weight: 25 lb (12 kg)

Oviraptor

Oviraptor ("egg stealer") was a small birdlike omnivore (it ate both meat and plants) propelled by two long, slender legs. The first one was discovered near what was thought to be a Triceratops nest; scientists thought it was there to steal an egg, which is why it was given the name Oviraptor. In fact, the name is a misnomer. The fetuses inside the eggs were Oviraptors, and these animals probably cared for their nestlings, much as birds do. Oviraptor looked something like an ostrich and probably ran as quickly as one: up to 43 miles per hour (70 kilometers per hour). It had a curved, flexible, S-shaped neck, a long tail, short, strong arms, and curved claws on its three-fingered hands and three-toed feet. The claws on its large hands were about 3 inches (8 centimeters) long. Its parrot-like head had a short, toothless beak and powerful jaws, designed for crushing. Oviraptors had small hornlike crests on their snouts, probably used primarily as mating displays.

VITAL STATISTICS		
OVIRAPTOR		
Length: 6–8 ft (1.8–2.5 m)		
Height: 3 ft (0.9 meters)		
Weight: 55–75 lb (25–35 kg)		

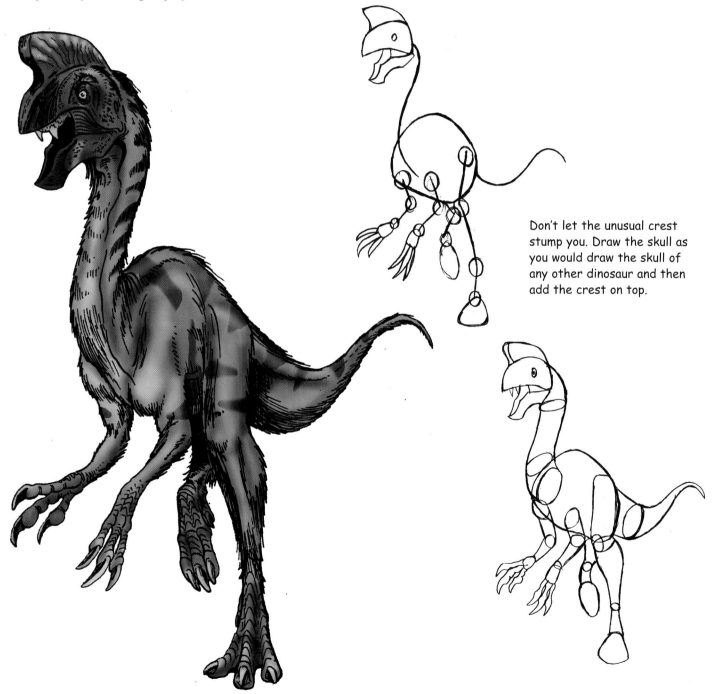

Don't let the unusual crest stump you. Draw the skull as you would draw the skull of any other dinosaur and then add the crest on top.

Struthiomimus

Struthiomimus ("ostrich mimic") is the best-known of North America's large birdlike running dinosaurs. It had a small head, large eye sockets, a toothless beak, a long neck, and long, birdlike legs. It had strong, three-fingered hands tipped with claws that were used to scoop up eggs. Besides eggs, Struthiomimus ate insects and small mammals. It may also have eaten plants. As it did on other birdlike runners, the long tail acted as a counterbalance and a stabilizer when the animal was making quick turns.

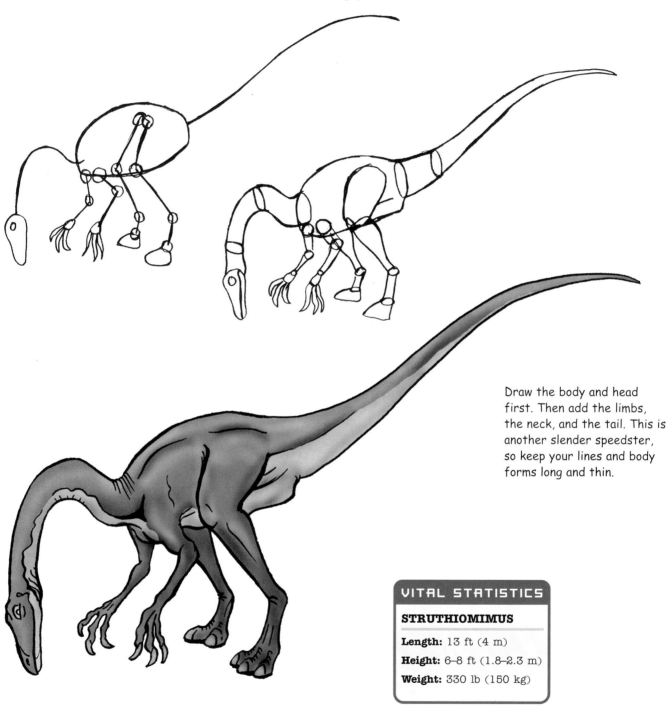

Draw the body and head first. Then add the limbs, the neck, and the tail. This is another slender speedster, so keep your lines and body forms long and thin.

VITAL STATISTICS

STRUTHIOMIMUS

Length: 13 ft (4 m)

Height: 6–8 ft (1.8–2.3 m)

Weight: 330 lb (150 kg)

Troodon

Many paleontologists believe that Troodon ("wounding tooth"), which had an enormous brain relative to its body size, was the most intelligent of all the dinosaurs. Its huge eyes—1.75 inches (44 millimeters)—angled forward, and scientists speculate that it was a nocturnal hunter with at least some degree of depth perception. Troodon had a light frame and long legs, making it quite agile. It had a curved toe claw, possibly used for eviscerating prey. It had long arms with three clawed fingers on each hand.

From top to bottom: a delicate preliminary drawing, skeletal system, musculature, and finished Troodon. Artist Demetrios Vital has provided his Troodon with eyelashes and feathers, which gives the animal a very different look from Bryan Baugh's version, on the facing page.

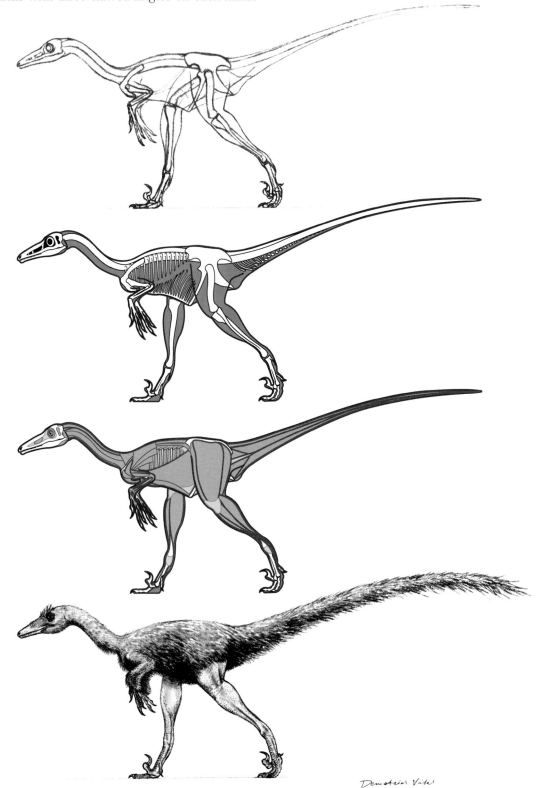

VITAL STATISTICS

TROODON

Length: 10 ft (3 m)

Height: 3.1 ft (94 cm) at the hip

Weight: 110 lb (50 kg)

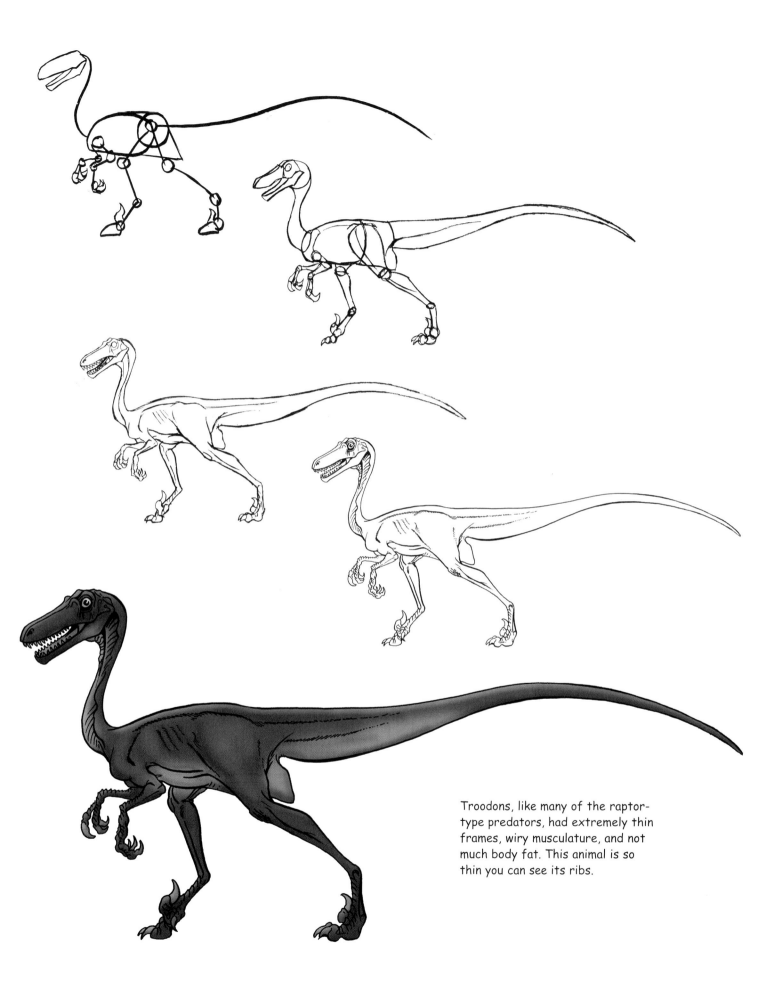

Troodons, like many of the raptor-type predators, had extremely thin frames, wiry musculature, and not much body fat. This animal is so thin you can see its ribs.

Utahraptor

Utahraptor ("thief from Utah"), another of the birdlike dinosaurs, was a lightly built, fast-moving, agile biped. The largest of the dromeosaurs ("swift lizards"), it had a curved, flexible neck and a relatively large head and brain. Sharp serrated teeth were set into powerful jaws to facilitate eating and tearing meat. Each hand had three fingers tipped with large, sharp, curved claws. Scientists believe that Utahraptor hunted in packs that were capable of taking down large sauropods. Utahraptor's second toe was tipped with a scythelike claw that was 9 inches (23 centimeters) long, and would have been a formidable tool for slicing open prey. The toe joints were constructed so that this massive claw could be raised upward and backward when running but lowered and thrust forward when the animal reached its prey. The bony rods running along the spine and tail provided stability when the animal was kicking out with its slashing claw.

VITAL STATISTICS

UTAHRAPTOR

Length: 16–23 ft (5–7 m)

Height: 6.5 ft (2 m)

Weight: 1 ton (907 kg)

It is important that you establish a strong S-curve to the neck in your initial layout. Utahraptor's large eyes give the animal a look of intelligence. Choose poses that emphasize the kinetic energy of this predator. This is one of the specimens that scientists theorize may have had feathers, so experiment with covering the back of the neck and arms.

Velociraptor

Velociraptor ("speedy thief") was a fast, agile, bipedal dromeosaur about the size of a large dog. Its long, flat snout was about 7 inches (17.8 centimeters) long; it had over 80 teeth, some nearly 1 inch (2.5 centimeters) long. This predator had an S-shaped neck, arms with three-fingered clawed hands and long, thin legs. Like Utahraptor, it had a retractable scythelike claw on the middle toe of each foot, but the claw was about a third of the size of Utahraptor's. This claw was perfect for gutting smaller prey or making substantial slashes on very large prey to slow it down. Velociraptor's stiff tail functioned as a counterbalance when the animal needed to make quick changes in direction or kick and slash with its curved claw.

Notice that Velociraptor's head was much larger relative to its body than Utahraptor's and its neck was much skinnier. *Jurassic Park* got the size all wrong, but the filmmakers had this fierce predator's intelligence right.

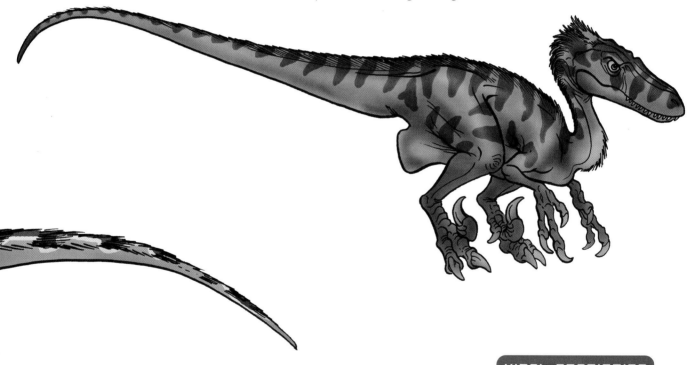

VITAL STATISTICS

VELOCIRAPTOR

Length: 5–6 ft (1.5–2 m)

Height: 3 ft (1 m)

Weight: 15–33 lb (7–15 kg)

Dinosaur fossils found together often provide information on important predator/prey relationships. As an artist you can take this information and re-create what those fierce encounters might have looked like, just as artisan Brett Booth has skillfully done here with a pair of *Velociraptor mongoliensis* taking down a Protoceratops.

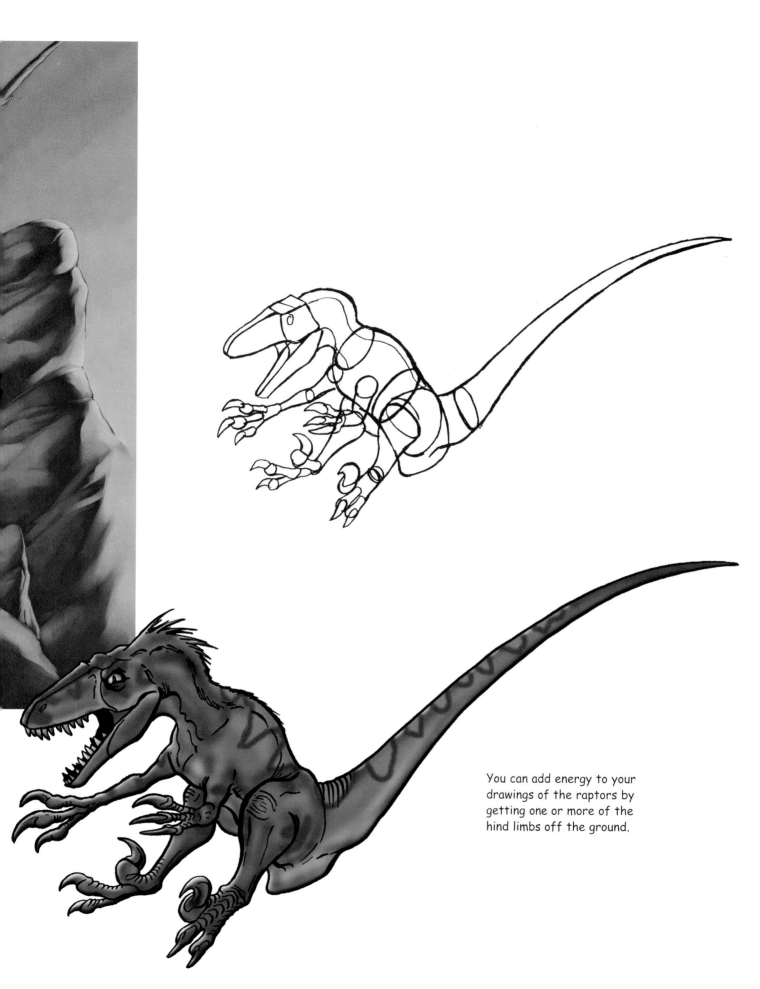

You can add energy to your drawings of the raptors by getting one or more of the hind limbs off the ground.

The Behemoths: Sauropodomorpha

The huge plant-eaters covered in this section are all sauropods. They were quadrupeds, which means they walked on all fours. Their total bulk was immense, and they had small heads and long tails and necks. Many of the sauropods on these pages had extremely flexible tails that may have been used as a whiplike defense. When drawing these creatures you will immediately think of their elephantine qualities, and will benefit from posing them in stances that go with their bulk. The sauropods had a limited range of motion because of relatively rigid joints in their limb and foot bones; this structure was beneficial in providing locomotor stability. The tubelike, parallel structure of the radius and the ulna in their forelimbs gave those limbs excellent load-bearing capacity. (If you don't know radius from ulna, turn back to page 22 for a labeled sauropod skeleton.)

The sauropods had small brains relative to their size, and were the least intelligent of the dinosaurs. They were, however, superbly adapted for their environments. They inhabited every continent and are considered among the most successful and long-lived of the dinosaurs. Fossil trackways suggest that sauropods, like today's elephants, traveled in herds.

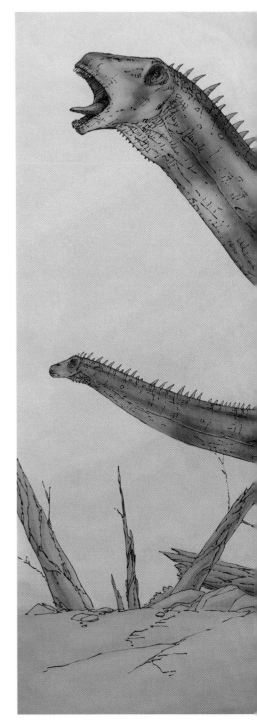

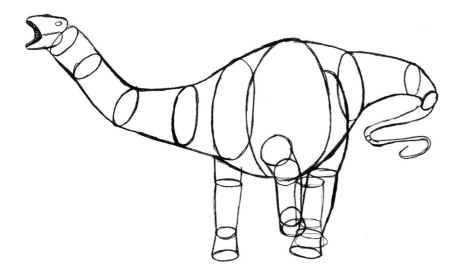

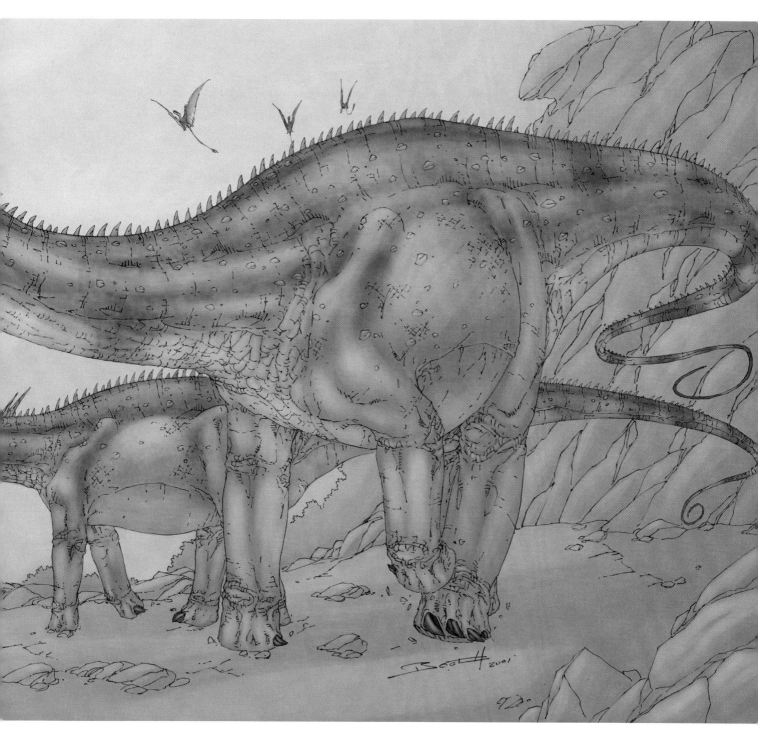

Apatosaurus's legs were like massive columns, and they ended in flat, blunt feet. The apatosaur in the background is walking, but without any flexibility in its legs. The necks and tails of the apatosaurs, however, had a wide range of motion. The apatosaur in the foreground has a beautifully curved neck, and the whiplike tails of both animals have beeen drawn with expressive, graceful lines.

Apatosaurus

Apatosaurus ("deceptive lizard"), formerly known as Brontosaurus ("thunder lizard"), was one of the largest dinosaurs that ever roamed the earth. After T-rex, Apatosaurus is probably the best known of the dinosaurs. This gigantic sauropod satisfied its equally gigantic appetite on a constant diet of vegetation. At the end of its enormous neck (15 vertebrae) was a 2-foot-long (0.6-meter-long) head with sharp, peglike teeth for raking off vegetation when it grazed. Apatosaurus's nostrils were located on the top of its head, above and between the eyes, rather than at the end of its snout. Apatosaurus had massive columnar legs with clawed feet, and the the rear legs were longer than the front ones. Its tail might have been used to create a sort of tripod support when Apatosaurus was reaching up to very tall plants. The last third of its 50-foot (15.2-meter) tail was whiplike and extremely flexible. Apatosaurus carried its head and neck almost parallel to the land it slowly lumbered across, probably no more than 17 feet (5.4 meters) off the ground [which was still 2 feet (0.6 meters) higher than the largest meat-eaters could reach].

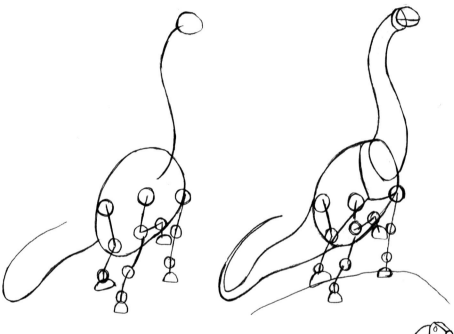

VITAL STATISTICS
APATOSAURUS
Length: 70–90 ft (21–27 m)
Height: 15 ft (4.6 m) at the hips
Weight: 33–38 tons (30,000–35,000 kg)

The hips and rib cage were connected by a somewhat flexible spinal column, so you can draw them as one mass. The central body mass has been roughed in somewhat like a shampoo bottle turned on its side. (Apatosaurus was quite boxy around the hips and ribs.) Remember to draw Apatosaurus's nostrils on top of its head rather than the end of its face.

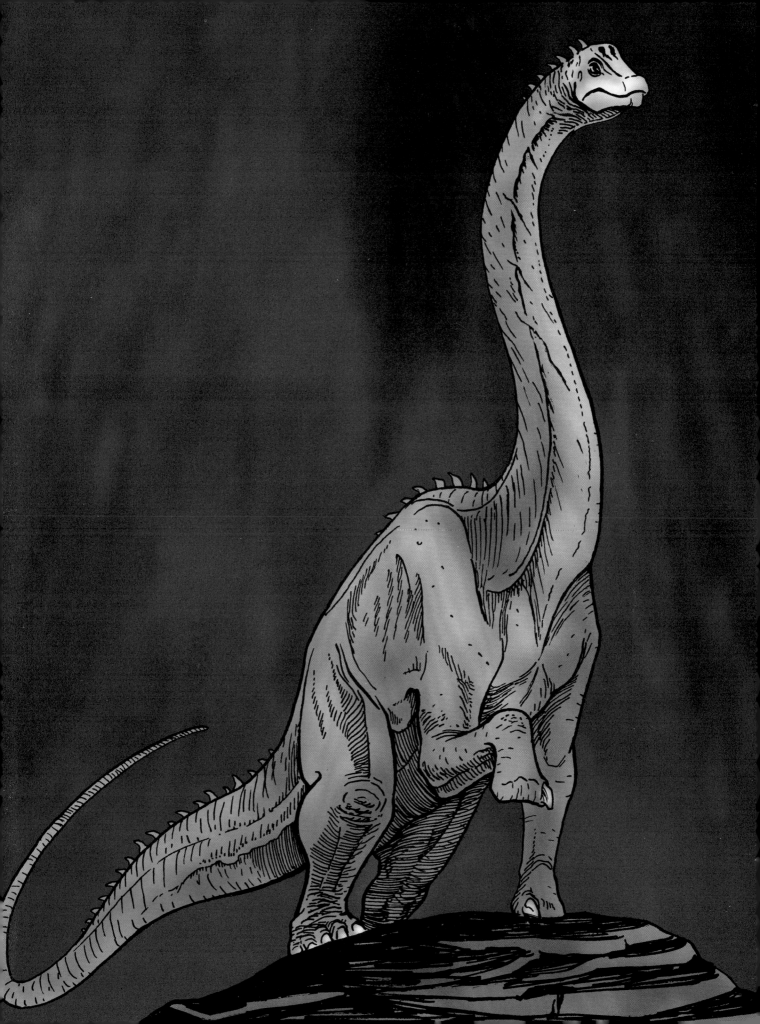

Argentinosaurus

Argentinosaurus ("Argentine lizard") is believed to be the largest dinosaur ever discovered. Argentinosaurus is most certainly a sauropod, but not much else is known about it. It may be a member of the titanosaurian family. One fossil Argentinosaurus vertebra has been found that is over 5.5 feet (1.7 meters) long. Extrapolating from this, scientists have theorized that Argentinosaurus would have been over 120 feet (36.5 meters) long, longer than three end-to-end school buses and taller than a six-story building! To get to this mammoth size, an argentinosaurian adolescent would have had to gain about 100 pounds (45 kilograms) a day.

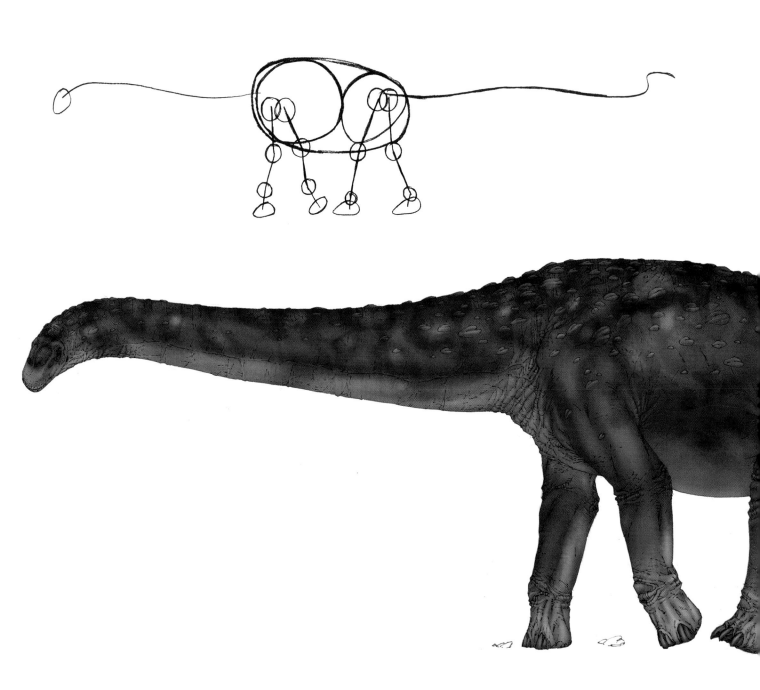

ARGENTINOSAURUS

Length: Over 120 ft
(37 m)

Height: 70 ft (21.4 m)

Weight: 100 tons
(90,000 kg)

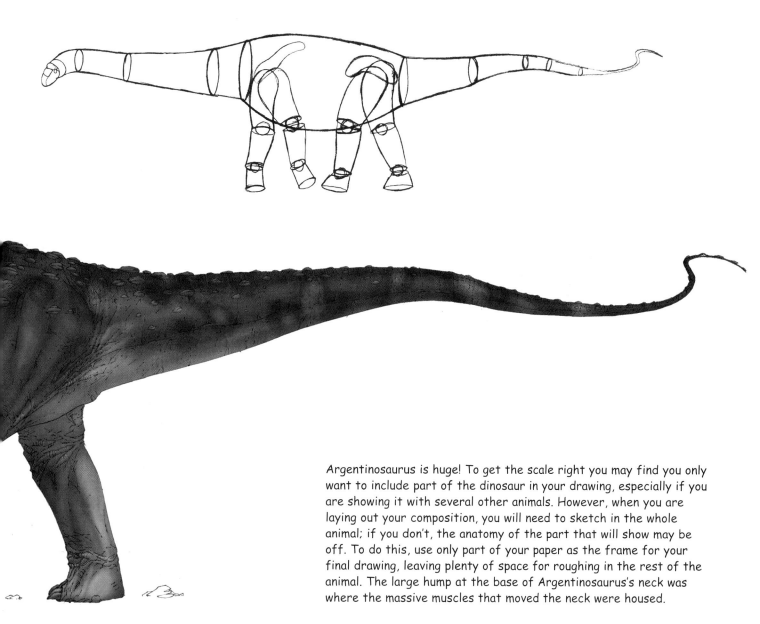

Argentinosaurus is huge! To get the scale right you may find you only want to include part of the dinosaur in your drawing, especially if you are showing it with several other animals. However, when you are laying out your composition, you will need to sketch in the whole animal; if you don't, the anatomy of the part that will show may be off. To do this, use only part of your paper as the frame for your final drawing, leaving plenty of space for roughing in the rest of the animal. The large hump at the base of Argentinosaurus's neck was where the massive muscles that moved the neck were housed.

Brachiosaurus

Brachiosaurus ("arm reptile") is one of the tallest and largest dinosaurs ever discovered. It had a long neck, a small head, and a relatively short, thick tail. Brachiosaurus was a quadruped, and its front legs were longer than its hind ones. It had a claw on the first toe of each front foot and claws on the first three toes of each rear foot (each foot had five toes with fleshy pads). Unlike most of the other long-necked herbivores, Brachiosaurus was specifically designed to reach high into treetops to gather its meals, much like a modern giraffe. Like other brachiosaurids, it had teeth shaped like chisels, for stripping vegetation from its stalks. Brachiosaurus had nostrils on the top of its head, above and between the eyes. Brachiosaurus should be drawn with its neck curved and perpendicular to its body; it did not lower its neck to a parallel position.

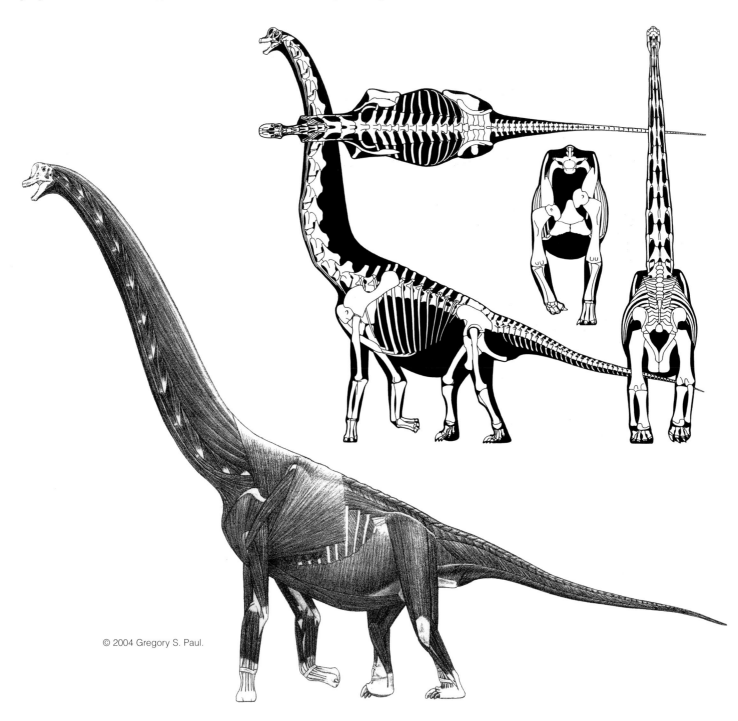

© 2004 Gregory S. Paul.

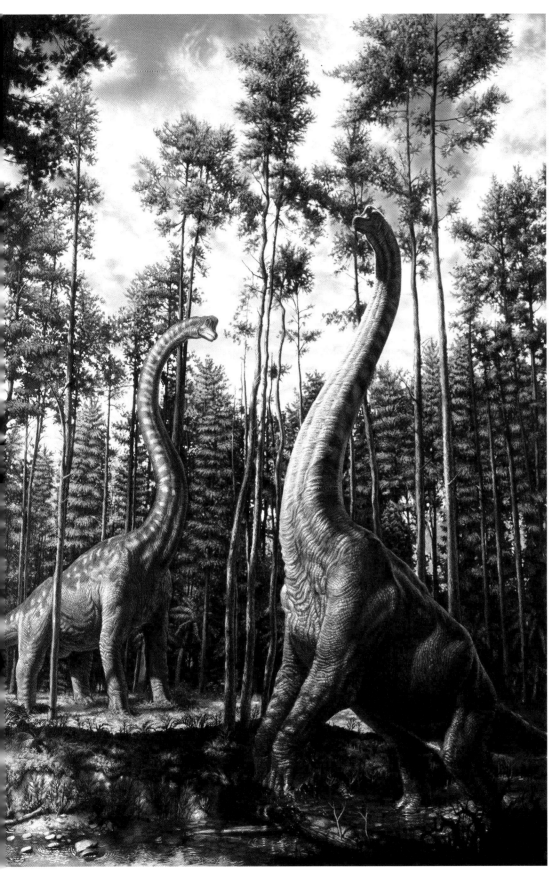

Artist Mike Compton's peaceful giants are big enough to reach all but the tallest of these prehistoric conifers. Clearly there is no room for the tails in a vertical composition, but you may be sure the artist sketched the entire animal before finishing the painting.

VITAL STATISTICS

BRACHIOSAURUS

Length: 85 ft (26 m)

Height: 40–50 ft (12–16 m)

Weight: 60 tons (54,500 kg)

Your initial line drawing should function as the skeleton of Brachiosaurus. Be sure to indicate all the joints where movement was possible. If you look back at the skeleton on page 84, you'll see that Brachiosaurus was a relatively flexible sauropod, and artist Bryan Baugh has made good use of that flexibility. Build weight and mass by blocking in the large central body area and adding cylinders for the legs, tail, and neck. Adding a slight S-curve to the neck will give the animal more flair.

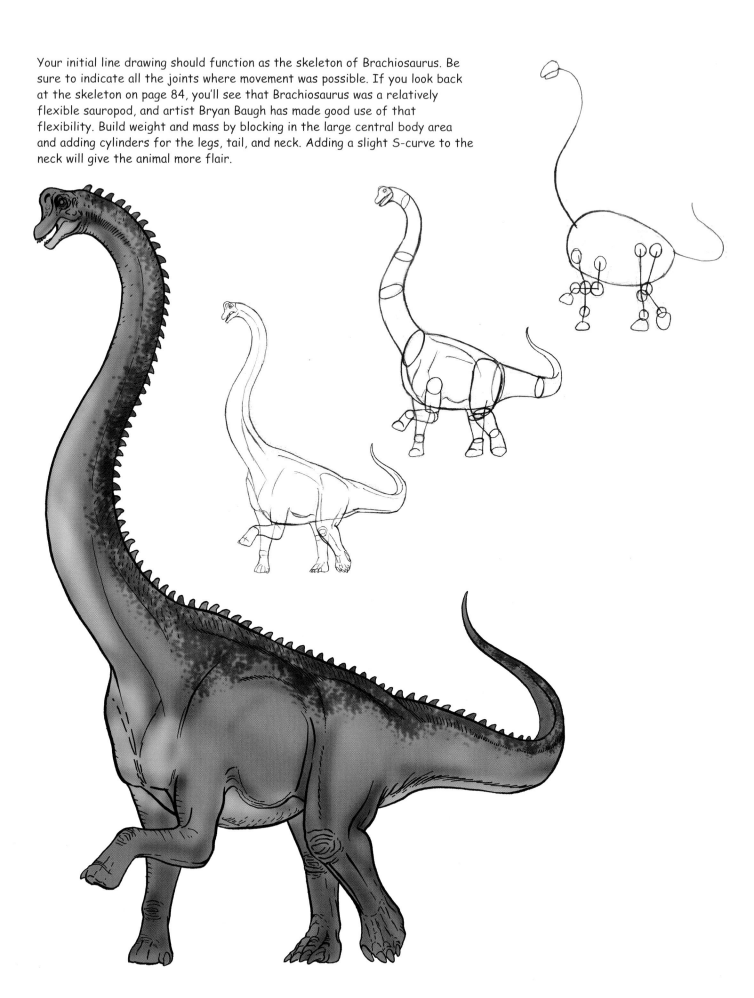

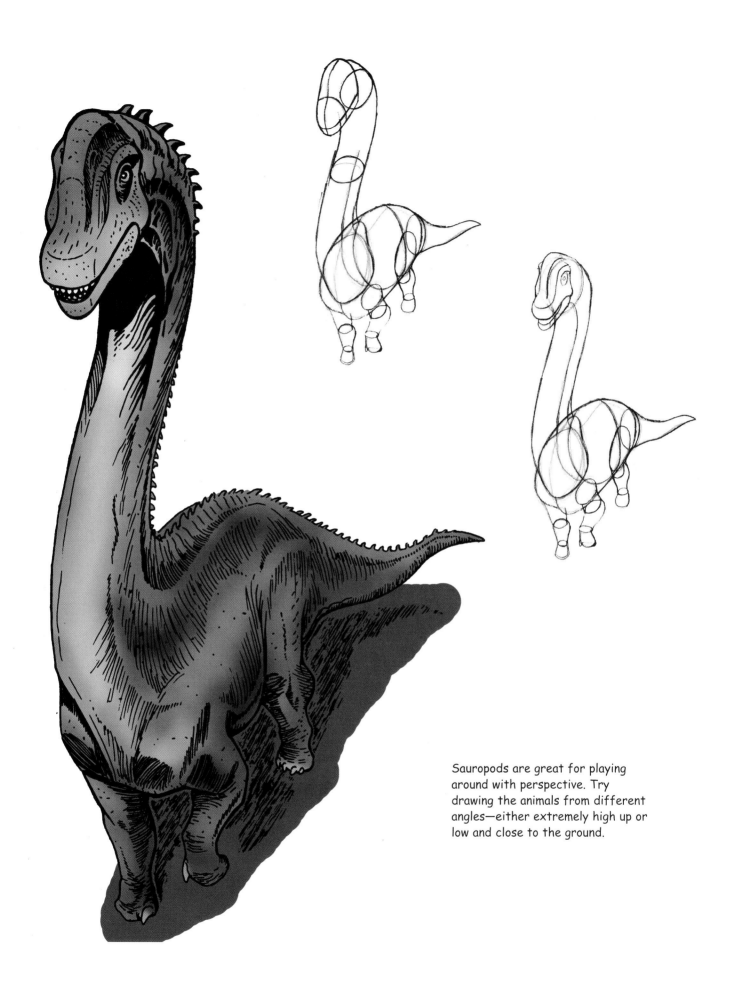

Sauropods are great for playing around with perspective. Try drawing the animals from different angles—either extremely high up or low and close to the ground.

Cetiosaurus

In 1841 Sir Richard Owen discovered the first sauropod fossils: they belonged to Cetiosaurus ("whale lizard," so named because its back vertebrae had a coarse texture, like those of a whale). Owen at first classified the animal as a crocodilian, and did not include it in his original description of Dinosauria. Cetiosaurians were giant plant-eating quadrupeds with five toes on each foot. They had small heads on long necks and long whiplash tails.

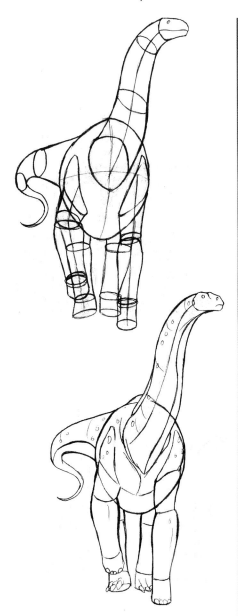

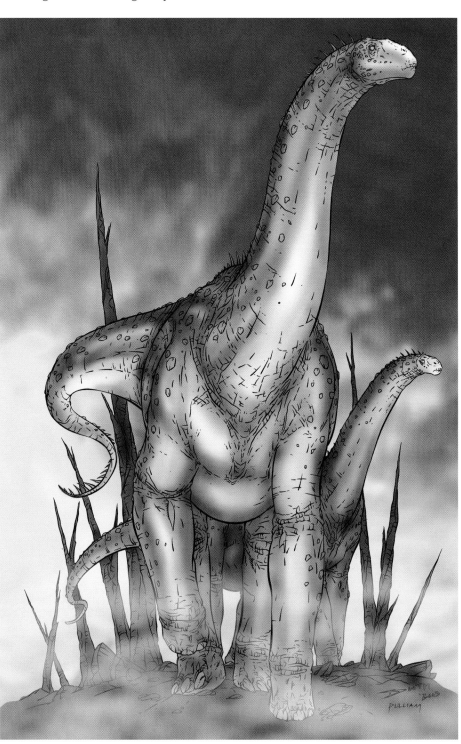

VITAL STATISTICS
CETIOSAURUS
Length: 45–60 ft (17–23 m)
Height: Up to 40 ft (15 m)
Weight: Over 50 tons (45,000 kg)

It is easy to see how leg muscles and bone worked together to create columns of support for this massive sauropod. Emphasize the cylindrical load-bearing strength of the legs to create a super-stable dinosaur.

Diplodocus

The massive neck of Diplodocus ("double beam") was 26 feet (8 meters) long, and its long, flexible whiplash tail was 5 feet (1.5 meters) long. Overall Diplodocus was more lightly built than the other giant sauropods. It had a relatively small head, only about 2 feet (0.6 meters) long, with nostrils at the top and peglike teeth in the front of its jaws. Its front legs were shorter than its back legs, but all four had elephantine five-toed feet. There was a claw on the first toe of each front foot and claws on the first three toes of each rear foot. Diplodocus had a row of spines running down its back. Diplodocus's first-line defense against predators was the animal's massive size, but it may have also used its tail. Diplodocus, like all sauropods, was a plant-eater; the plants that could have made up its diet include conifers, ginkos, seed ferns, club mosses, and horsetails.

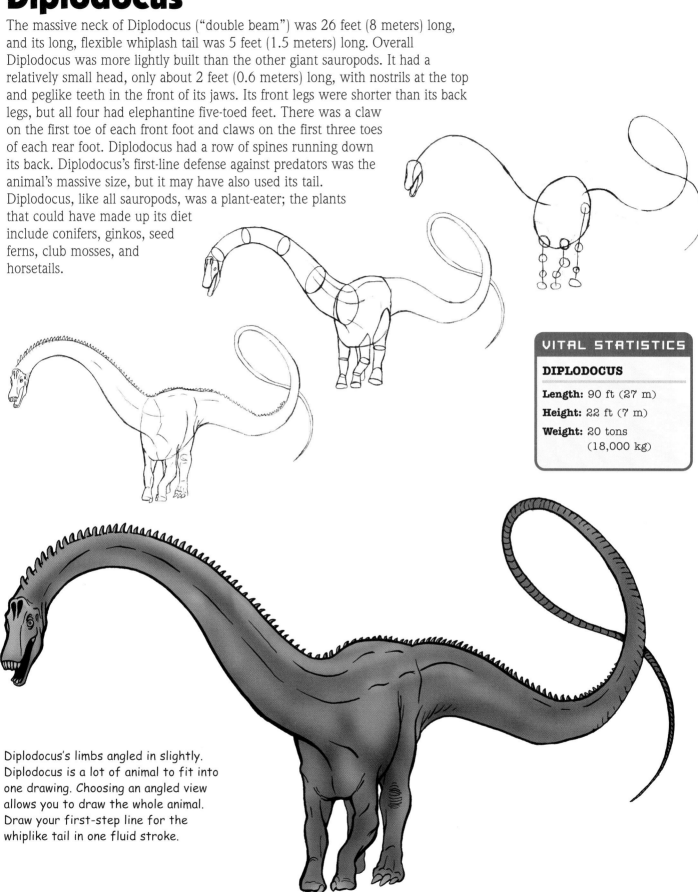

VITAL STATISTICS

DIPLODOCUS

Length: 90 ft (27 m)

Height: 22 ft (7 m)

Weight: 20 tons
(18,000 kg)

Diplodocus's limbs angled in slightly. Diplodocus is a lot of animal to fit into one drawing. Choosing an angled view allows you to draw the whole animal. Draw your first-step line for the whiplike tail in one fluid stroke.

Saltasaurus

For a sauropod, Saltasaurus ("Salta lizard") had a short neck. It had bony armor plates about the size of a human palm, called scutes or dermal plates, covering much of its back to protect it from predators. Some scientists speculate that these plates had bony spikes protuding from them. Its feet and legs were similar to those of Diplodocus. All four feet had five toes with fleshy pads; there was a claw on the first toe of each front foot and claws on the first three toes of each rear foot. Like some other sauropods, Saltasaurus may have used its thick tail as a third leg so it could rear up on its hind legs to feed on vegetation.

VITAL STATISTICS

SALTASAURUS

Length: 39 ft (12 m)

Height: 13–16 ft
 (4–4.9 m)

Weight: 8 tons (7,250 kg)

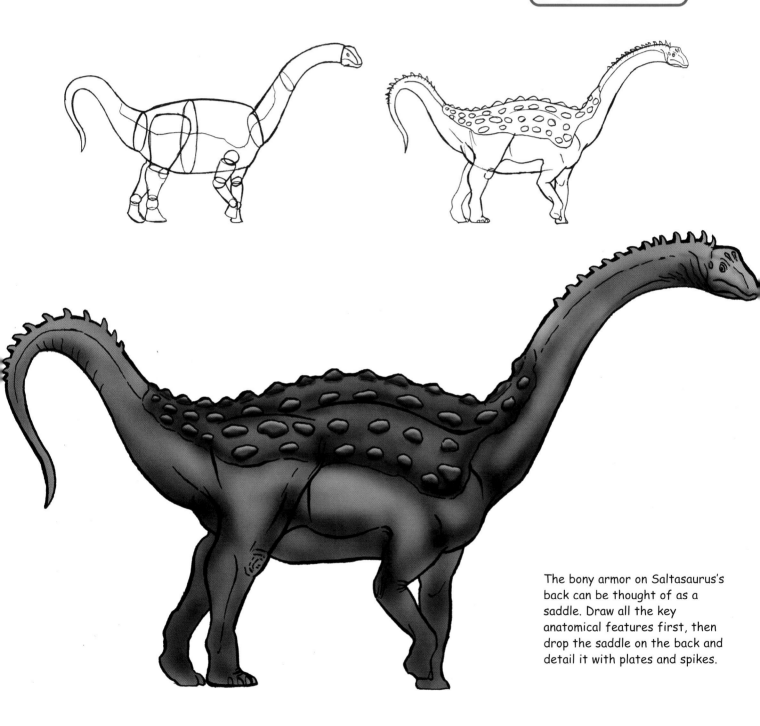

The bony armor on Saltasaurus's back can be thought of as a saddle. Draw all the key anatomical features first, then drop the saddle on the back and detail it with plates and spikes.

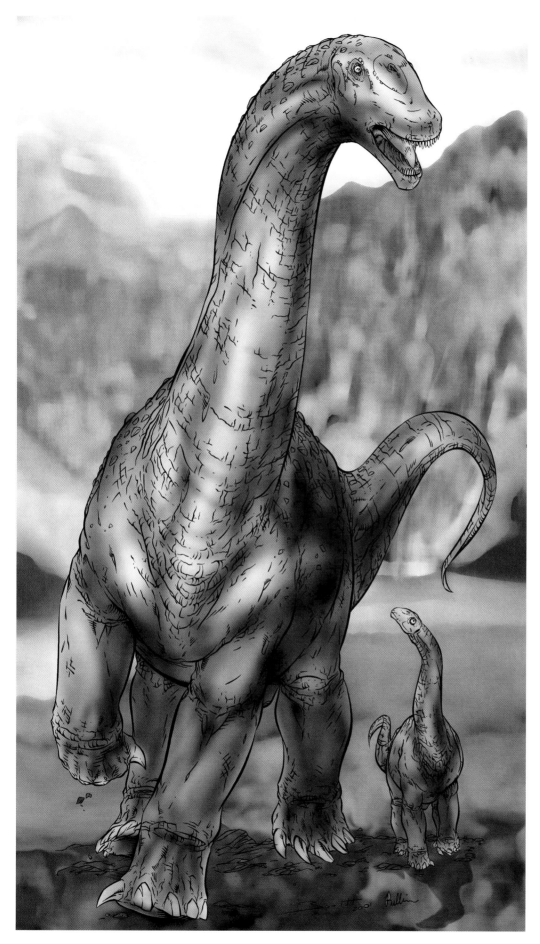

It may be hard to believe, but this little fellow would eventually grow into an 8-ton adult.

Seismosaurus

Seismosaurus ("earthquake lizard") was the longest animal that ever lived. It had a small head, a huge neck, enormous columnar legs, and a whole lot of tail. Seismosaurus's nostrils were on top of its skull. Its small mouth had peglike teeth that were designed for chewing up roughage and other tough plants. Its front legs, like the front legs of many of the other sauropods, helped provide stability for these massive animals. Each elephantine foot had five toes with a thumb claw.

It is easy to see how this dinosaur got its name: every step would register on the Richter scale. Note the heavier line weights on the tail, hind legs, and underside of the neck, which help to convey this behemoth's massive heft.

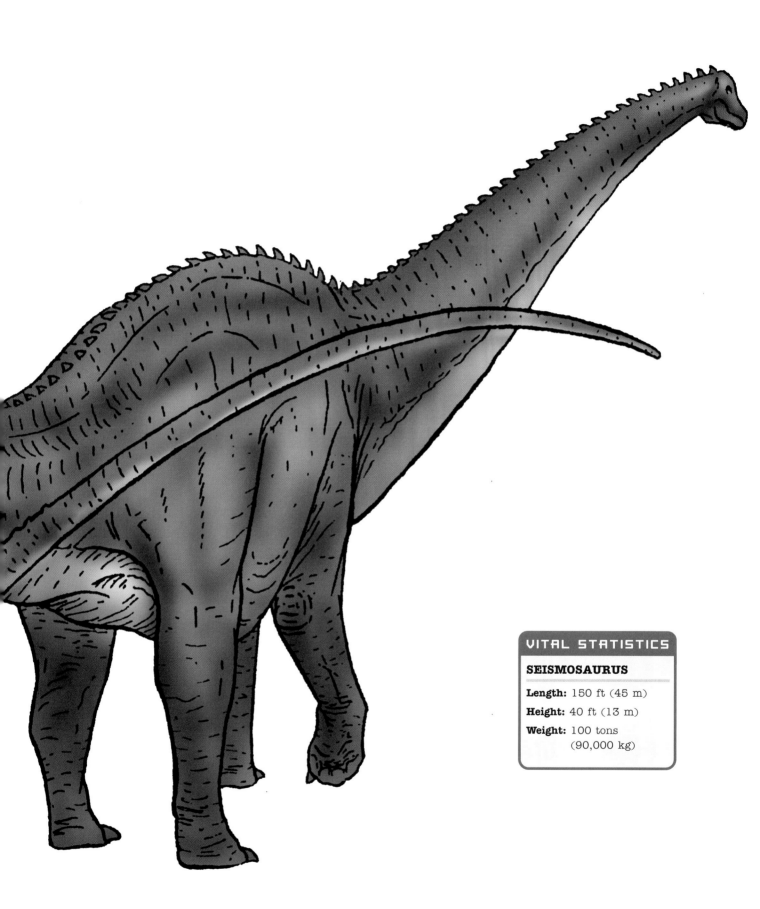

VITAL STATISTICS

SEISMOSAURUS

Length: 150 ft (45 m)

Height: 40 ft (13 m)

Weight: 100 tons
(90,000 kg)

Shield Bearers: The Thyreophorans

Thyreophorans, a subgroup of the bird-hipped dinosaurs (Ornithischia), had heavy-duty defensive armor (ankylosaurans) or plates (stegosaurans), and the name thyreophoran means "shield bearer." All of them were quadrupeds, and most of them were plant-eaters. They had heavy limbs, short tails, short necks, blunt skulls, and small, primitive teeth. The two most famous thyreophorans are Ankylosaurus, whose defensive maneuvers included shoulder thrusts and whipping their club-tipped tails, and Stegosaurus. Stegosaurans had more flexible spines than ankylosaurans, and in addition to using their spiked tails for defense they could take a porcupine-like defense posture.

Mike Compton's take on *Stegosaurus stenops* shows the animal's distinctive characteristics: flexible tail with four spikes at the tip and a double row of plates extending from the back of the skull almost to the end of the tail. Recently discovered fossils show that the plates were in two alternating, rather than paired, rows, and the artist is clearly up on the latest research. Paleontologists are not in agreement about the leathery extensions. Different species had different numbers of tail spikes. *Stegosaurus stenops* had four, as shown here. In 1992 it was discovered that Stegosaurus had armorlike scutes (scales) on the skin of the neck, the pelvic area, and, in some species, the sides.

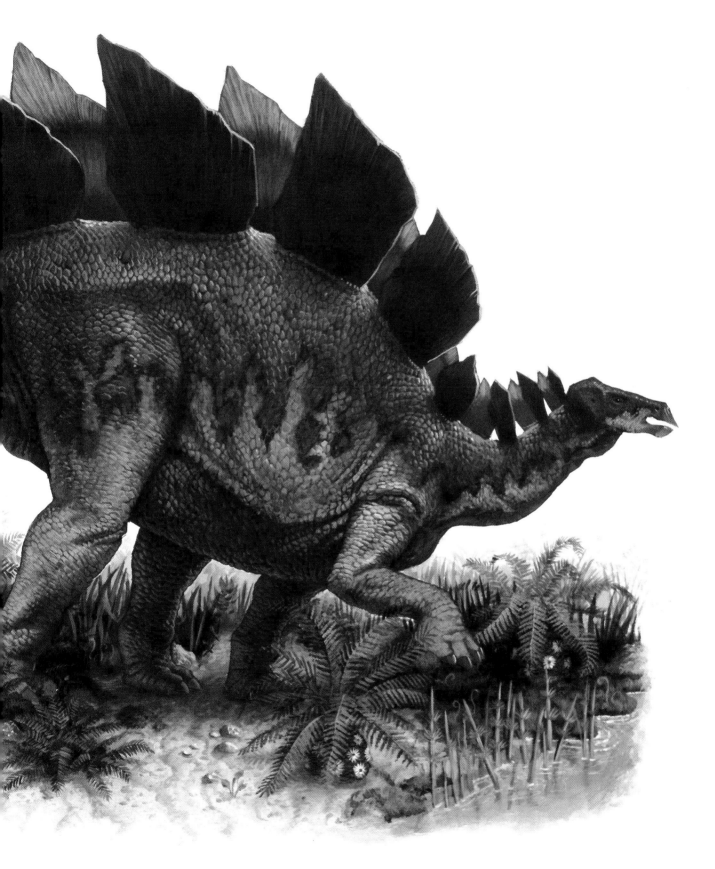

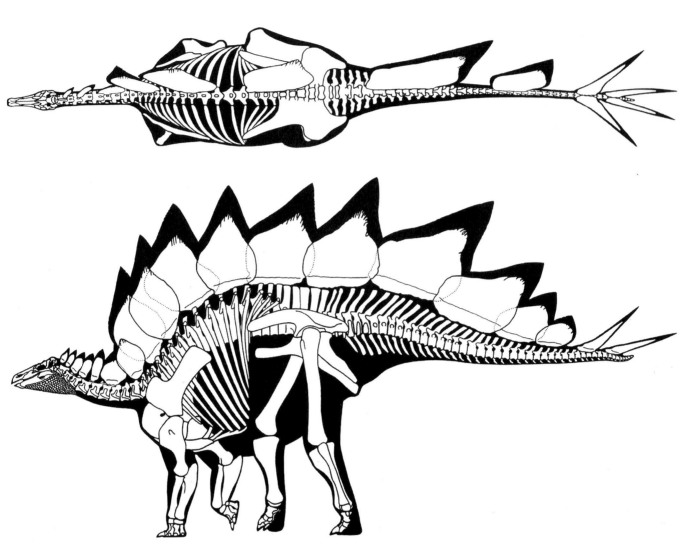

By looking at Gregory S. Paul's Stegosaurus skeletons, you can see important anatomical features, such as the placement of the plates and the structure of the leg joints. If you have a firm picture of the dinosaur's skeleton in your head when you lay out the initial design, you will be able to position each component of its anatomy correctly.

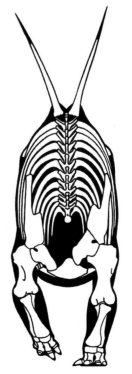

Ankylosaurus

Ankylosaurus ("fused lizard") was the dinosaur equivalent of a tank: it was heavily protected from carnivores by thick, oval plates embedded in its leathery skin, two rows of spikes along its body, large horns that projected from the back of its head, and even eye plates. The only vulnerable area on Ankylosaurus was its unprotected belly. Its anatomy was not all defensive; it had a tail club for battering would-be assailants. It had a short neck, a wide skull, and four short legs; the rear legs were larger than the front legs. The skull was so thick that there was little room for anything but a very small brain, so it is believed that Ankylosaurus was relatively unintelligent.

VITAL STATISTICS

ANKYLOSAURUS

Length: 22 ft (7 m)

Height: 5 ft (1.8 m)

Weight: 4 tons (3,600 kg)

Ankylosaurus had a thick body the torso of which can be drawn as one football-like shape. Its stubby neck allowed the head about as much movement as a human's. The club tail was where the real action was. It could be raised high and swung with great force. When drawing Ankylosaurus attacking with its tail, be sure to draw the legs spread out for greater support.

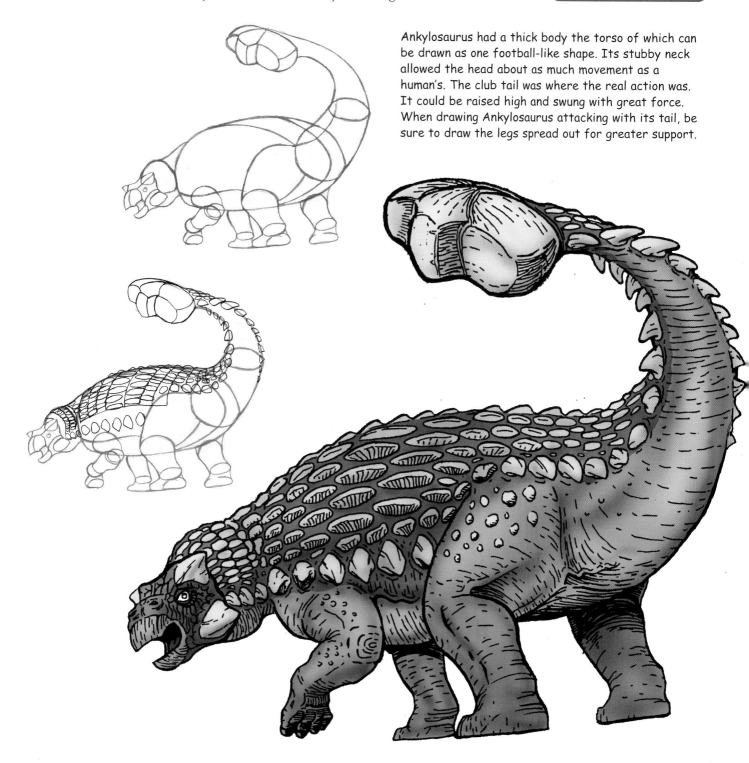

Edmontonia

Edmontonia ("of Edmonton") is very similar to Ankylosaurus in that it had bony armor on its back and head. Edmontonia, a quadrupedal herbivore, was another example of a living tank, but instead of a heavy tail club it had shoulder spikes that would have been useful for gouging into the knees of unsuspecting theropod attackers. Its teeth were small and flat and possibly redundant, as all it would have needed to grind up its plant diet was its beak.

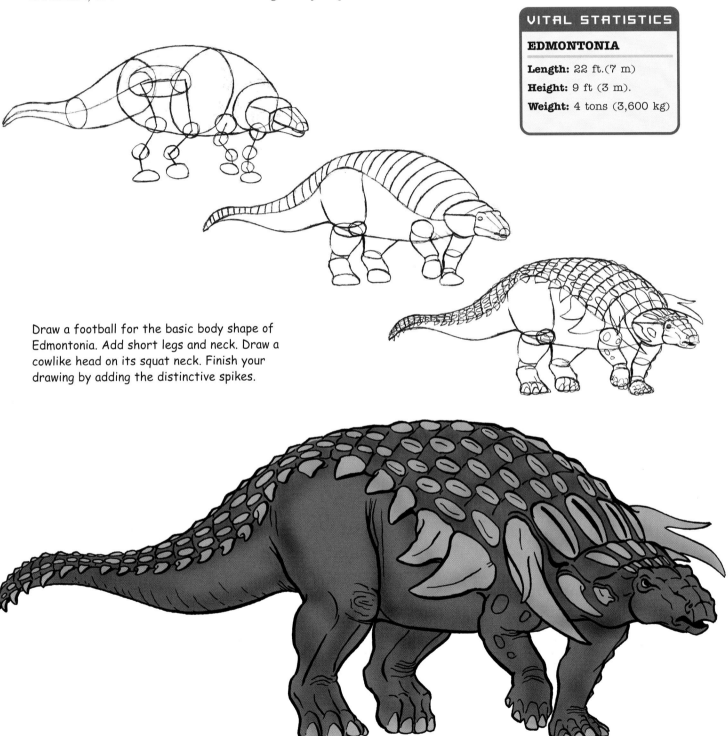

Draw a football for the basic body shape of Edmontonia. Add short legs and neck. Draw a cowlike head on its squat neck. Finish your drawing by adding the distinctive spikes.

Euoplocephalus

Euoplocephalus ("well-armored head") had a low, rotund body with a tail ending in a heavy, bony club. Its hind legs were longer than its front ones; all limbs were stocky, and tipped with short claws. It had a stubby neck, a wide head with a beak, bony side horns, and a small brain. Euoplocephalus's entire top side—head, back, and tail—was heavily protected from carnivores by thick oval plates attached to its tough, leathery skin. Rows of large spikes ran the length of its body, and its long tail—7 feet (2 meters)—ended with a 50-pound (20-kilogram) club of fused bone. Euoplocephalus's softer underside was its only vulnerable spot.

Always start with the simple shapes and move to the more detailed. As much fun as it is to draw all of Euoplocephalus's spikes, you have to save that for the icing on the basic body cake.

Kentrosaurus

Like most thyreophorans, Kentrosaurus ("spiky lizard") was a small, relatively unintelligent, quadrupedal herbivore. It had a medium-sized tail topped off with two large spikes; a small head at the end of a stubby neck; squat, sturdy forelimbs; and somewhat longer hind limbs. It had pairs of plates running down its neck, shoulders, and back, and pairs of long, sharp spikes above its hips and along its tail. Kentrosaurus may or may not have had shoulder spikes; paleontologists disagree. It had well-developed olfactory bulbs, and so probably had a good sense of smell.

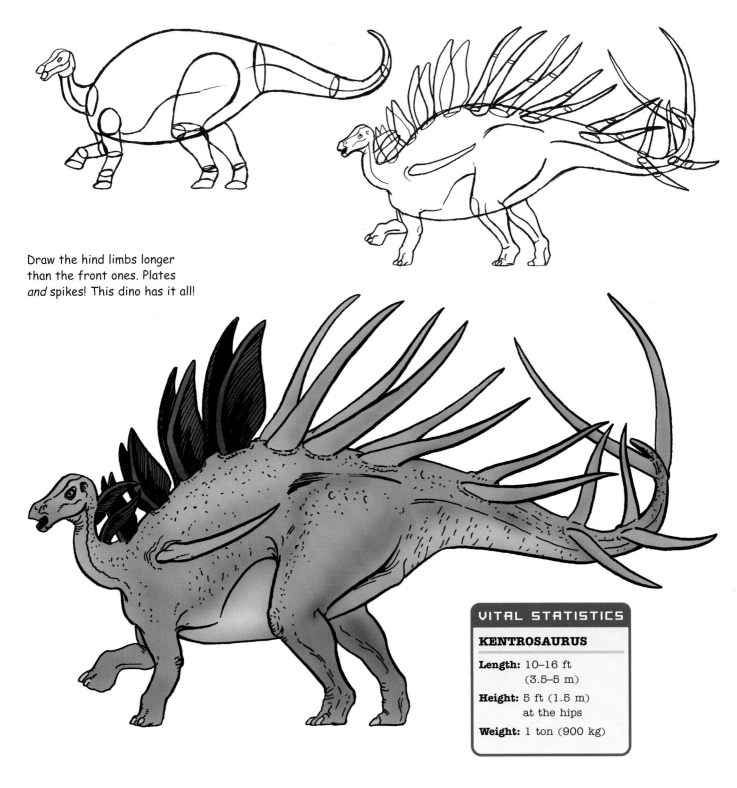

Draw the hind limbs longer than the front ones. Plates *and* spikes! This dino has it all!

VITAL STATISTICS

KENTROSAURUS

Length: 10–16 ft (3.5–5 m)

Height: 5 ft (1.5 m) at the hips

Weight: 1 ton (900 kg)

Scelidosaurus

Scelidosaurus ("limb lizard") was one of the earliest of the armored dinosaurs. A quadrupedal herbivore, it had a low-slung, small head with a short neck and leaf-shaped teeth in its bony beak; a long, stiff tail; and a heavy body with studded plates embedded in its back. Behinds its ears were small three-pronged horns, called tricorns.

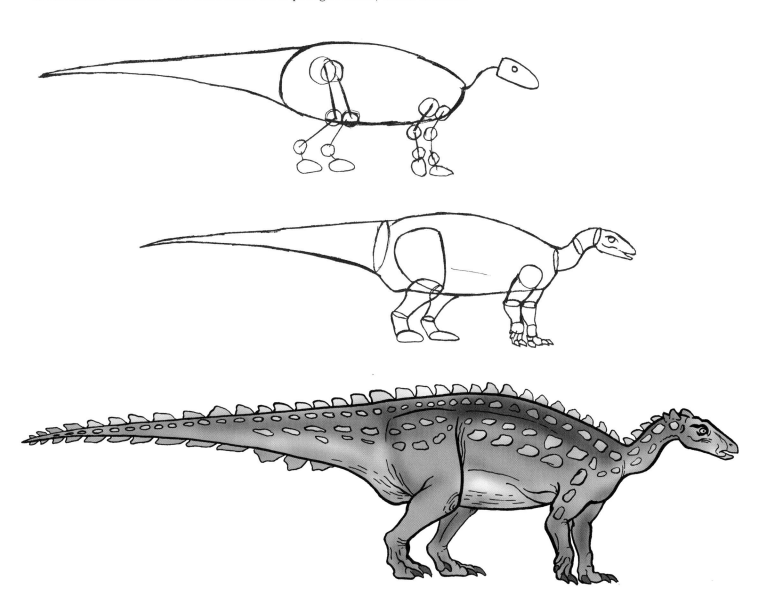

Scelidosaurus had an uncomplicated shape (very nearly an oval), so it's a good dinosaur for beginners to to draw.

Stegosaurus

Stegosaurus ("roofed lizard") had distinctive plates running along its neck, spine, and tail. These unique plates may have had multiple purposes: for regulation of body temperature, in courtship display, and as protection from predators. Scientists are still theorizing about the exact function of this unique feature. There is little doubt what the spikes on its tail were for: They would have been a powerful weapon against predators. Its front legs were considerably shorter than its hind legs, allowing it to angle its small head and short neck for optimal plant gathering. Stegasuarus's brain was too small to coordinate the movements of its entire body, and it had a nerve center in its hips—which was probably larger than its brain—that controlled the movement of the hindquarters.

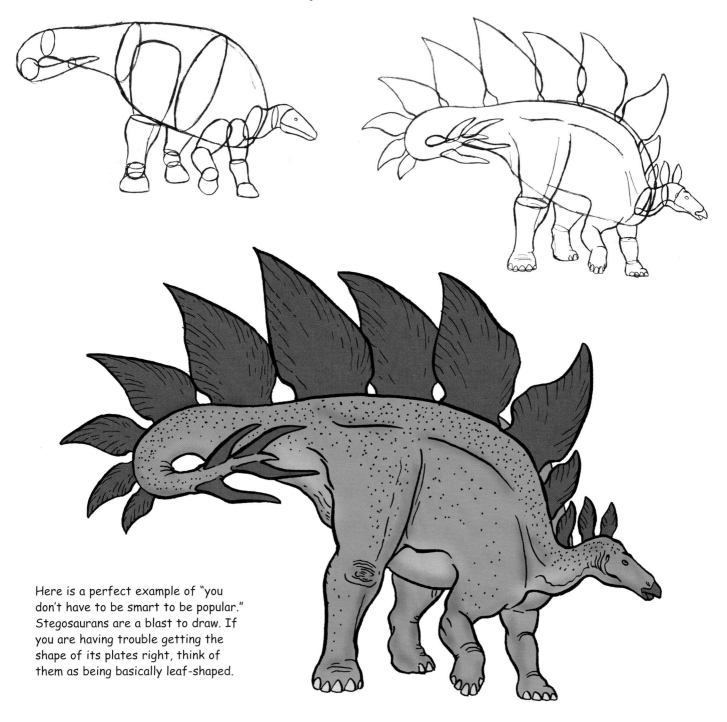

Here is a perfect example of "you don't have to be smart to be popular." Stegosaurans are a blast to draw. If you are having trouble getting the shape of its plates right, think of them as being basically leaf-shaped.

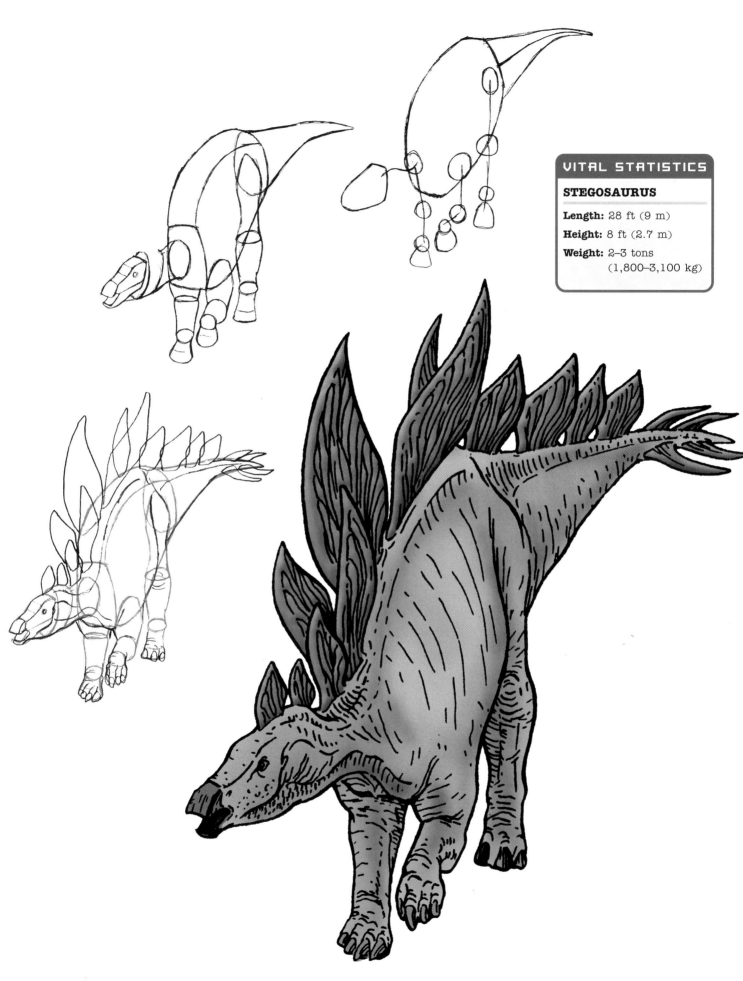

The ornithopods

The ornithopods are bird-hipped dinosaurs (ornithiscians), in the subgroup Cerapoda. They include one of the earliest discovered dinosaurs, Iguanodon, as well as the visually striking crested and duck-billed hadrosaurs. Several of these animals are noted for their spacious and bizarrely shaped sinus regions, which scientists theorize could have produced some unique mating calls. Sometimes these herbivores are thought of as the "cows" of the dinosaur kingdom since they did not hunt and kill other dinos, but preferred to graze. (As a result of their peaceful lifestyle, they were apparently easy prey for the carnivores.) Some had flat teeth, similar to the teeth of today's bovines (cattle); while others had horny, toothlesss beaks but, farther back in the jaw, densely packed "cheek" teeth. Ornithopods had blunt, short nails and short, hooflike feet. Ornithopods could walk or run on their long hind legs or graze on all fours, so they were quadrupeds and bipeds depending on the situation. Their intelligence ranks midway between the Sauropoda (least intelligent) and the Velociraptors (most intelligent).

Many of the shapes needed to draw ornithopods have already been covered in previous chapters. The overall body shape is similar to that of some theropods, but compressed at the sides, making it flatter. The skull is either long like a horse's or blunt like a sauropod's. The forelimbs are similar to those of the thyreophorans. All in all the ornithopods are a truly fascinating group of dinosaurs that, because of their nonviolent nature, do not get much of the Hollywood limelight.

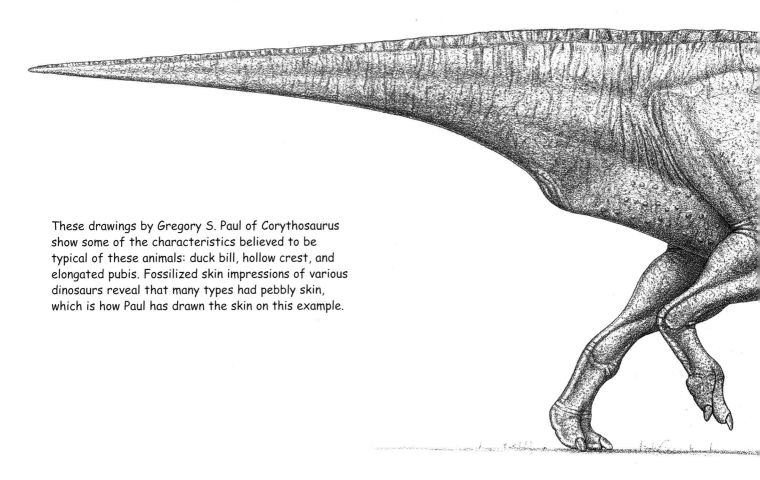

These drawings by Gregory S. Paul of Corythosaurus show some of the characteristics believed to be typical of these animals: duck bill, hollow crest, and elongated pubis. Fossilized skin impressions of various dinosaurs reveal that many types had pebbly skin, which is how Paul has drawn the skin on this example.

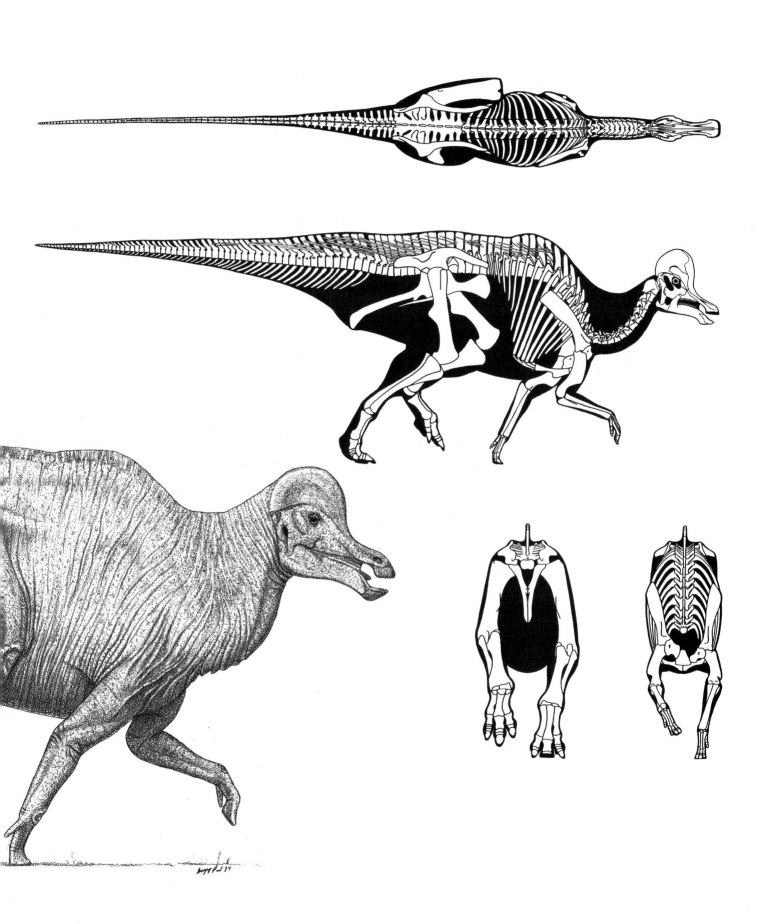

Anatotitan

Anatotitan ("giant duck") was nearly the size of a school bus, but was lightly built for an ornithopod. Anatotitan had long hind legs, short arms, a long, pointy tail, three hoofed toes, and hands with mitten-like coverings. A slow-moving dinosaur with no real means of defense, Anatotitan was a herd animal, and there may have been some safety in numbers.

VITAL STATISTICS

ANATOTITAN

Length: 33 ft (10 m)

Height: 8 ft (2.5 m)

Weight: 5 tons (7,300 kg)

Usually we think of the more aggressive dinosaurs when we sit down to draw, but here Brett Booth has given a gentle giant some special attention.

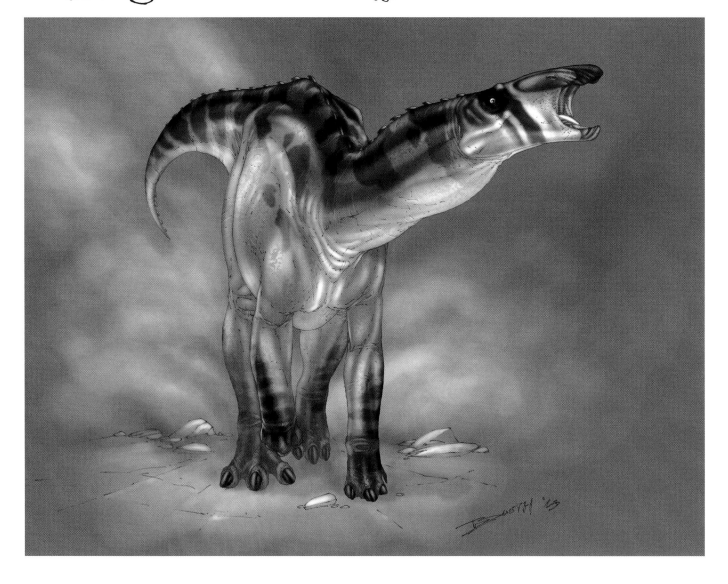

Corythosaurus

The hollow bony crest on top of Corythosaurus's long head was similar in appearance to the helmets worn by ancient Corinthian warriors (hence its name, which means "helmet lizard"). It was formed from the upper lip bone and the nasal bone. The nasal passage was constructed somewhat like a woodwind instrument, and scientists believe that crests of this type allowed the animals to make loud sounds or bellows, which may have been used in courtship. The crest also housed enlarged olfactory lobes, which indicates that Corythosaurus had a keen sense of smell. Its beak was toothless, but the cheeks were filled with hundreds of tiny teeth that were used to grind its vegetarian diet.

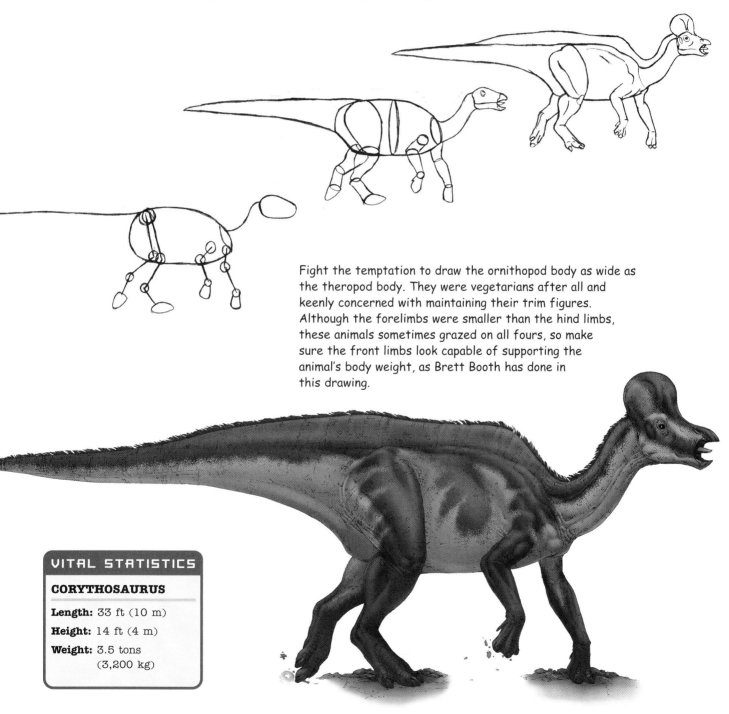

Fight the temptation to draw the ornithopod body as wide as the theropod body. They were vegetarians after all and keenly concerned with maintaining their trim figures. Although the forelimbs were smaller than the hind limbs, these animals sometimes grazed on all fours, so make sure the front limbs look capable of supporting the animal's body weight, as Brett Booth has done in this drawing.

VITAL STATISTICS

CORYTHOSAURUS

Length: 33 ft (10 m)

Height: 14 ft (4 m)

Weight: 3.5 tons (3,200 kg)

Edmontosaurus

The skeletal and muscular structures of Edmontosaurus ("Edmonton lizard") were very similar to those of Anatotitan, but instead of a crest, it had a series of bumps running down its neck, back, and tail. Like Anatotitan and Corythosaurus, it was probably mainly bipedal, but switched to all fours to graze on low-lying plants. (Alternatively, it could have been primarily a quadruped that sometimes balanced on its back legs to reach high vegetation.)

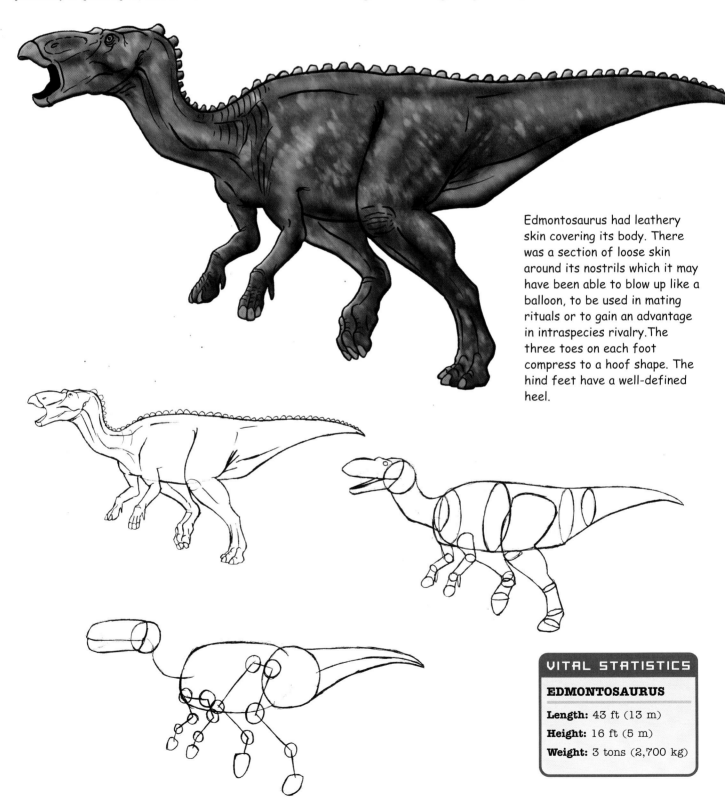

Edmontosaurus had leathery skin covering its body. There was a section of loose skin around its nostrils which it may have been able to blow up like a balloon, to be used in mating rituals or to gain an advantage in intraspecies rivalry. The three toes on each foot compress to a hoof shape. The hind feet have a well-defined heel.

VITAL STATISTICS

EDMONTOSAURUS

Length: 43 ft (13 m)
Height: 16 ft (5 m)
Weight: 3 tons (2,700 kg)

Hadrosaurus

Hadrosaurus ("big lizard"), a duck-billed plant-eater, had a toothless bill, many cheek teeth, and a pronounced bump above its nasal cavity. It had a bulky body and a stiff tail and probably most often moved about as a quadruped. It was the first duck-billed dinosaur fossil found in the United States, the the first relatively complete dinosaur skeleton found anywhere. In 1868 Hadrosaurus became the first dinosaur skeleton in the world to be mounted and displayed.

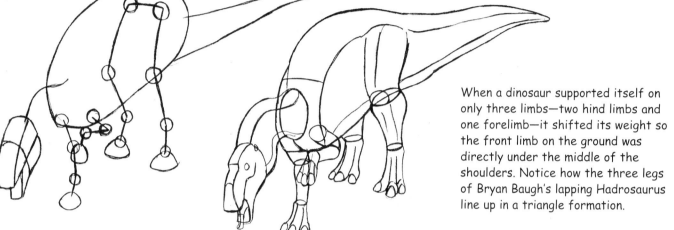

When a dinosaur supported itself on only three limbs—two hind limbs and one forelimb—it shifted its weight so the front limb on the ground was directly under the middle of the shoulders. Notice how the three legs of Bryan Baugh's lapping Hadrosaurus line up in a triangle formation.

Iguanodon

Iguanodon ("iguana tooth"), a plant-eating ornithopod with a huge toothless beak and cheek teeth as long as 2 inches (5 centimeters), was a bipedal plant-eater. It had well-developed arms longer than a human's, and its hands were outfitted with a formidable 2- to 6-inch-long (5- to 15-centimeter-long) thumb spike, making it one of the few ornithopods with something that could be used for defense.

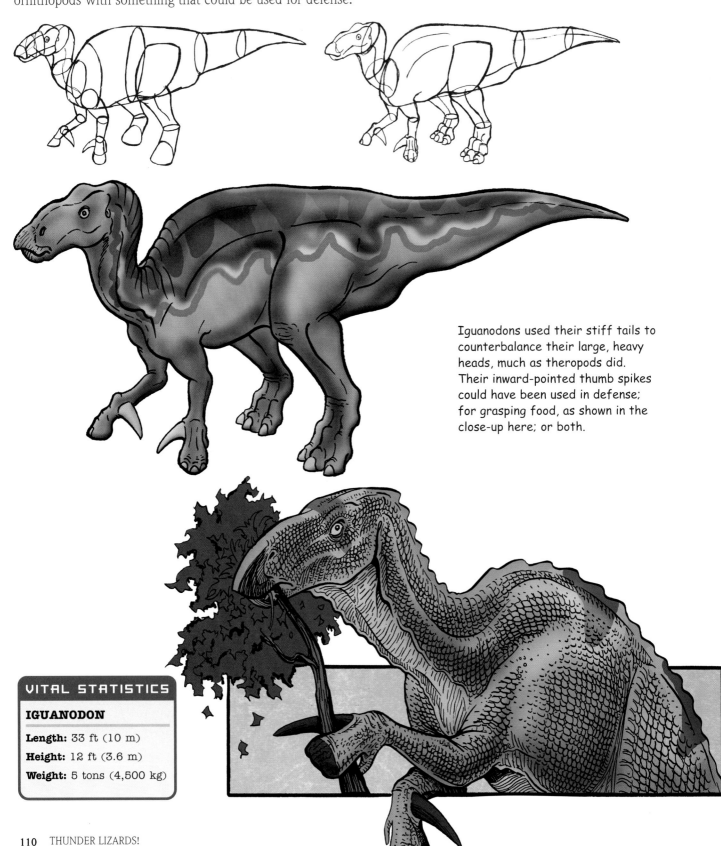

Iguanodons used their stiff tails to counterbalance their large, heavy heads, much as theropods did. Their inward-pointed thumb spikes could have been used in defense; for grasping food, as shown in the close-up here; or both.

VITAL STATISTICS

IGUANODON

Length: 33 ft (10 m)

Height: 12 ft (3.6 m)

Weight: 5 tons (4,500 kg)

Lambeosaurus

Lambeosaurus ("Lambe lizard") had a distinctive forward-facing, hollow, hatchet-shaped crest on top of its head, which may have enhanced its sense of smell (its nostrils went up through the crest). It may also have been used to produce loud sounds, or in courtship displays. Some lambeosaurans also had a large, backward-jutting spike, the function of which is unknown. It had a narrow snout, a wide, blunt beak, and pebbly skin.

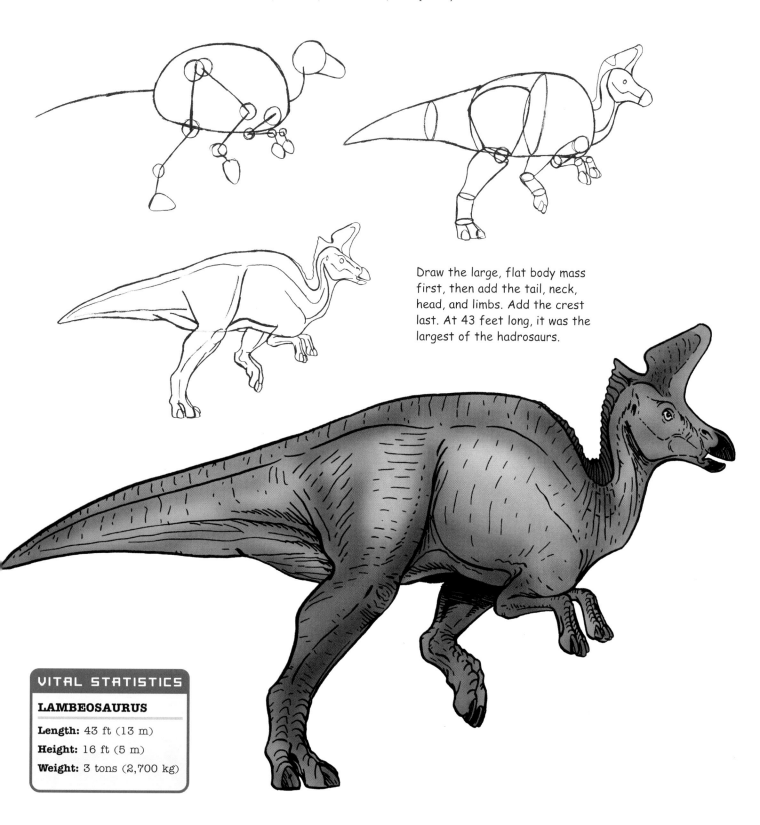

Draw the large, flat body mass first, then add the tail, neck, head, and limbs. Add the crest last. At 43 feet long, it was the largest of the hadrosaurs.

VITAL STATISTICS

LAMBEOSAURUS

Length: 43 ft (13 m)

Height: 16 ft (5 m)

Weight: 3 tons (2,700 kg)

Maiasaura

Maiasaura ("good mother lizard) was a fairly typical, mid-sized hadrosaur that was very similar to the lambeosaurans or corythosaurans. Instead of a large distinctive crest, however, it had a small, spiky crest between its eyes. Relatively recently, evidence has suggested that more than one group of dinosaurs toook care of their young, but maiasauran mothers *must* have done so because the bones of the babies, even past the hatchling stage, were too weak for them to be able to leave the nest.

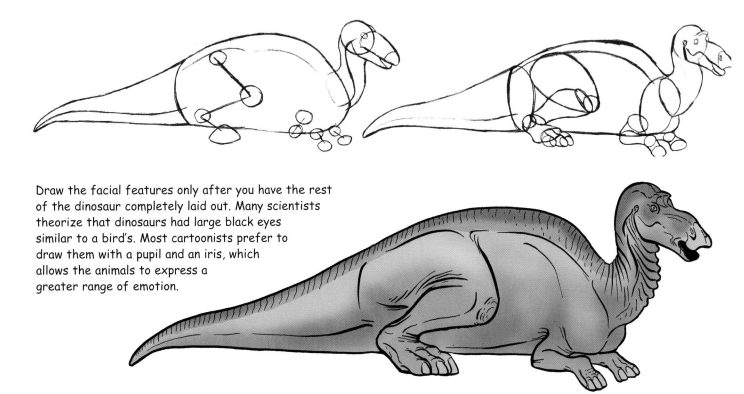

Draw the facial features only after you have the rest of the dinosaur completely laid out. Many scientists theorize that dinosaurs had large black eyes similar to a bird's. Most cartoonists prefer to draw them with a pupil and an iris, which allows the animals to express a greater range of emotion.

Good mother Maiasaura tending one of her hatchlings.

VITAL STATISTICS

MAIASAURA

Length: 30 ft (9 m)
Height: 6–8 ft (1.8–2.4 m)
Weight: 2–4 tons
　　　　　(1,800–3,600 kg)

Ouranosaurus

Ouranosaurus ("valiant lizard") was very similar to Iguanodon. Unlike Iguanodon, Ouranosaurus had spines sticking up along its back and tail that were covered with skin, forming a sail-like appendage. The primary purpose of the sail was probably temperature regulation, which would have been an advantage in the hot African environment in which it lived. During the hot parts of the day, the sail would help disperse body heat. In colder weather, the sail could collect heat from the the sun. The sail may also have been used in mating displays, as a way of gaining advantage in intraspecies rivalry, or to make Ouranosaurus appear larger to predators.

The exaggerated S-curve of the neck is established immediately. Notice how differently the head is constructed from the way the theropod heads, for example, are constructed. Remember the lunchbox that was used for the basic shape of T-rex's head? Here the head is built from a slender, slightly tapered cylinder.

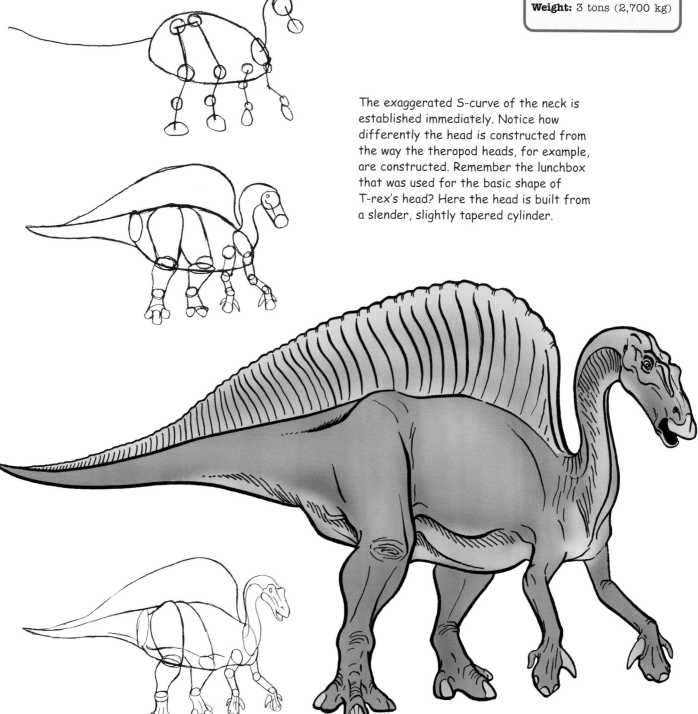

Parasaurolophus

Although many ornithopods had crests, Parasaurolophus deserved its name, which means "crested lizard," because it had the longest crest of any of the duck-billed dinosaurs. Some paleontologists believe it had a notch in its back, which may have helped it move its neck freely or been a sort of crest holder. This backward-leaning, hollow, bony crest was around 6 feet (1.8 meters) long and may have been used to produce a low-frequency sound, to enhance its sense of smell, and/or in courtship displays. Parasaurolophus's nostrils (at the end of its snout) went up through the crest and back down it, forming four tubes. It had a toothless, horny, spoon-shaped beak which was narrower and shorter than the beaks of the other hadrosaurs.

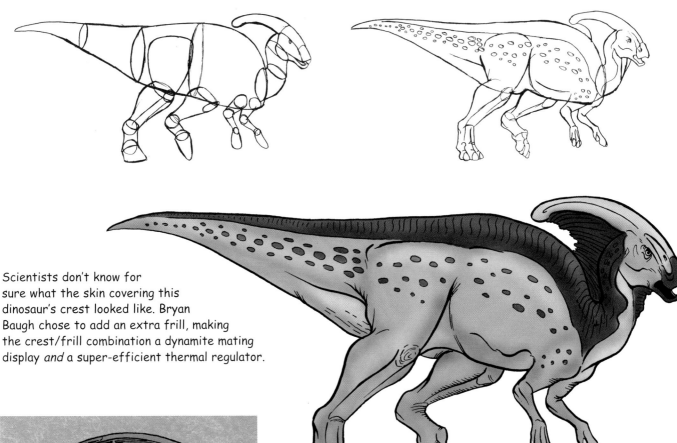

Scientists don't know for sure what the skin covering this dinosaur's crest looked like. Bryan Baugh chose to add an extra frill, making the crest/frill combination a dynamite mating display *and* a super-efficient thermal regulator.

It is a natural inclination to show dinosaurs as ferocious, but consider depicting the softer emotions. After all, this dinosaur weighed less than a female elephant, and elephants are often shown engaging in romantic courtship behavior.

VITAL STATISTICS

PARASAUROLOPHUS

Length: 40 ft (12 m)

Height: 8 ft (2.8 m) at the hips

Weight: 2 tons (1800 kg)

Tenontosaurus

Tenontosaurus ("sinew lizard"), a medium-size herbivore, was a member of the family of dinosaurs that includes Iguanodon, although it had a stance similar to that of some sauropods. Its tail was very long (in some specimens longer than the rest of its body!) compared to other members of its family, further distancing it from other Iguanodontia, and it had a relatively large skull and robust arms. The name Tenontosaurus references the fact that the tail was supported by a network of rods and tendons (sinews). The paleontologist who discovered Tenontosaurus (in 1970) also unearthed the bones of three Deinonychus right next to it. This discovery gave rise to speculation that the raptors were intelligent pack hunters, a hypothesis that has since been supported by many other findings.

Here is another great basic dinosaur model for beginners. When you don't have to deal with a lot of extra ornamentation, you can concentrate on the six key anatomical features: head (modified lunchbox), neck (curved cylinder), torso (football shape), pelvic girdle (sketched in ever so slightly in step 3, but clearly visible in the final drawing), limbs (cylinder for forelimbs, bottom half of bowling pin for upper hind limbs), and tail (tapering S-curve).

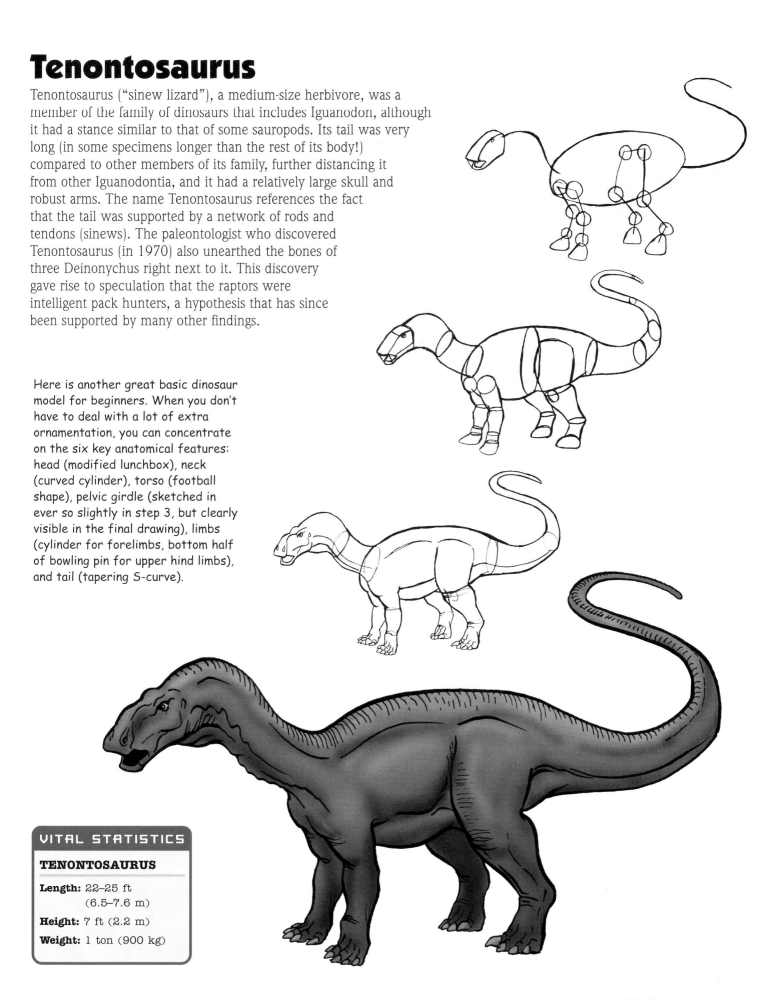

VITAL STATISTICS

TENONTOSAURUS

Length: 22–25 ft
(6.5–7.6 m)

Height: 7 ft (2.2 m)

Weight: 1 ton (900 kg)

The Fringed Lizards

The two major subgroups of the so-called "fringed," or "frilled," lizards (Marginocephalia) are the ceratopsians ("horned face") and the pachycephalosaurs ("thick-headed lizards").

The rhinoceros-like ceratopsians are easily distinguishable by the unique combination of horns and bony "frills" at the back of their skulls. The frills of some ceratopsians, such as Triceratops, were solid and heavy, and probably offered some defense against predators. The frills of others had an open framework of bone that was covered with a thick skin, which would have been almost useless defensively. This type may have simply been an ornament—to discourage predators or to attract mates—but recent evidence suggests that its major function was heat exchange. The edge of the frill on most horned ceratopsians had blunt, triangular spikes called epoccipitals. The front legs of ceratopsians were shorter than their hind legs, which put their heads in an excellent defensive position when they were on all fours. They had large, parrot-like, toothless beaks connected to powerful jawbones with immense crushing power.

Ceratopsians almost certainly traveled in herds; some fossil sites contain the bones of hundreds of the same species of Ceratopsia.

For more information on the pachycephalosaurs, see page 122.

Protoceratops

Protoceratops ("first horned face") was like a smaller version of Triceratops— 10 feet (3 meters) long as opposed to 28 feet (9 meters)—but without the horns. This drawing is by Jim Lawson.

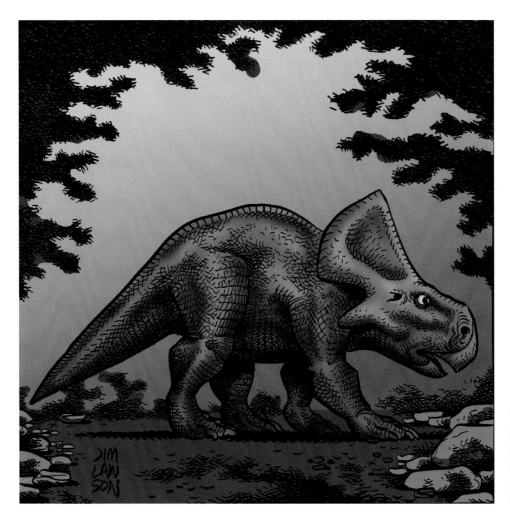

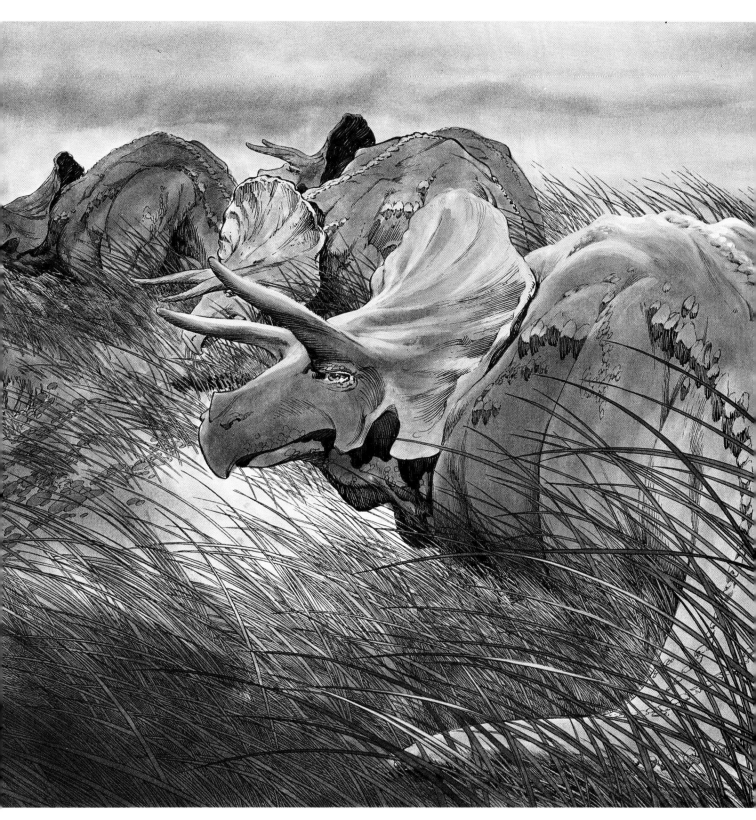

Part of the fun of dinosaurs as subjects is getting to draw an animal as large as an RV. Bernie Wrightson has portrayed this pack of Triceratops— animals that could be fiercely combative— quietly grazing, ready to ride out an approaching storm.

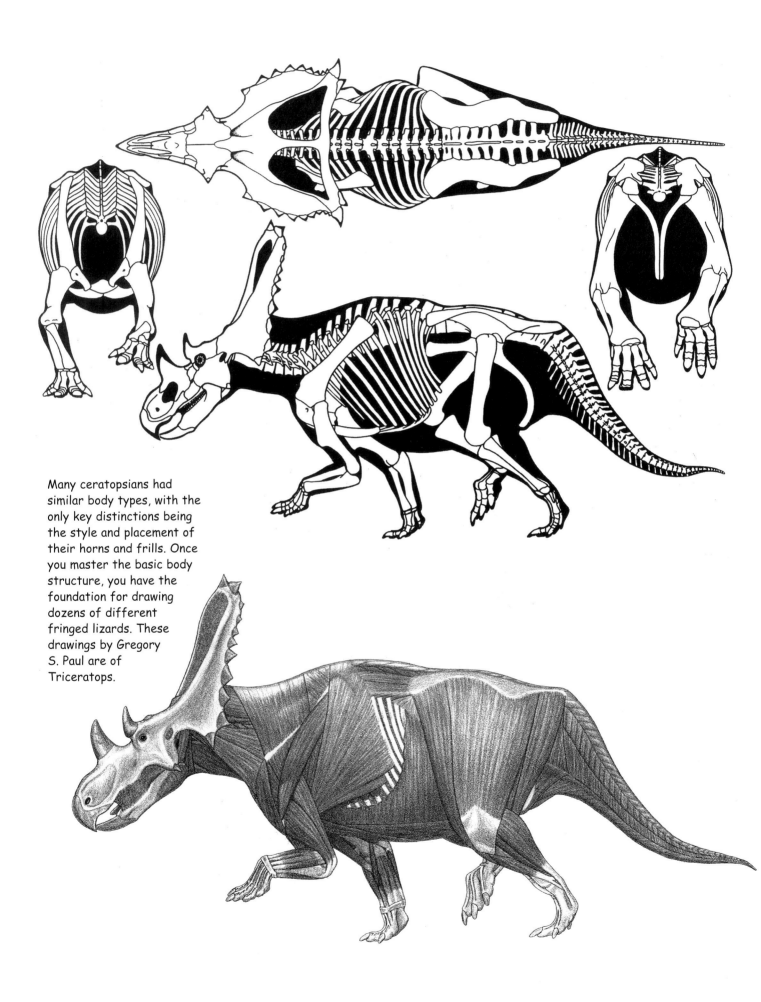

Many ceratopsians had similar body types, with the only key distinctions being the style and placement of their horns and frills. Once you master the basic body structure, you have the foundation for drawing dozens of different fringed lizards. These drawings by Gregory S. Paul are of Triceratops.

Centrosaurus

Centrosaurus ("spur lizard") was a stocky, powerful, rhinoceros-like dinosaur with one large forward-curving horn on its snout and smaller curved horns on its neck frill. The neck frill was not solid, but had two large holes on either side, which were protected by drooping tongues of skin. Centrosaurus is one of the best-documented dinosaurs in the world. A herd's worth of fossils have been found in Canada, where thousands of centrosaurans perished in a great flood.

VITAL STATISTICS

CENTROSAURUS

Length: 20 ft (6 m)

Height: 6.6 ft (2 m)

Weight: 3 tons (2,700 kg)

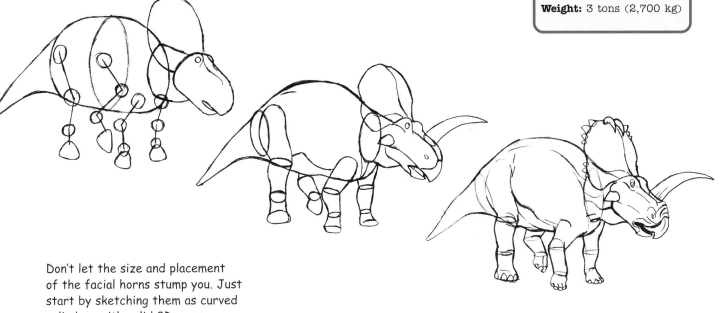

Don't let the size and placement of the facial horns stump you. Just start by sketching them as curved cylinders with solid 3D mass.

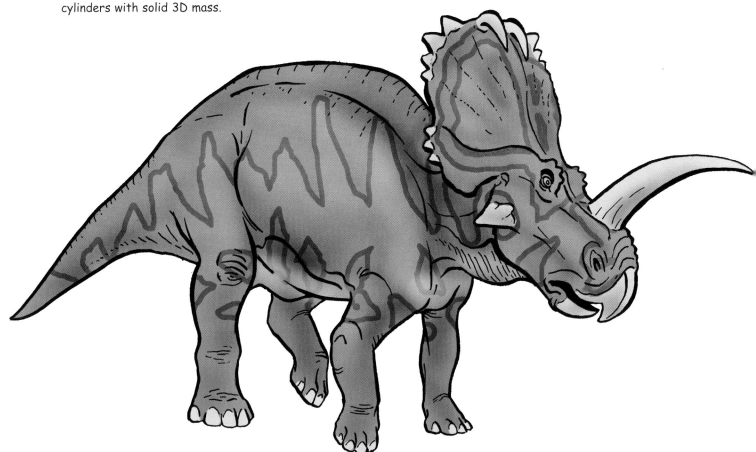

Chasmosaurus

Chasmosaurus ("chasm lizard") had many features in common with Centrosaurus: It was a frilled, rhinoceros-like dinosaur. The three backward-facing horns on its face (one short, wide horn just up from its beak and two above its eyes) would have been useful for defensive purposes only. Its frill was similar to that of Centrosaurus, but it was larger, as were the two holes on either side. Without the holes, the frill would have been so heavy that the animal would not have been able to lift its head. It had a large skull, four sturdy legs with hooflike claws, a bulky body, and a short, pointed tail.

CHASMOSAURUS

Length: 16 ft (5 m)

Height: 10 ft (3 m)

Weight: 3 tons (2,700 kg)

A good reference for the shape and size of Chasmosaurus is the modern rhinoceros. (The white rhino weighs 2.5 tons, or 2,300 kilograms.)

Einiosaurus

Einiosaurus had a thick, forward-curving horn over its beak and two backward-curving horns protruding from its hard neck frill. Its body type—large skull, four sturdy legs with hooflike claws, bulky body, and short pointed tail—was very like that of Triceratops—but it was at least 8 feet (2.4 meters) shorter and it was much lighter. Einiosaurus means "buffalo lizard" in the language of the Black Feet tribe on whose land the fossils were first found.

VITAL STATISTICS

EINIOSAURUS

Length: 20 ft (6 m)

Height: 6.6 ft (2 m) at the hips

Weight: 2 tons (1,800 kg)

Think of Einiosaurus's curved front horn as a can opener and the two horns protruding from the frill as a bottle opener.

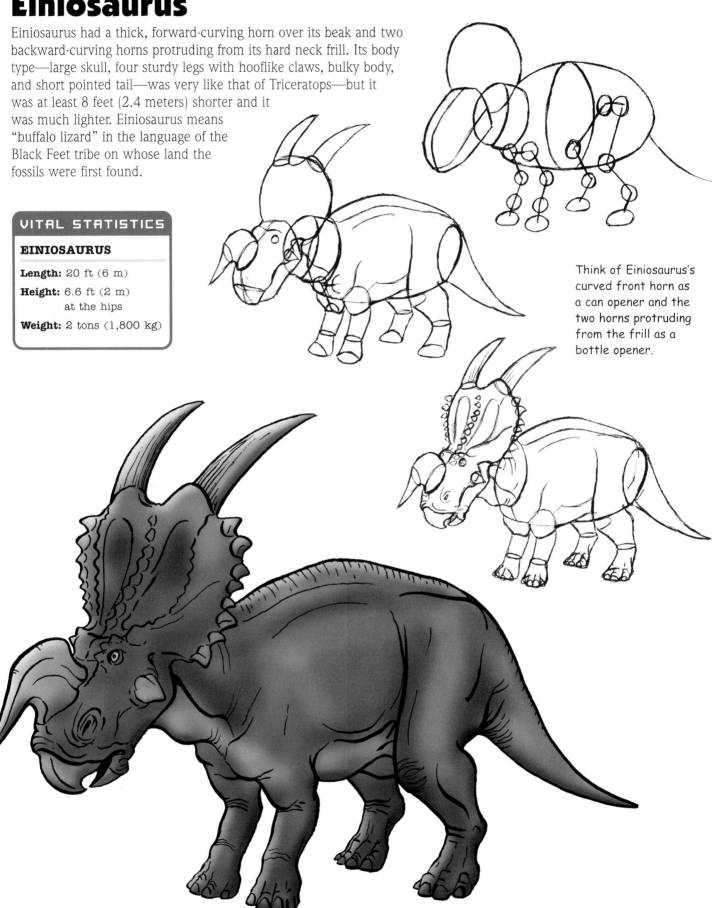

Pachycephalosaurus

Pachycephalosaurs had massively thick skulls (9 inches, or 23 centimeters, thick), which gave their heads a domelike appearance, and some also had small bone nodules around the base of the dome and at the end of the snout. Their spines show strengthening, which would have been useful for absorbing shock during head butting, and when pachycephalosaurs were first discovered, it was assumed that they used their thick skulls as battering rams, for straight-on head butting. Later, this idea was modified, and scientists theorized that it probably delivered glancing blows or strong side pushes to protect its head and neck from damage.

In June of 2004, paleontologists at the University of California suggested that pachycephalosaurs did not use their domes for head butting at all; rather, the primary function of the domes was as ornament, like the bony crests of some birds, such as the toucan. What is certain is that these animals were bipedal herbivores with five fingers and three toes.

This drawing was done before scientists suggested that Pachycephalosaurus did not use its head as a battering ram. But since what we know about dinosaurs changes from year to year and even from month to month, down the road the battering-ram hypothesis may yet prove to be true.

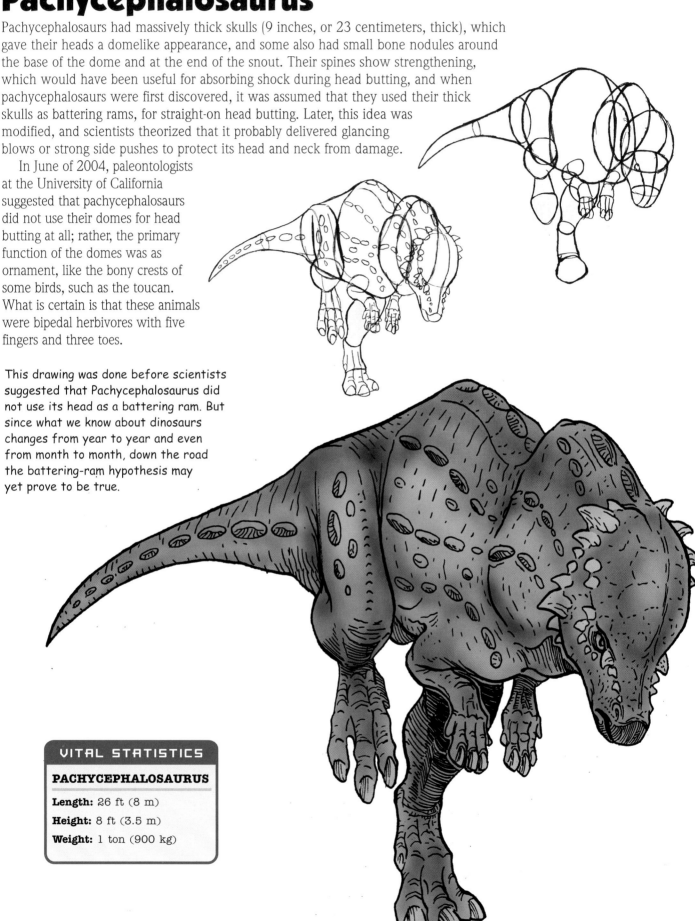

VITAL STATISTICS

PACHYCEPHALOSAURUS

Length: 26 ft (8 m)

Height: 8 ft (3.5 m)

Weight: 1 ton (900 kg)

Stygimoloch

Stygimoloch ("demon from the river Styx") was a thick-skulled biped. It was very similar to Pachycephalosaurus, but some of its head spikes were much longer than Pachy's. The largest were up to 4 inches (10 centimeters) long. It had teeth suitable for chewing up vegetation in the back of its mouth, but the front of the mouth had sharp teeth that could tear and chew meat, which has led scientists to believe that it was an omnivore, meaning that it ate both meat and plants.

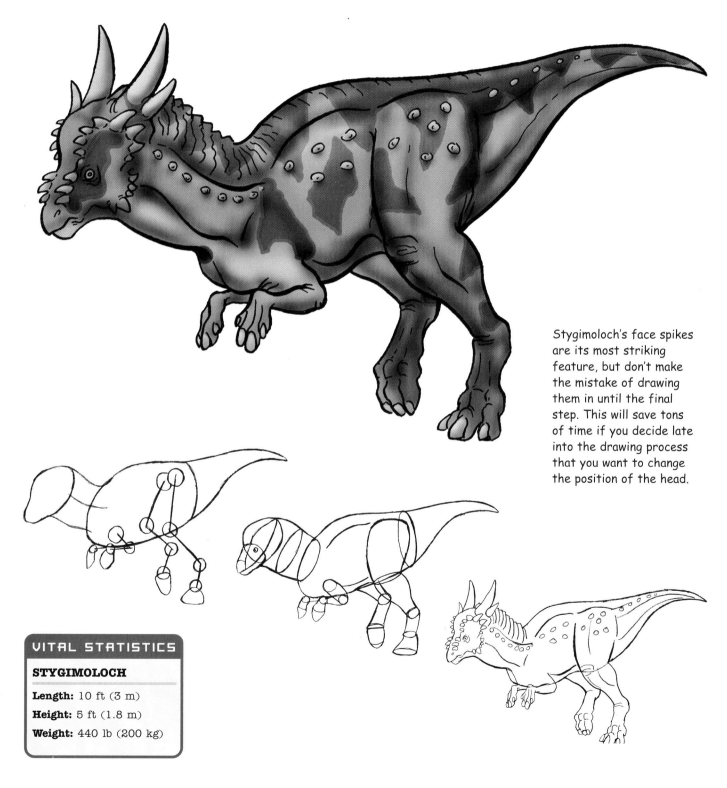

Stygimoloch's face spikes are its most striking feature, but don't make the mistake of drawing them in until the final step. This will save tons of time if you decide late into the drawing process that you want to change the position of the head.

VITAL STATISTICS

STYGIMOLOCH

Length: 10 ft (3 m)

Height: 5 ft (1.8 m)

Weight: 440 lb (200 kg)

Styracosaurus

Styracosaurus ("spiked lizard") was a plant-eater with a large skull, a neck frill with six long spiked horns, four sturdy legs with hooflike claws, a bulky body, and a short pointed tail. It also had an upward-pointing horn on its nose that was 2 feet (60 centimeters) long and two small horns on its brow above its eyes. Like most ceratopsians Styracosaurus had a beak designed to chew up the tough leaves of low-growing plants.

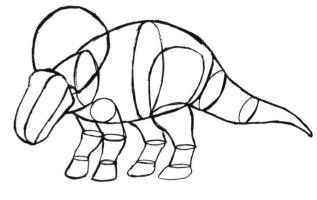

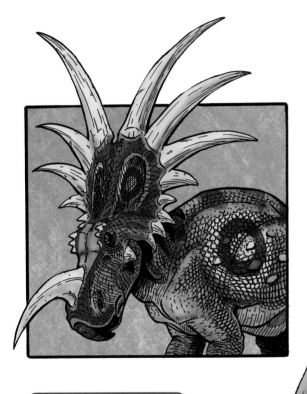

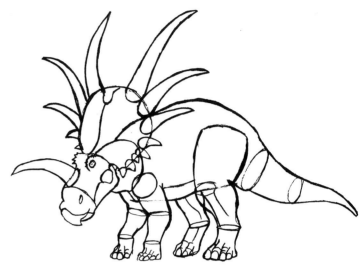

What a fantastic animal! Yet the formidable horns are still just basic cylinders. As long as the bases of the horns are solidly connected to the frill, and you have the correct shape of the curves, your Styracosaurus head will come out right every time.

VITAL STATISTICS

STYRACOSAURUS

Length: 18 ft (5.5 m)

Height: 6 ft (2 m)

Weight: 3 tons (3,000 kg)

Triceratops

Triceratops, after T-rex, is the world's second most popular dinosaur. Triceratops ("three horn face"), as its name suggests, had three prominent horns on its face: one central horn just back from its beak and two large brow horns that were 3 to 4 feet (1 to 1.2 meters) long. The central horn probably had multiple uses: defense, offense, and as a way to butt into and topple tall trees to get at the tender top branches. Its head, which was up to 10 feet (3 meters) long, is the largest of any land animal that ever lived, and was capable of holding up Triceratops's heavy frill, which, unlike that of most of the fringed lizards, was solid. The heaviest of the larger ceratopsians, it would have been a formidable adversary. Its main predator was probably T-rex.

When Triceratops bones were first found, in Colorado in 1887, they were thought to be the bones of a huge buffalo. The size and shape of the nose horn of Triceratops varied from animal to animal, and so you've a lot of leeway when laying out your drawing.

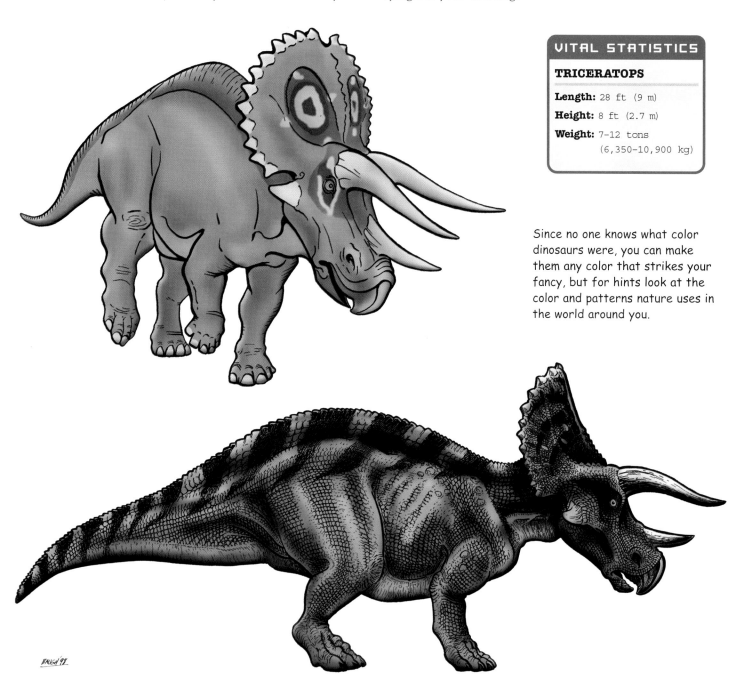

VITAL STATISTICS

TRICERATOPS

Length: 28 ft (9 m)

Height: 8 ft (2.7 m)

Weight: 7-12 tons
(6,350-10,900 kg)

Since no one knows what color dinosaurs were, you can make them any color that strikes your fancy, but for hints look at the color and patterns nature uses in the world around you.

Many ceratopsian horns and skulls (including the frills) have been found damaged or scarred, indicating that these creatures sparred and locked horns as they fought over territory and mates. This Triceratops is ready for battle.

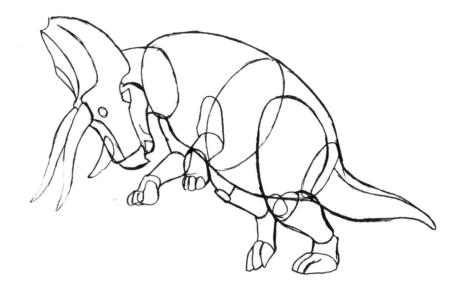

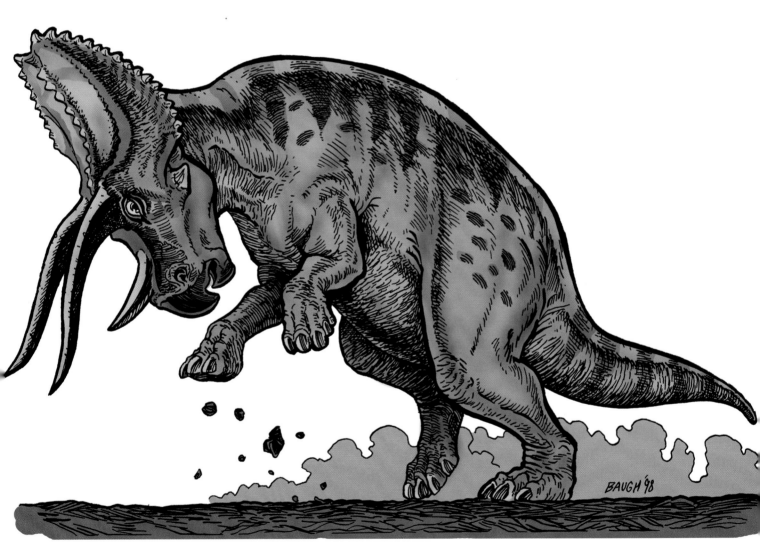

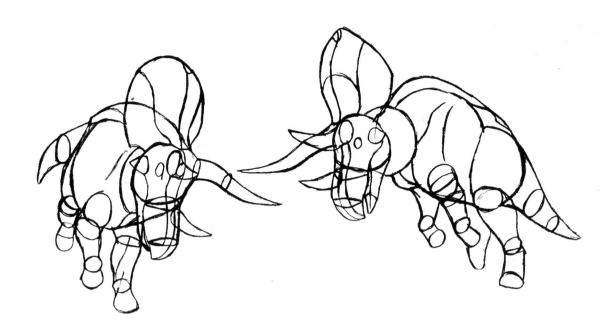

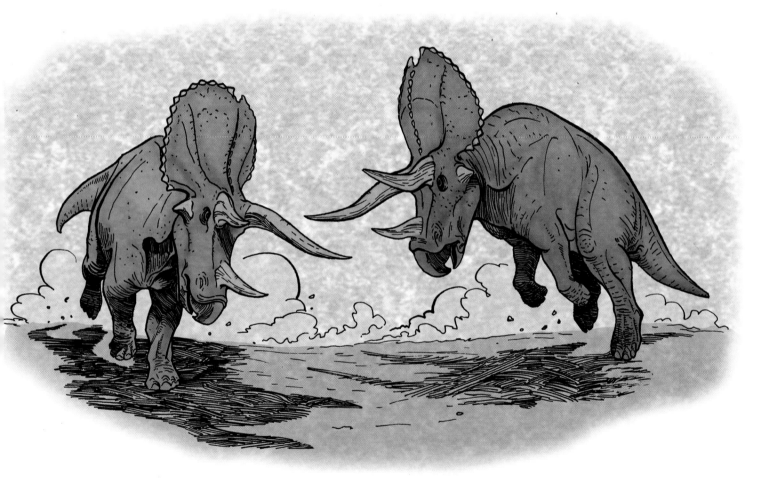

These two Triceratops are in serious combat.

Pterosaurs

Pterosaurs ("winged lizards") are not technically dinosaurs, but what fun is a prehistoric sky without some flying reptiles to fill it? Some animals have the ability to glide, like the flying fox or the gliding lizard, but pterosaurs were actual flyers, like bats and birds. They had a wing membrane attached to the lengthy fourth finger on their hands. They were probably warm-blooded, and some of them had a covering of fur on their bodies for thermal regulation. Currently, Pterosauria is divided into two major subgroups—Rhamphorhynchoidea ("prow beak") and Pterodactyloidea ("wing finger")—although the classification could change at any time. All members of Pterodactyloidea are pterodactyloids.

Pterosaurs were superbly adapted for flight: their bones were hollow, to reduce weight; many bones were fused together, providing a strong protective framework for muscles and organs; and the pelvic vertebrae were fused with the pelvic bones, creating a structure that absorbed shock during landing.

Different groups had different diets. Pterosaurs with long, pointed beaks ate fish; species with heavy jaws and peglike teeth were probably insect-eaters. One group, with long, thin, closely spaced teeth, may have strained seawater in order to dine on plankton, like the modern flamingo.

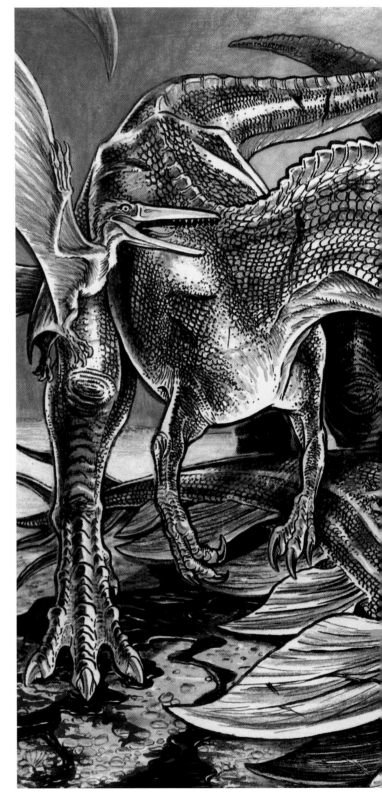

It is believed that pterosaurs scavenged prey from kills brought down by much larger hunters, and even ate alongside ferocious theropods like these allosaurs.

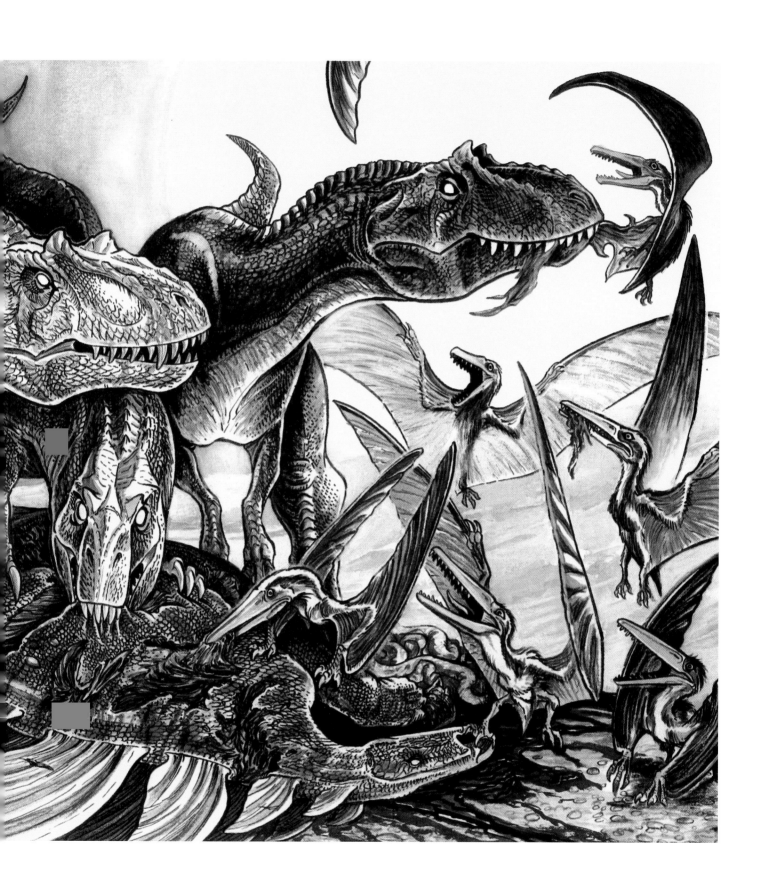

Dimorphodon

The jaws of Dimorphodon ("two-form tooth") resembled the beak of the modern-day puffin, but were full of sharp teeth. Dimorphodon had a short neck and a diamond-shaped flap of skin at the end of its tail. Dimorphodon, with its large skull and long tail, is usually grouped with the rhamphorhynchoids.

Unlike most other pterosaurs, Dimorphodon's upper leg bones sprawled out sideways from the hips, giving it a clumsy flight pattern, similar to that of a bat. This has led many scientists to speculate that Dimorphodon spent much of its time hanging upside down from branches or cliff faces before dropping into flight.

Draw the head and body with the wings outstretched. Think of the two wings as a single unit with a joint in the middle. This will help you achieve symmetry in form and function. Finish by refining the secondary features like the tail and claws.

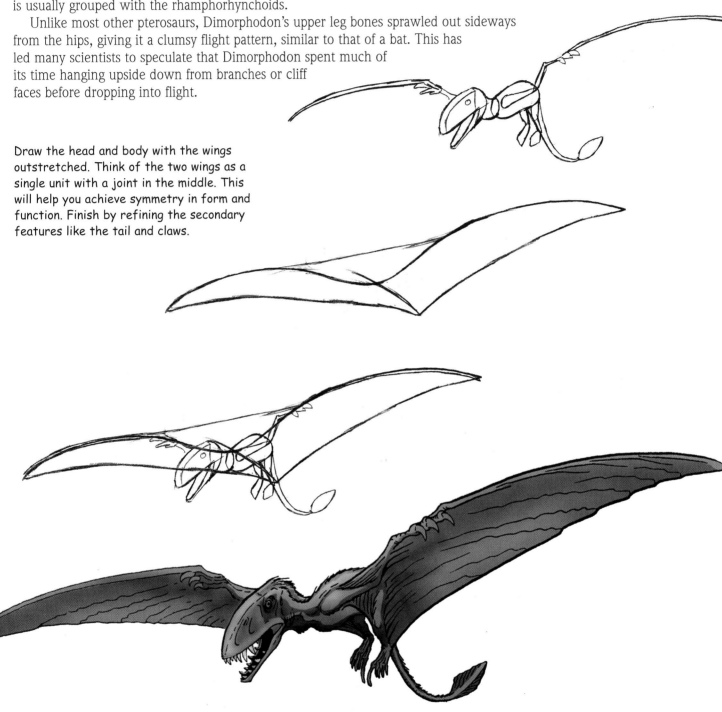

Dsungaripterus

Dsungaripterus was a lightly framed pterosaur with an unusual bony crest running along its pointed snout. The name comes from the Chinese for "Junggar-wing"; many Dsungaripterus fossils have been found in China's Junggar Basin. It had long, narrow, curved jaws full of flat teeth for eating shellfish. The large crest on its head may have acted as a rudder when Dsungaripterus was flying and/or may have been a mating display. Its keen eyesight and long, curved neck was perfectly designed for plucking fish and crustaceans from the oceans or scavenging prey on land. Dsungaripterus wings were covered by a thin, elastic, leathery membrane. The wing membrane stretched between its body, the top of its legs, and its elongated fourth fingers.

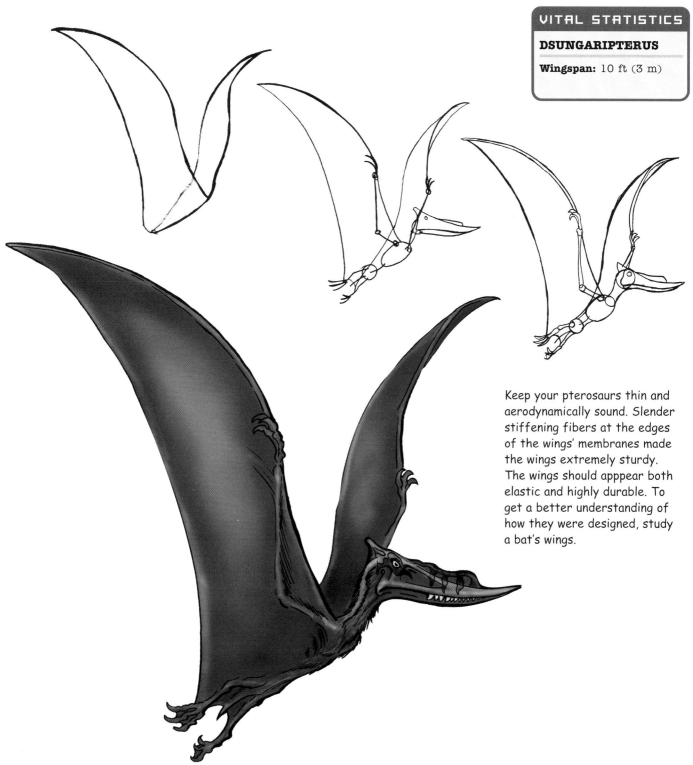

VITAL STATISTICS

DSUNGARIPTERUS

Wingspan: 10 ft (3 m)

Keep your pterosaurs thin and aerodynamically sound. Slender stiffening fibers at the edges of the wings' membranes made the wings extremely sturdy. The wings should apppear both elastic and highly durable. To get a better understanding of how they were designed, study a bat's wings.

Ornithocheirus

With its tremendous wingspan, and a total wing-membrane area of 328 square feet (100 square meters), Ornithocheirus ("bird hand") was the size of a small airplane. Despite its size, because its bones were hollow, it probably weighed less than a human. It had a long, slender skull, a bony crest on its snout, and long, tooth-filled jaws. Its wings were made of elastic skin stretched between its body, the tops of its legs, and its elongated fourth fingers. The other three fingers on both hands were tipped with claws. Ornithocheirus was an expert at riding rising air currents called "thermals," and it could glide hundreds of miles with only a few flaps of its wings!

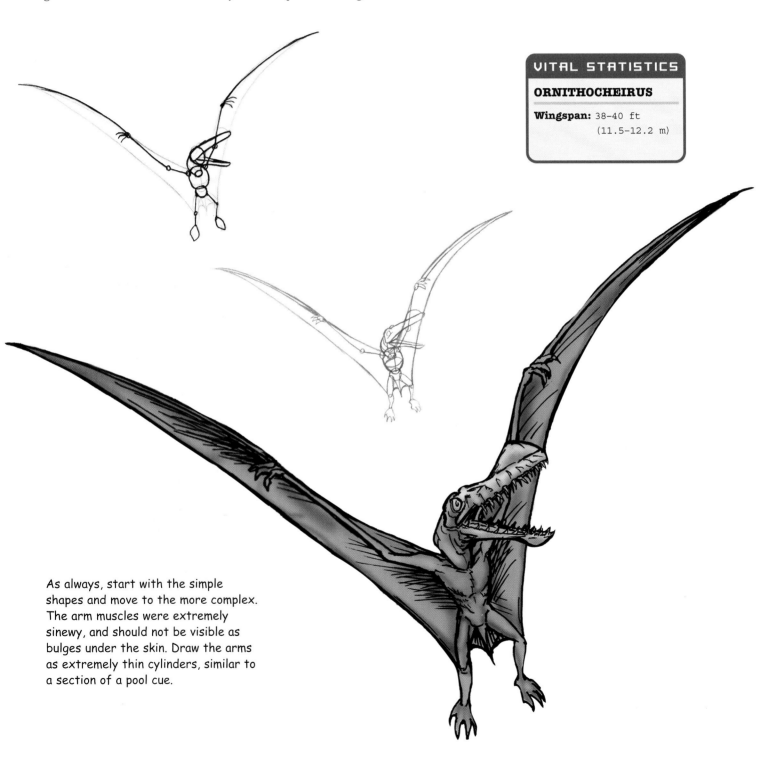

VITAL STATISTICS

ORNITHOCHEIRUS

Wingspan: 38–40 ft
(11.5–12.2 m)

As always, start with the simple shapes and move to the more complex. The arm muscles were extremely sinewy, and should not be visible as bulges under the skin. Draw the arms as extremely thin cylinders, similar to a section of a pool cue.

Pteranodon

Pteranodon ("wing without tooth") was a large crested pterosaur that, despite its size, probably weighed only about 25 pounds. Its bones were hollow, and many of them have holes, which means that the respiratory tissue from the lungs extended into the bones, as in birds, and would have acted as a cooling system during flight. The crest could have been used both as a rudder and as a display attracting mates. Pteranodon had a short tail and probably some body fur. Like the wings of Ornithocheirus, Pteranodon wings were covered by an elastic leathery membrane stretched between its body, the top of its legs, and its elongated fourth fingers. The rest of the fingers on its hands all had claws.

VITAL STATISTICS

PTERANODON

Wingspan: 30 ft (9 m)

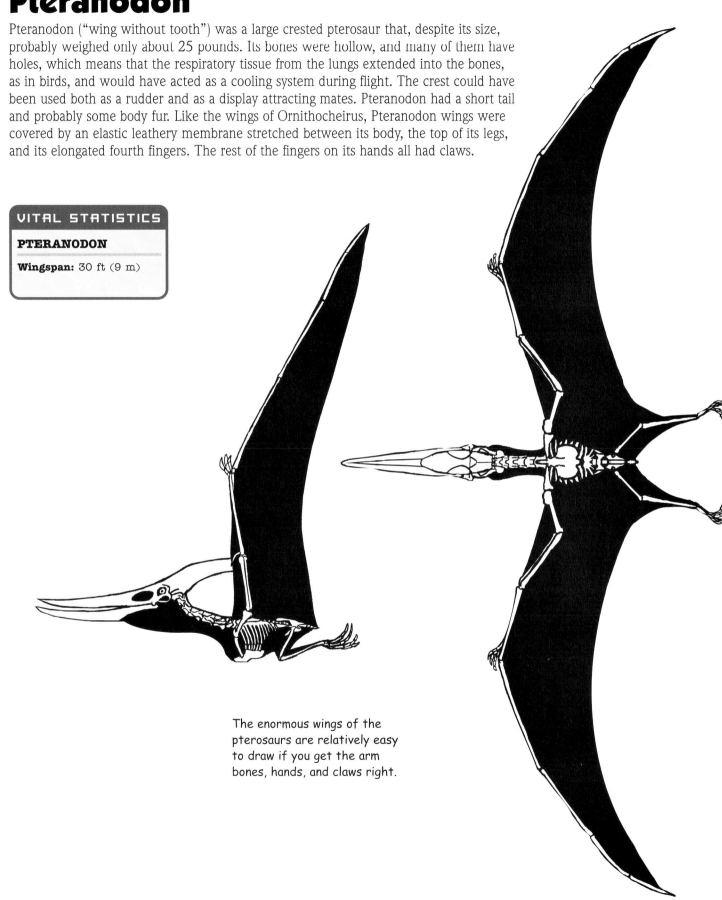

The enormous wings of the pterosaurs are relatively easy to draw if you get the arm bones, hands, and claws right.

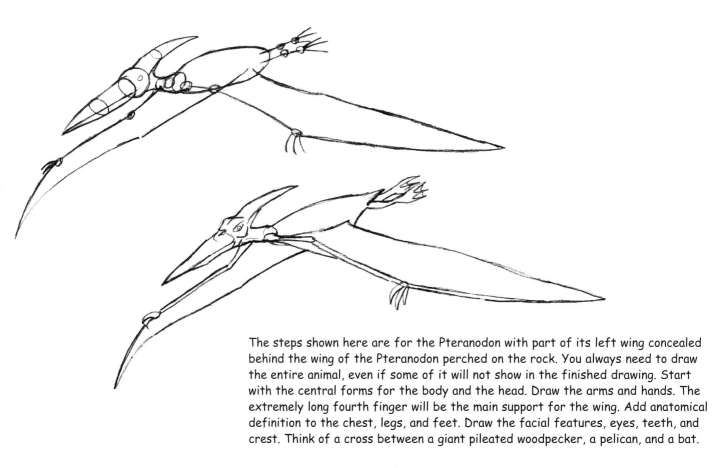

The steps shown here are for the Pteranodon with part of its left wing concealed behind the wing of the Pteranodon perched on the rock. You always need to draw the entire animal, even if some of it will not show in the finished drawing. Start with the central forms for the body and the head. Draw the arms and hands. The extremely long fourth finger will be the main support for the wing. Add anatomical definition to the chest, legs, and feet. Draw the facial features, eyes, teeth, and crest. Think of a cross between a giant pileated woodpecker, a pelican, and a bat.

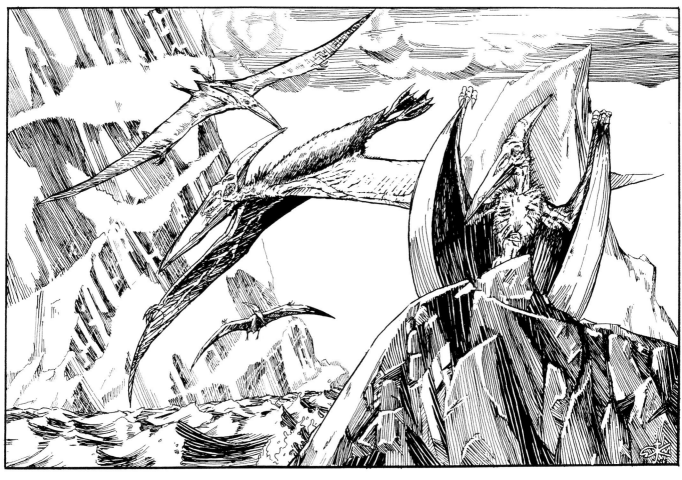

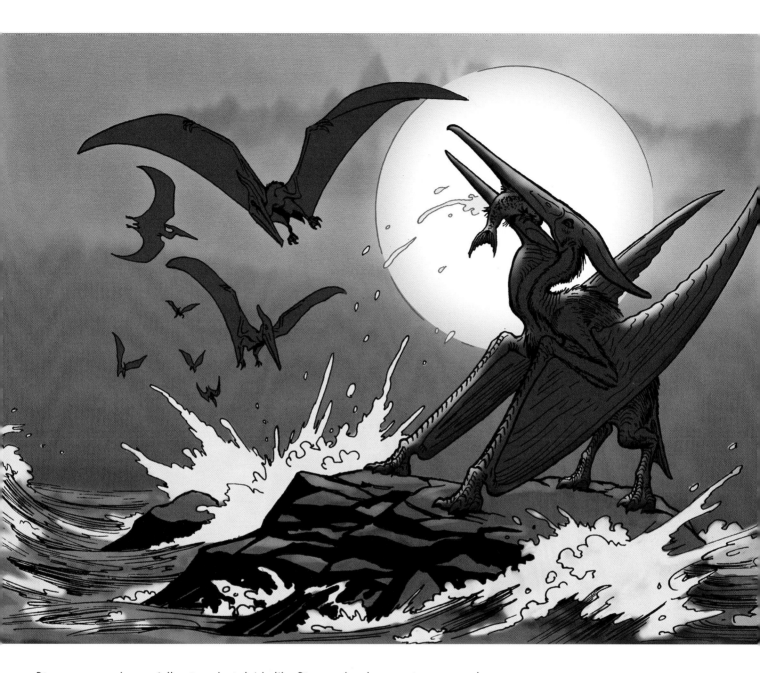

Pterosaurs, and especially pteradactyloids like Pteranodon, have a strong appeal to storytellers, and are featured in numerous works of fiction. Pteranodon's lengthy screen credits include Disney's *Fantasia* (1940); Spielberg's *The Land Before Time* (1998); and Disney's *Dinosaur* (2000). A Pteranodon appears in the last scene of *The Lost World*, and part of the logo for *Jurassic Park III* shows the huge shadow of a crested Pteranodon hovering over a Spinosaur skeleton. This drawing captures their exotic appeal.

Pterodactyl

The first fossilized flying reptile found was named Pterodactyl ("flight finger"), and for years scientists used Pterodactyl as a generic term for all flying reptiles; the terminology used today is *pterodactyloid* for members of groups such as *Pteranodon* and the many subgroups of *Pterodactylus*. The pterodactyloids had long, curved necks, long, uncrested heads, long jaws with numerous small teeth, small bodies, and small, pointed tails. As with Ornithocheirus and Pteranodon, and many other pterosaurs, its wings were made of elastic skin stretched between its body, the tops of its legs, and its hugely elongated fourth fingers.

VITAL STATISTICS

PTERODACTYL

Wingspan: 3 ft (1 m)

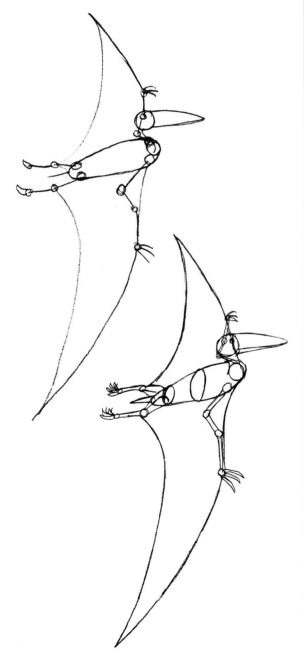

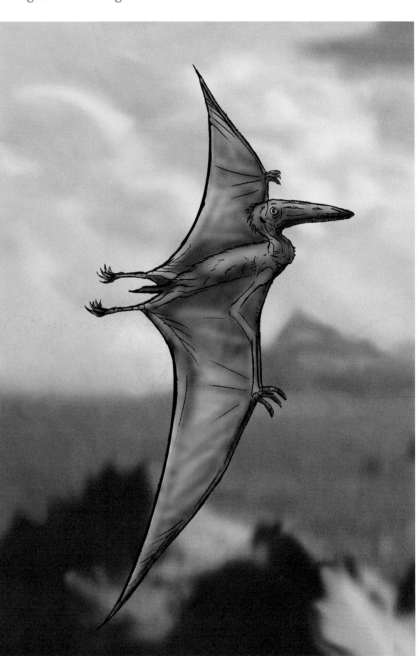

Many pterodactyloids spent a good portion of their air time gliding. It takes practice to draw these flying lizards so they look capable of smooth gliding, but it's worth the effort. A correctly rendered pterodactyloid—or, even better, a group of them—can be spectacular.

Archaeopteryx

Archaeopteryx ("ancient wing") was not a pterosaur; it is widely thought of as an ancient bird, but the lines between bird and reptile are blurred. It is believed to have been about the size and weight of a crow. It had feathers on its forelimbs; a long, bony, reptilian tail covered with feathers; a tooth-filled jaw rather than a beak; and two clawed fingers on each wing. Its skeleton is similar to the skeletons of small dinosaurs. There are many unanswered questions about this animal. For instance, we still don't know whether it flew at all—and if it flew, how.

VITAL STATISTICS

ARCHAEOPTERYX

Wingspan: 2 ft (61 cm)

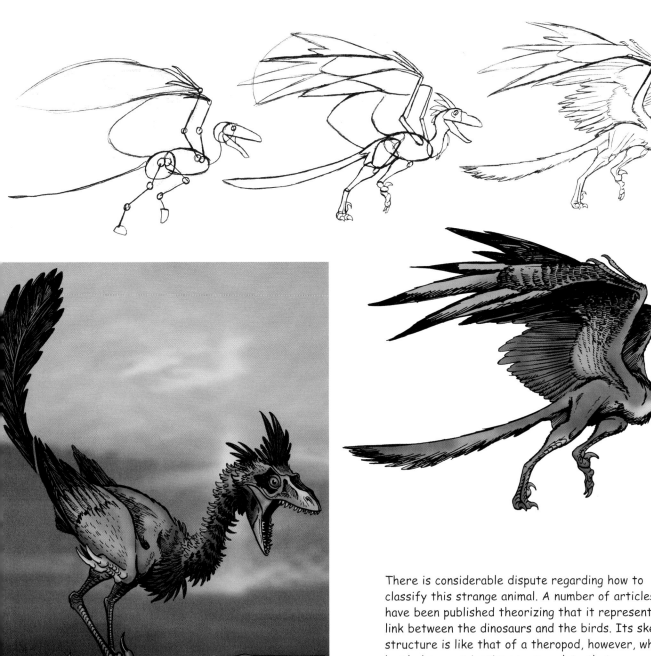

There is considerable dispute regarding how to classify this strange animal. A number of articles have been published theorizing that it represents a link between the dinosaurs and the birds. Its skeletal structure is like that of a theropod, however, which has led some scientists to speculate that Archaeopteryx was a true dinosaur. Whatever group it belongs to, we're pretty sure it ate fish.

Appendix
13 Skeletons by Scott Hartman

All of the images in this section were drawn by Scott Hartman. By now you should be able to point out some of the distinguishing characteristics of these creatures, for example, whether the pelvic region is typical of the saurischians or the ornithischians.

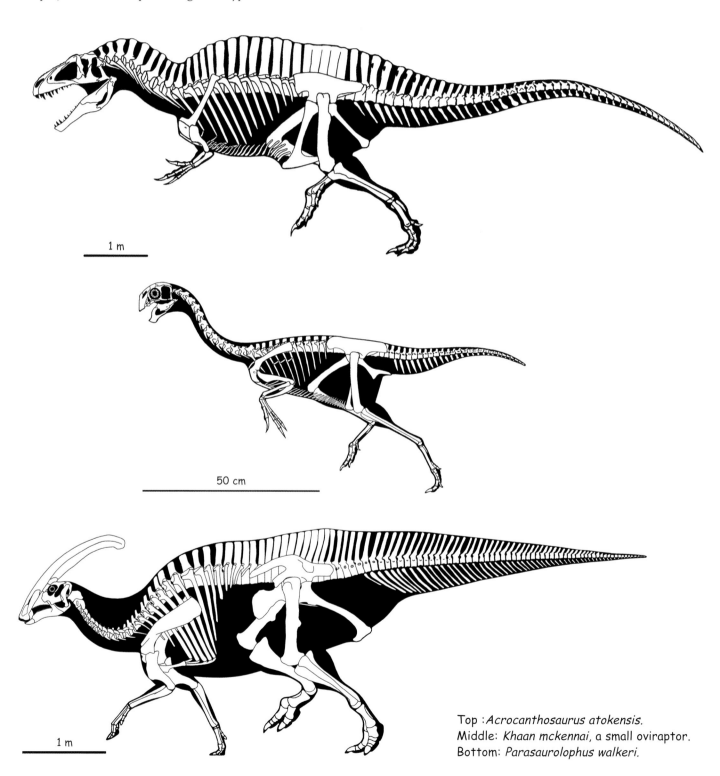

1 m

50 cm

1 m

Top : *Acrocanthosaurus atokensis.*
Middle: *Khaan mckennai,* a small oviraptor.
Bottom: *Parasaurolophus walkeri.*

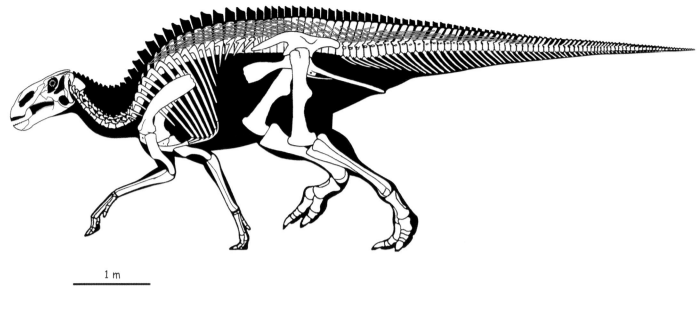

1 m

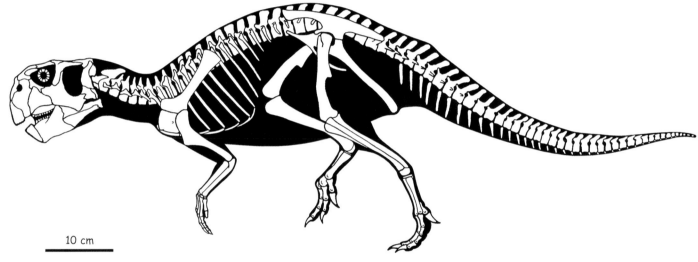

10 cm

Top: *Brachylophosaurus goodwini.*
Middle: *Psittacosaurus neimongoliensis*, a small
[about 4 feet (1.2 meters) tall] ceratopsian.
Bottom: *Sapeornis chaoyangensis. Sapeornis
chaoyangensis* is classified as an avian (bird)
rather than a dinosaur, but its skeletal
structure, like that of Archaeopteryx (next
page), has many similarities with the skeletal
structure of a theropod.

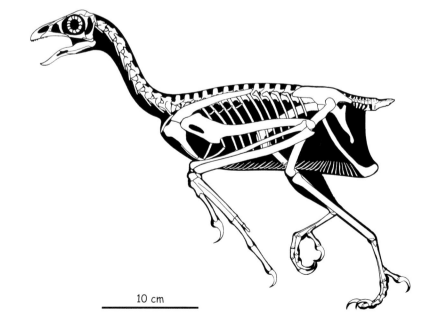

10 cm

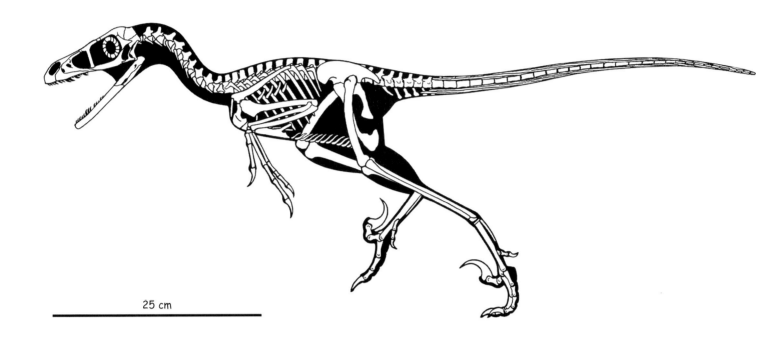

25 cm

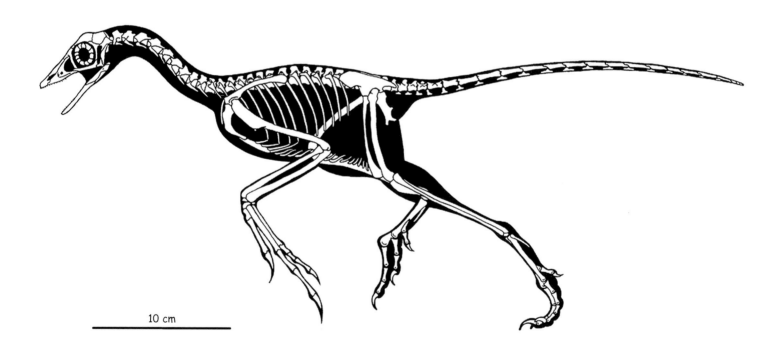

10 cm

Top: *Bambiraptor feinbergi*; bottom, *Archaeopteryx "bavarica."* As the text points out, Archaeopteryx is not technically a dinosaur, but there are some striking similarities between the theropod skeleton and that of Archaeopteryx.

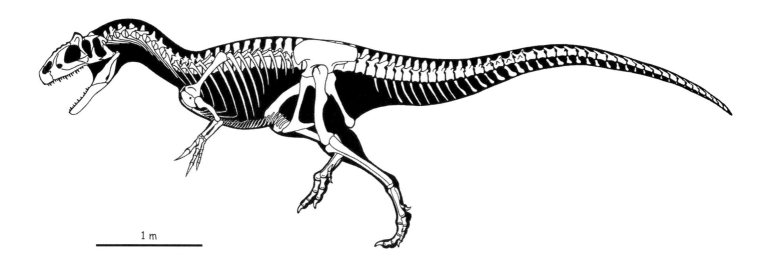

1 m

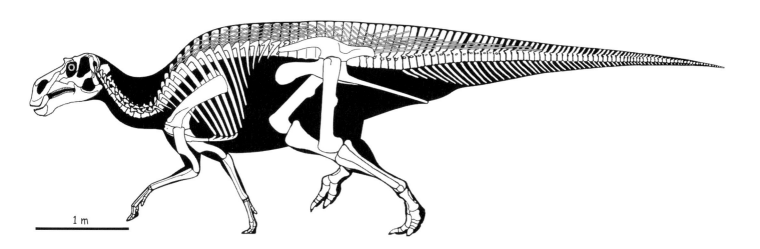

1 m

Top: *Allosaurus "jimmadseni"*; bottom: *Maiasaura pebblesorum*. These two dinosaurs, which were not far apart in length and weighed about the same, have vastly different skeletal structures.

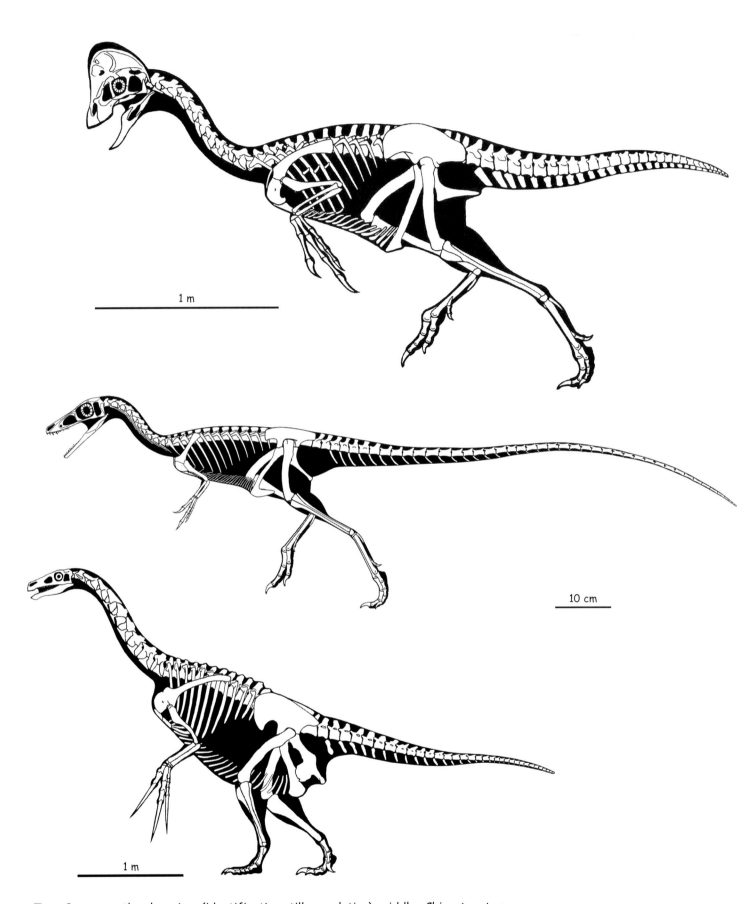

Top: *Compsognathus longpipes* (identification still speculative); middle: *Chirostenotes pergracilis*; bottom: *Nothronycus mckinleyi,* a totally bizarre animal with feathers and a huge, Godzilla-like pot belly.

SOURCES

Books

Arnold, Caroline. 2004. *Pterosaurs, Rulers of the Skies in the Dinosaur Age.* Clarion Books: New York. 40 pages.

Barrett, Paul. 2001. *National Geographic Dinosaurs.* National Geographic: Washington, D.C. 192 pages.

Brett-Surman, Dr. Michael, and Thomas R. Holtz, Jr. 2001. *Jurassic Park Institute Dinosaur Field Guide.* Random House: New York. 160 pages

Czerkas, Sylvia J., and Everett C. Olson, editors. 1987. *Dinosaurs Past and Present*, vol. 1. University of Washington Press: Washington. 180 pages.

Czerkas, Sylvia J., and Everett C. Olson, editors. 1987. *Dinosaurs Past and Present*, vol. 2. University of Washington Press: Washington. 164 pages.

Gee, Henry, and Luis V. Rey. 2003. *A Field Guide to Dinosaurs.* Barron's Educational Series: New York. 144 pages.

Dixon, Douglas. 1988. *The Macmillian Illustrated Encyclopedia of Dinosaurs and Prehistoric Animals.* Collier Books: New York. 312 pages.

Lambert, David. 1993. *The Ultimate Dinosaur.* Dorling Kindersley: New York. 192 pages.

Lambert, David, and the Diagram Group. 1990. *The Dinosaur Data Book.* Avon Books: New York. 320 pages.

Lessem, Don, and Donald F. Glut. 1993. *The Dinosaur Society Dinosaur Encyclopedia.* Random House: New York. 533 pages.

Malam, John, and Steve Parker. 2004. *Encyclopedia of Dinosaurs and Other Prehistoric Creatures.* Paragon Publishing: Bournemouth, U.K. 256 pages.

Norman, David. 1985. *The Illustrated Encyclopedia of Dinosaurs.* Crescent Books: New York. 208 pages.

Paul, Gregory S., editor. 2000. *The Scientific American Book of Dinosaurs.* Byron Preiss Visual Publications: New York. 424 pages.

Paul, Gregory S. 1988. *Predatory Dinosaurs.* Simon & Schuster: New York. 464 pages.

Stout, William. 1981. *The Dinosaurs: A Fantastic View of a Lost Era.* Bantam Books: New York. 150 pages.

Weishampel, D. B., P. Dodson, and H. Osmolska, editors. 1992. *The Dinosauria.* University of California Press: Berkeley, Cal. 733 pages.

Wellnhofer, Dr. Peter. 1991. *The Illustrated Encyclopedia of Pterosaurs.* Crescent: New York. 192 pages.

Zimmerman, Howard. 2001. *Dinosaurs!: The Biggest Baddest Strangest Fastest.* Atheneum: New York. 64 pages.

Websites

BBC: http://www.bbc.co.uk/dinosaurs

Jurassic Park Institute: http://www.jpinstitute.com/index.jsp

Natural History Museum: http://internt.nhm.ac.uk/jdsml/dino

Yahooligans Dinosaurs: http://yahooligans.yahoo.com/content/science/dinosaurs

Zoom Dinosaurs: http://www.enchantedlearning.com/subjects/dinosaurs

Index

Note: Page numbers in **boldface** type refer to illustrations.